DATE DUE

APR 2 5 2005			

DEMCO 38-296

Places of Grace

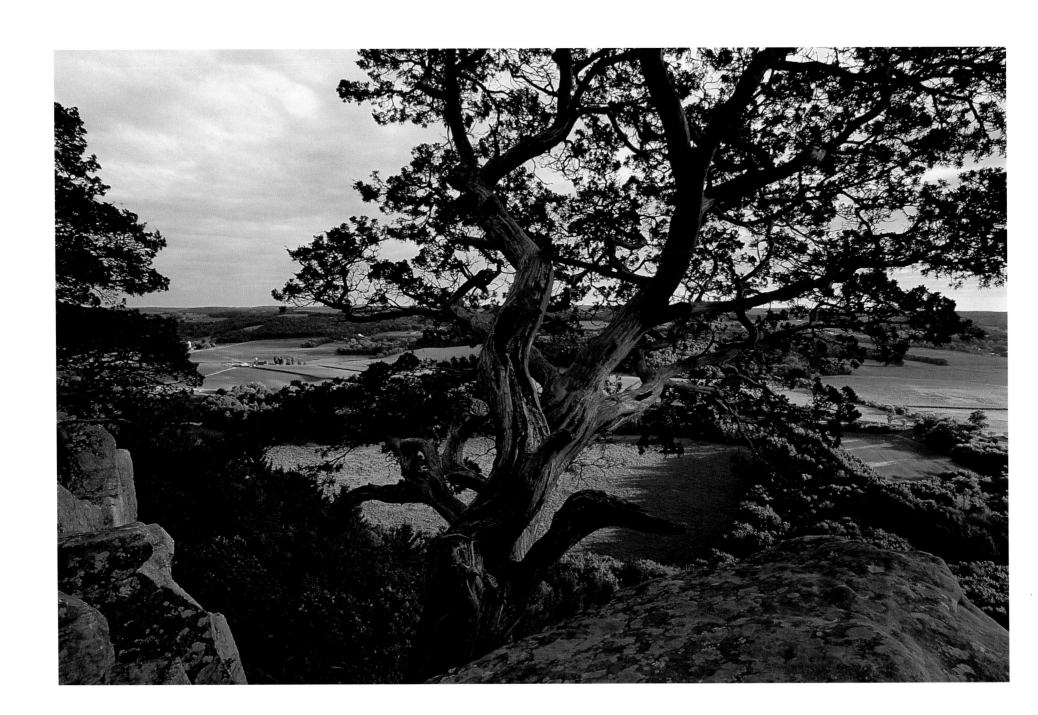

PLACES *of* GRACE

The Natural Landscapes of the American Midwest

PHOTOGRAPHS BY GARY IRVING

Essay by Michal Strutin

UNIVERSITY OF ILLINOIS PRESS URBANA AND CHICAGO

Photographs © 1999 by Gary Irving
Essay © 1999 by Michal Strutin
Manufactured in Canada
c 5 4 3 2 1
∞ This book is printed on acid-free paper.

Library of Congress Cataloging-in-Publication Data
Irving, Gary.
Places of grace: the natural landscapes of the American Midwest / photographs by Gary Irving ;
essay by Michal Strutin.
p. cm.
ISBN 0-252-02323-4 (cloth : acid-free paper)
1. Natural history—Middle West—Pictorial works. 2. Natural history—Middle West.
3. Landscape photography—Middle West. I. Strutin, Michal. II. Title.
QH104.5.M47 I78 1999
508.77—DDC21
98-58012
CIP

Preface

GARY IRVING

A few years ago I was commissioned by the Smithsonian Institution to photograph the Great Lakes region for a guidebook series on the natural landscapes of this country. It was during this time that I became acquainted with Michal Strutin, the writer for that project. We would occasionally correspond regarding location details or general impressions of areas we were assigned to document. As the work on the guidebook neared completion, we talked about our mutual desire to extend our time in this wonderful landscape. I suggested that we produce another book, one that would include the entire midwestern region, allowing both of us to explore the furthest reaches of forest, prairie, and wetland. Michal, eager to express her long-felt affection for these subtle natural wonders, agreed to the idea. This book is the result of that collaboration.

The title *Places of Grace* was one that I had been wanting to use for a monograph on landscapes, but I offered it for this volume because it describes so well the nature of the Midwest. Other areas may be noted for their obviously dramatic, even spectacular, attributes. But anyone who heads for the heartland will find amazing places of grace and serenity that offer their own rewards. In her fine essay, Michal offers insight into her responses to the varied pleasures of this landscape. The photographs contained within this book represent my own. I hope that through our words and images you may gain a sense of how precious this remnant landscape is.

While photographing for this book, I had a particularly memorable experience. It was late summer in a marshy area of northern Indiana, early one morning. The mist had risen off a nearby pond when I found myself on a small trail that led through the wetland. The morning fog had left in its wake a paradise of breathtaking beauty. Swirling grasses, like calligraphic brushstrokes, were punctuated by explosions of blossoming wetland flowers. I was lost in the moment, composing with the camera, when I became aware that I was being observed. I slowly turned my head in the direction of a silent motion I had caught out of the corner of my eye, and I found myself receiving the gaze of a female deer. Some moments later she looked away and quietly retreated into the brush. It was an encounter that has since caused me to look back on that entire morning, and mornings like it, and recall one of my favorite passages from the work of C. S. Lewis: "At present we are on the outside of the world, the wrong side of the door. We discern the freshness and purity of morning, but they do not make us fresh and pure. We cannot mingle with the splendors we see. But all the leaves of the New Testament are rustling with the rumour that it will not always be so. Some day, God willing, we shall get in."

Discovering the Land in the Middle

MICHAL STRUTIN

The Midwest is a place hidden in plain view. People fly over, drive through, and never really see this land in the middle. Yet, for those who know the Midwest, its landscapes shape the way we see the world. It is a land of broad, open prairies, opulent forests, and lakes without number. The nature of the heartland is profound in its artlessness . . . and wonderfully diverse.

Above a hidden, twisted sandstone gorge, golden autumn leaves drift thickly over the floor of an Indiana hardwood forest, their crunch underfoot releasing crisp, earthy odors. In Michigan's Upper Peninsula, the setting sun hovers—red as a blood orange—just above Lake Superior's cool blue horizon as the laughing cry of a loon rises from behind a screen of balsams.

A boulder, left behind by glaciers more then ten thousand years ago, serves as a seat on a Kansas prairie from which a visitor can listen to the whispered songs of a sea of grasses. Undulating under fickle winds, the big bluestem and dancing switchgrass part to reveal flashes of purple coneflowers and orange butterflyweed.

Roiling over the broad plains of Nebraska, clouds sketch the earthen canvas with shadow shapes, and a narrow ribbon of blacktop road stretches across a seemingly infinite green and tan land. It is a view that offers possibility.

Midwestern landscapes are rich with such natural grace. This land may not shout for attention, but it does penetrate the soul.

I knew nothing of the land's subtle influence when I was eight and moved with my family from Pennsylvania's Pocono Mountains to Illinois. We arrived at Midway, the only airport serving the Chicago area then, and my immediate reaction was agoraphobia. The sky was too big, the horizon too far. Gravity seemed to have a tenuous hold on the flat crust of the earth that extended in all directions. There were no mountains to anchor us, and I felt sure the gusting wind would suck us up into the overwhelming sky.

Gary Irving, whose photographs fill *Places of Graces,* says of this need to see the sky pierced by mountains, "We've been trained to see images that obliterate the horizon line." Over the years my vision has improved. I became comfortable with the breadth of my new home, and the space itself became an anchor, part of my world view. I have learned the land and, in turn, carry a reassuring sense of these Shaker-plain, bone-known places within.

For me, the Midwest provides internal as well as external geography. It allows a vision of life as expansive as the prairies themselves. But, focusing for a moment on the purely practical, where

do we draw the lines? What exactly are the physical boundaries of the Midwest? Lying at the foot of the Appalachian Mountains, Ohio is a good place to set the eastern border.

Perhaps a logical western demarcation would be at the foot of the Rockies and the finale of the shortgrass prairies. But somewhere toward the western edge of the Great Plains there is a sense that the West has begun. Though somewhat arbitrary, let us say the Midwest includes these states: Ohio, Indiana, Illinois, Michigan, Wisconsin, Minnesota, Missouri, Iowa, Kansas, and Nebraska.

Geologic facts back up an intuitive sense that here lies the stable center of the nation. All around, colliding tectonic plates have thrust up mountains: the Appalachians on one side and, much later, the Rockies on the other. Certainly the Midwest landscape has seen its share of mountain building as evidenced by the ancient, eroded domes of Michigan's Porcupine Mountains on the northern border and Missouri's Ozark Mountains bracketing the south. But, for the most part, the rock layers that tell this region's geological story lie in calm order—how midwestern—just as they were laid down, with little visible faulting or folding.

Over hundreds of millions of years shallow seas ebbed and flowed over the heartland. Rivers running from the Appalachians and other eroding mountains carried mud and sand to the inland seas, and the deposits became shale and sandstone under the pressure of their own weight. The sea itself contributed rock layers as countless generations of marine life left shells and skeletons that became limestone.

Dinosaurs roamed the shores of this sea. Later, prehistoric horses, rhinoceroses, and other long-extinct mammals filled the plains that emerged as the ancient seas drained away. Today researchers from around the world come to the banks of the Ohio River to study benches of Devonian limestone etched with thousands of crinoid fossils, or delve the fossil beds full of extinct beavers and boars in Nebraska. The Midwest serves as a showcase for the earth's long record of life.

The region's most recent geologic events were the Ice Ages. Four times over the past two million years, massive sheets of ice covered Canada and advanced south across the Midwest. The names of these glacial ages reflect the areas most affected: Nebraskan, Kansan, Illinoisan, and—ending about ten thousand years ago—the Wisconsin glaciation. Moving little more than inches a day, the ponderous glacial sheets scoured rock and earth from Canada and the upper Midwest, crushed it with the weight of mile-high ice, then tilled it evenly over large parts of the region's midsection.

As the earth warmed, glaciers and the cold, coniferous swamp forests at their feet retreated. Forests of astounding diversity moved up from the southern Appalachians to colonize the eastern third of the Midwest, exploding in a riot of life as the crushed rock of midwestern till-plains released its rich mineral energy. Rising toward the Rockies, the higher, drier western realm grew a thick pelt of grasses, which teemed with wildlife no less than the most fecund savannas of Africa.

As glaciers withdrew, their meltwaters filled enormous northern basins that the weight of the ice helped create: the Great Lakes. The five lakes—Superior, Michigan, Huron, Erie, and Ontario—hold one-fifth of all fresh water on earth, and four of them fringe the Midwest. Another of the world's great waters rises in the upper Midwest: the inexorable Mississippi River.

The peopling of North America occurred comparatively late, toward the end of the Ice Ages. By the time Europeans arrived, maybe twenty million people inhabited the continent. Although the numerous native groups that lived across the Midwest used fire to clear land or hunt bison, the region remained in a relatively natural state until Europeans entered the land.

The first to arrive were French *voyageurs* of the 1600s, traveling through the northern Great Lakes. As they moved west, they entered the myriad rivers and lakes of Michigan, Wisconsin, Illinois, and Minnesota to trap a wealth of beaver, mink, and other fur-bearing wildlife of the northern forests. For the most part, they did not come to settle the land, but they opened the way for

Sunset, Elephant Rocks State Park, Missouri

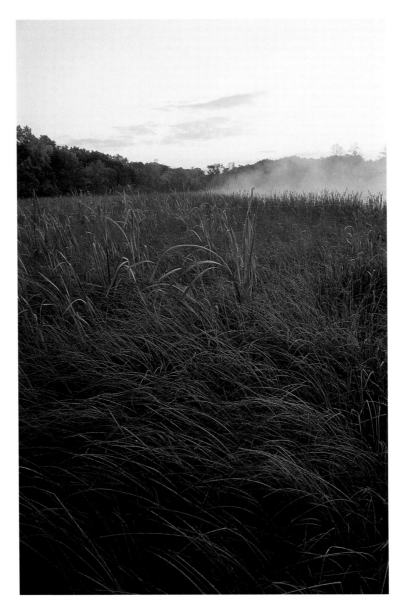

Cattail Marsh, Potawatomi Nature Preserve, Indiana

others. Two centuries later, miners were excavating the ancient ranges of upper Michigan and Minnesota for iron and copper. Logging magnates, whose workers felled whole forests of white pine and hardwoods, made millions from the North Woods.

Farther south and east, settlers breached the Appalachians in the late 1700s. Looking for land to farm, they found the till-plains of Ohio and Indiana covered with deciduous forests so broad and lofty that leafy canopies blotted out the summer sky. But the soils were rich and the land looked untouched and available. Tree by towering tree, they cleared the land and tamed the wild. The Ohio River and tributaries such as the Scioto and the Wabash became their highways to the Mississippi and, from there, as far south as the French port of New Orleans.

Settlers understood forests, but when they reached Illinois in the early 1800s, they paused before the great ocean of grass that lay before them. Nothing in Europe had prepared them for such a scene. They did not even know what to call the land. The French called it *prairie*—"meadow"—because meadows were the only European landscapes that even remotely resembled the Midwest's vast grasslands. The Midwest had "meadows" that stretched a thousand miles.

If felling and clearing a hundred-foot-high tree was hard, busting an equal mass of prairie sod was that much harder. To complicate matters, grasslands provide little wood for fuel or for building houses. But we humans are inventive, and new types of plows dug up much of the deep, interlocking prairie roots of Iowa and Illinois. The black soils that lay beneath ten-foot-high tallgrass prairies were the most fertile on earth and, in time, bluestem and Indiangrass were replaced by more cultivated grasses—corn and wheat.

At Independence, Missouri, where tallgrass prairies begin yielding to shorter, more drought-resistant mixed grasses, settlers gathered themselves for the great push west along the newly grooved Oregon and Santa Fe Trails. The opening of the West marked the end of the wild.

Sod busting and grain planting continued across the prairies of Kansas and Nebraska, giving way to cattle grazing in the shortgrass prairies, where water is scarce. In less than a century, the natural landscapes of the Midwest were found—and lost.

But not all was lost. Although people will try anything, some things just take too much trying. Settlers attempted to farm the gnarled hills of southern Ohio, Indiana, and Illinois. Untouched by glaciers, these thin-soiled uplands were often too rocky and wrinkled for plow or ax. People gave up and moved on, and abandoned farms eventually devolved to the U.S. Forest Service. Much the same happened throughout the Ozarks of Missouri.

The cold, dank swamp forests of the far north were deemed too hard to drain. Nebraska's Sand Hills proved too arid and irregular for intensive agriculture. Even a plow couldn't crack the Flint Hills of Kansas. Iowa's Loess Hills were not as easy to plant as nearby floodplain fields or the low roll of land to the east. Marshes and other midwestern wetlands not conquered by drainage schemes were called pestilential and left to wildlife. Many of the natural landscapes that remained were not worth the effort of putting them to good use.

The Midwest is full of useful, productive land, but the lands that were left are equally valuable, in terms not calculated by units produced or metric tons shipped. It is hard to measure the pleasure and serenity that comes from walking among the sculpted sandstones of Ohio's Hocking Hills, being lulled by the smooth sheet of Illinois River that passes beneath Starved Rock, or viewing the vastness of the Great Plains from Scotts Bluff, that ship of stone sailing on the western reaches of Nebraska's sea of grass. Our spirits as well as our bodies need occasional recharge on the sun-warmed beaches of the Great Lakes, in boats on the Boundary Waters, amid the careless beauty of wildflowers crowding an Iowa "meadow."

Connections with the wild enrich us no less than tangible acquisitions. Although the Midwest has long been valued as the world's breadbasket, its natural landscapes have been undervalued for too long. By any measure, they are places of incomparable grace.

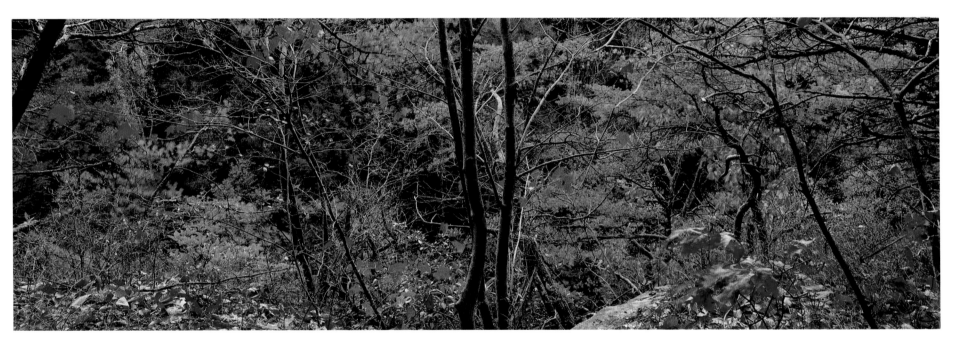

Autumn, Wayne National Forest, Ohio

FORESTS

For many of us, forests are the essential natural landscape. We have learned to love prairies and deserts, but forests inhabit our history; they were the landscapes of our ancestors. Yet, the forest each of us imagines is unlike any other.

Some see picnics on a grassy savanna under a green umbrella of oak leaves. Some imagine primeval places, full of tall, dark ranks of evergreens. Others visualize crisp woodland walks among autumnal yellow leaves of beech and hickory. Forests are as various as our imaginations. In the Midwest, the forest imagined can easily become the forest experienced because the Midwest spans a full range of forest types, from boreal to bayou, north to south.

Trees once shaded the eastern third of the Midwest so thoroughly that, in the heart of summer, the forest floor for hundreds of miles in any direction must have been shadowed, lit only by filtered light except where fallen trees or lakes opened the canopy. The forests that once blanketed the eastern Midwest were part of the world's richest temperate forests, whose demise was akin to the ravaging of the rain forests.

Forest still covers large swaths of the Midwest. But in presettlement days it swung in a enormous, nearly unbroken backward "C" from northern Minnesota, across Wisconsin and Michigan, Ohio, Indiana, and back through southern Illinois and southeastern Missouri.

The north is rimmed by coniferous boreal forests, which came down from Canada. South of the boreal, northern transition forests hold sway to the middle of Minnesota, Wisconsin, and Michigan. These are the Great North Woods of Paul Bunyan, the size of the forests matching the size of the legends. The region's midsection is filled with a leafy mix of deciduous trees, where north and south meet. Bottomland forests washed by rivers inhabit low midwestern floodplains. And, though rare, baldcypress swamp forests show up in the southernmost drainages of the Midwest.

Each of these different forest types has its own character, its own understory of shrubs and wildflowers. Each supports a broad array of insects, amphibians, reptiles, birds, and mammals. And each overlaps, intertwines, and wrestles for space with ecosystems on each side. Dramatic tension lies on the land.

A hardwood forest ten miles from Lake Superior might change to boreal evergreens along the cool, damp lakeshore. An Ohio valley clothed with deciduous trees may be flanked by hills covered with more northerly trees. Where forest and prairie meet in Illinois and elsewhere, advances and retreats create a ragged, shifting line with incursions of oaks here, forays of switchgrass there. As the landscape changes, so does all that lives within.

A Cloak of Boreal

Boreal: the word conjures the face of a stern North Wind blowing blasts of icy air across a map. In the contiguous United States, that cold, boreal breath is directed at the upper Midwest, especially the lands that rim Lake Superior.

The icy image surely fits in winter. International Falls, Minnesota, regularly leads the list of coldest places in America and parts of Michigan's Upper Peninsula are blanketed by more than fifteen feet of snow each winter. These forests of the far north are thick with conifers because few other trees can survive the long winters and severe conditions. Their tight needles preserve moisture, their sloping shapes shed snow.

Boreal forests cover the thin soils of the Canadian Shield, the vast rock layer that covers much of Canada and the upper Midwest and is one of the oldest geological formations on earth. This realm is streaked with rivers and pocked by lakes and bogs created by the grinding of glaciers.

Water that evaporates from lakes and rivers during the heat of a summer's day condenses during the hours of darkness. Often veils of mist gather as night cools the air and, by morning,

all is cloaked in evanescent white. Along a mist-shrouded lake in northern Minnesota the dark figures of conifers lean over the water like crowds around a steamy cauldron. As the mist lifts, it reveals a placid scene of anglers in small boats playing a waiting game with pike.

At the edge of an outback highway on Michigan's Upper Peninsula a line of spruce and balsam parts to reveal the spindly white legs of a grove of paper birch. In the fairy-tale evening, with the aurora borealis shimmering across the sky, I am reminded of Baba Yaga, a witch whose magical house in birch woods rested atop giant chicken legs. Baba Yaga lived in a Russian forest no doubt similar to this.

Along a crosscountry ski trail in northern Wisconsin, the snow-laden skirts of spruce appear from a lacy veil of snowflakes, evoking an image of a young woman in white with a Christmas crown of candles. Boreal forests have their counterpart in Scandinavia as well.

Such places are not difficult to find. Although much of the Midwest's boreal forests have been logged, more of this forest remains untouched than any other because the climate is severe and the terrain difficult, edged everywhere by water: lakes, rivers, shrub swamps, bogs, fens, and swamp forests.

During the Ice Ages, boreal forests and bogs lay at the feet of glaciers near the southern edge of the Midwest, not far from the Ohio River. Here mastodons, ten feet tall and protected by thick auburn hair, browsed among spruce and tamarack. Remains of boreal peat bogs are still strewn over the region. In Ohio, mastodon remains have been discovered in the sterile depths of an ancient peat bog. At Indiana Dunes National Seashore, rare plants survive in remnant bogs left as glaciers slowly retreated.

Today, America's greatest boreal forests lie where northeastern Minnesota and Ontario meet in a maze of wetlands and woods: along the linked lakes of Voyageurs National Park, within Superior National Forest, and edging the Boundary Waters, the epitome of northern watery wilderness where canoes are the vehicles of choice over twelve thousand miles of fluid trails.

Wisconsin's lake-rich Northern Highlands and the northwest islands of the Apostle archipelago are dark with boreal forests, too. If Minnesota is the Land of Ten Thousand Lakes, northern Wisconsin is a match. Even the northeastern shores of Door Peninsula, blasted in winter by Lake Michigan, support boreal forests. Michigan's Isle Royale and its Upper Peninsula, especially the rocky trigger of the Keweenaw Peninsula, are a weave of both boreal and northern transitional forests.

Although fire often plays a critical role in maintaining healthy forests, boreal forests are usually too wet and too cool to burn. Where still water rests atop an impermeable base, peat bogs spangle the land. The thick spongy beds of green sphagnum peat are ringed by tight-needled black spruce, feathery blue-green tamarack that shed their needles each winter, and white cedar. Pink ladyslipper and other orchids thrive in the moist conditions. Scattered at the edges of this damp gathering are clusters of bunchberry, whose leaves and berries glow burgundy in autumn, pretty pipsissewa with its bell-like flowers, dwarf blue iris, tall waxy spears of bluebead lily, and a host of other wildflowers.

I saved a few strands of sphagnum from just such a place in Wisconsin and keep it in my car where only I can see it plainly. The living green has turned to dusty beige, but the sight of that dried sphagnum brings me back to that glowing emerald carpet encircled by somber spruce whose stillness was broken only by my breathing and the brilliant flight of a yellow swallowtail.

If the emerald of sphagnum and the gloomy green of black spruce color boreal forests, balsam fir provides the dominant scent. Spires of balsam fir shape boreal horizons, but its resinous odor stirs the memory of those jagged skylines long after the view has passed.

White spruce helps complete the mix of evergreens and provides food for grouse. Spruce grouse is the ground bird of these forests, just as wild turkey favors deciduous forests and prairie chickens prefer prairie. Scuffling among the trees, grouse dine on the buds of evergreens and ironwood, a small tree with wood so hard they say it can break an ax.

The white-throated sparrow sings the quintessential song of the north, its "O Canada, Canada, Canada" a friendly summer greeting. But the summer woods are also full of warblers, woodpeckers, and other birds. Loons, shovelers, herons—myriad waterfowl crowd the lakes and bald eagles overlook all from their massive nests in the crotches of giant white pines.

The true ungulate of boreal forests is the moose, which browses balsam and aspen in winter and takes to the water in summer, soaking itself against voracious black flies and mosquitoes and slurping up water plants rich in nutrients and salts. Chatty red squirrels are as obvious as black bears are secretive. And wolverines, ferocious low-slung predators who live only in cold country, are seldom seen at all.

Great North Woods

From a hilltop in Michigan's Porcupine Mountains, I have looked out toward where Lake Superior and the sky merged in a line of blended blue. At my back, hill upon forested hill advanced to the horizon. Part of the greatest swath of forest east of the Rockies, the trees stretched much farther than I could see, filling me with a sense of its Paul Bunyan bigness. I was in the heart of the Midwest's northern transitional forests.

Rambling over some of the oldest mountains in America and filling in broad benches along the northern Great Lakes, northern transitional forests form the greatest band of tree-covered land remaining in the Midwest. They cover much of northern Minnesota and Wisconsin, Michigan's Upper Peninsula, and the northern third of lower Michigan. If intimate, evergreen boreal forests ask for a close view, northern hardwoods are big-picture forests where broadleaf trees spread hundreds of square miles.

The North Woods is just that much warmer and drier than the boreal so that deciduous trees begin to outnumber conifers: maple, yellow birch, aspen, basswood with its large, heart-shaped leaves, and, near water's edge, thickets of alder. Where geologic faulting and folding created cool, moist ravines, hemlocks spread curtains of dark lacy needles over clefts cut by lyrical streams.

Come autumn, these forests become festivals of color. Sugar maples blaze red and orange against gold-leaved birches while oaks' dark burgundy add a muted hue. In spring, when the sap flows, these become sweet woods. A sugar maple can give up thirty-five gallons of sap—about one gallon of syrup—per season. Early settlers learned to tap the trees from the Chippewa and other tribes who lived among the North Woods.

The forests are still home to Chippewa, Menominee, and Potawatami, the Algonquian peoples who once lived throughout the region. Their heritage is reflected in the names of the national forests: Chippewa, Chequamegon, Hiawatha. Aldo Leopold, John Muir, and Sigurd Olson are other names linked with the upper Midwest because here is where these seminal conservationists learned to love the wild.

Mesabi and Penokee-Gogebic are ancient mountain ranges whose names also resonate with the North Woods. The Mesabi in Minnesota and the Penokee-Gogebic straddling the Wisconsin-Michigan border gave up iron ore that was loaded on ships at Duluth. Worn mountains from early in earth's history, the Penokee-Gogebic once soared four miles high, higher than the present-day Rockies. Now the range is merely one-third mile above sea level.

Loggers as well as miners worked the North Woods, so most of the forests are second growth. Deep within, however, pockets of old growth survive. The majestic conifer of old northern forests is the white pine, which once stood in towering, almost-pure stands. With straight trunks topped by thick, outspread limbs, mature white pines are massive, dignified trees—the elders of the forest.

Because the North Woods was scraped by glaciers, soils are thin—less than two feet in places. Atop bluffs, soils become even thinner. Northern hardwoods on exposed bluffs from the Porcupine Mountains south to Wisconsin's Devil's Lake endure weather that vacillates between the furious cold of wind-riven

winters and the burning heat of summer. In such extreme conditions oak and satiny yellow birch eke out an existence as pygmy forests. A hundred-year-old yellow birch, which may be a hundred feet high and four feet in diameter on the forest floor, may reach only ten feet high and four inches in diameter on a weatherbeaten bluff.

Winter in the north is no easy matter for any living thing. The days are short, the snow lies thick, and the winds, blowing from the Lakes, are infamous. We, like the landscape, endure midwestern winters, but we boast about it. What's our choice? Winters polish us like diamonds, and we shine, wrapped like hemlock trees, in thick layers. I have lived high in the Rockies, at nine thousand feet, and even there winter seemed a cinch by comparison.

In winter, the bears of the North Woods endure by lying low. If wealth is counted in black bears, the region is rich. Black bears require a range of about ten square miles, so room is no problem in these expansive forests. And board—well, there's plenty: banks of thimbleberry and raspberry in summer, blueberries in fall along with acorns and other mast, trout in cold rivers and countless streams, tree sap, roots, grasses, and insects. Despite omnivorous appetites and a curiosity almost as well developed as our own, black bears generally avoid people.

There are marshes in the backwoods of the upper Midwest so primeval they look as though earth's waters had parted for the first time, revealing lost worlds from the Carboniferous period, when dragonflies with two-foot wingspans buzzed the skies. In such a place I saw the retreating back of a black bear, the only time I've seen bear in the north country of the Midwest, except . . .

A North Woods restaurant I happened upon was fitted with a large picture window that looked out on a grassy clearing in the forest. The owners had laid out barrels baited with food, which had attracted a large, long-legged male bear. Diners enjoyed the show, but the bear had learned a terrible lesson: contact with humans equals food. Encounters that result from such lessons can be deadly, most often for the bear.

For our sake and theirs, bears are wise to avoid us. Wolves are even more wary. The North Woods, especially in and around Superior National Forest, is the heart of America's wolf country. Hundreds of the animals inhabit that forest and dozens live in Chequamegon National Forest, hunting beaver, deer, and rabbit.

Isle Royale's longstanding wolf packs cull old and weak moose, keeping the moose population healthy. They live as they hunt, in tight families with a language that leaves little to question. Ears back or erect, tail up or down, mouth open or grinning—the semaphore language of wolves allows them to communicate with precision.

Eventually, those who sleep in the North Woods hear wolves. Seeing them move through the forest with their long, loping gait is another matter—rare and auspicious. But their voices are enough to assure that we haven't tamed every inch of the wild.

Forest Remembered

The forests that once covered the midsection of the Midwest must reign in memory alone. Spreading over Ohio, Indiana, lower Michigan, southeastern Wisconsin and Minnesota, and large patches of Illinois were deciduous forests so thick and various that they turned summer's light to a dim green glow beneath their leafy cover. For the most part, those rich, temperate forests are gone. They had the misfortune to occupy the fertile, even soils of the till-plains, among the country's most recent geological deposits.

The Midwest possesses the nation's oldest and youngest geological deposits, from the ancient igneous greenstones of the Upper Peninsula to the recent, glacier-raked till-plains of Indiana and neighboring states. Ice-age glaciers scraped rocks and soil from the north and deposited them in the midsection, the great weight of the glaciers grinding the land to a fine, level *tabula rasa*.

Over millennia, the new-made land was colonized by a profusion of trees, shrubs, and wildflowers. Wolves, elk, bear, skunk, fox, raccoon, and small rodents by the millions once lived in the mixed deciduous forests. Small mammals still do, but most large

Detail, Chippewa National Forest, Minnesota

mammals were driven out when nineteenth-century settlers made their way over the Appalachians to what was then America's western frontier. Their first work was to clear forests for agriculture. Now, cornfields and urban areas fill most of these gentle lands.

Deciduous forests still cradle Illinois's Rock River and other river valleys, climb the sides of eskers and other glacial landforms within Wisconsin, and lie in remnants throughout Michigan. The last of the Midwest's great deciduous forests, however, lies south of the territory last touched by glaciers.

Contour distinguishes the unglaciated southern third of Ohio, Indiana, and Illinois as well as Missouri's Ozarks. Unlike the even till-plains just to the north, the unglaciated lands are full of knobby buttes, sculpted sandstone gorges, rolling hills underlain with caves, and dark tree-shaded ravines. Farmers who wore out their plows and their patience on these difficult contours gave back the land to the government. As with logged lands of the North Woods, public lands such as Illinois's Shawnee National Forest and Ohio's Hocking Hills are mostly second-growth forests with pockets of virgin woods.

In the spring, before tree leaves unfurl to shade the forest floor, hundreds of wildflower species bloom. Bluebells flutter atop green bouquets of their own leaves. Trillium in white, yellow, and purple stand stately above an apron of triplet leaves. Squirrel corn and wood anemone wink white amid layers of filigree foliage. Violets clump together in groups of yellow, blue, lavender, and white.

Spring is also the time to spot birds, before they too are hidden by tree leaves: from year-round residents such as cardinals, juncos, and towhees to tanagers, warblers, and others that migrate farther south for the winter.

These are the forests of my youth, and early one bare-bough spring I returned to explore Turkey Run. No matter how many other places I have seen or how many times I return to Turkey Run, Indiana—where my parents took us as children, where I took my children when they were small—its recesses and the quiet, forested closeness of its rounded ridges always show me something new.

Setting out just after dawn, I passed four teenaged boys stumbling across the Sugar Creek footbridge, obviously returning from an illegal night in the nature preserve. I entered the dark mazeway of Rocky Hollow and its cascades, shaded to spooky darkness by hemlock. Emerging, I forked onto another trail that took me into deep, old woods.

Perched on the back of an old log, I ate a roll and watched a large pileated woodpecker engaged in a more energetic meal—hammering the sides of trees, probing stumps—and, frequently, watching me. I'm sure that beneath the rotting bark of the log I sat on lay a banquet of appetizing insects. I also heard titmice and chickadees, but I can see them in any scrap of woods. Pileated woodpeckers—the largest woodpeckers in North America—prefer the giant trees and standing snags of old-growth forests.

In mixed deciduous forests old-growth is anchored by maples and beeches. Few other trees can develop in the shade of taller trees, so shade-tolerant beeches and maples are the heart of a climax forest community. They are accompanied by a huge retinue of other broadleafs: black cherries, yellow poplars, oaks, hickories, birch, aspen, buckeye, ash, with a few coniferous species—mostly pines—to round out the mix.

If boreal forests call for intimate closeups and North Woods the long view, deciduous forests claim the middle distance. Just as the temperature and terrain in this belt are moderate, so too are the forests: comfortable places, like a favorite chair in the family room.

I've gotten to know many of the inhabitants of these woods. Leaves and fruits are always good guides—from the hand-shaped leaves of maples to the acorns thrown off by oaks. Even in winter, the leaf litter surrounding a bare tree can indicate the tree's identity.

Some trees have other distinctions that advertise who they are. Black cherry's bark looks like an orderly mosaic of dark square tiles. Beech's smooth gray bark is elegant, a tree's version of raw silk, but too often scarred by graffiti. The bark of shagbark

hickory hangs from the tree in shaggy strips. And sycamores, which like their feet kept moist at the edge of rivers and streams, are patterned with scalloped patches of tan, pink, and cream bark. I'm also taken with the solid shape of an oak, promising that the world really is a steady place, or the languid arch of a river birch, which hints at a southern drawl and a life of leisure.

Lands with Southern Accents and Western Twangs

Deciduous forests make all sorts of compromises. They interweave with northern forests where latitude dictates. West of Indiana they compete with prairies for dominance. At the wet, southernmost edges of the region, they vie with bald-cypress swamp forests.

Even along riverbanks within a deciduous forest, the tenor changes. Unlike northern rivers that plunge wildly through rocky beds, rivers of the midsection are, like the land around them, moderate. Conditions there are right for silver maples, river birches, and other water-loving trees, and for minks, muskrats, and wood ducks. These are the Midwest's bottomland forests, which fill floodplains in southern Missouri, Illinois, Indiana, and Ohio. In spring, rivers flood into the bottomland forests, and then you can paddle a canoe into the woods—or, matching style with substance, take a pirogue into the bald-cypress swamps of Indiana, Illinois, and Missouri.

Missouri's Ozarks claim their own type of forest. Among the oldest, most eroded mountains in the nation, the Ozarks bear thin soils and lie closer toward the arid West and deeper into the heat of the South than other midwestern forests. In the St. François Mountains—the heart of the Ozarks—oaks, hickories, and pines predominate because they don't mind being dry. Wild azaleas color the understory where soils are sandy and acidic.

Lightning-sparked fires used to burn Missouri's forests regularly, leaving some understories open to wildflowers and grasses. In fact, wherever forest and prairie meet in the Midwest, patches of these parklike areas, called savannas, thrive. On dry, sandy soils of savannas thick-barked bur oak and other fire-tolerant trees space themselves broadly among grasses and flowers.

Eventually, prairies prevail—except along watercourses where sinuous lines of trees create "gallery forests." These lines of oak, hickory, and hackberry are the farthest outposts of eastern forests, clinging close to streams and rivers in lands that become increasingly dry as they rise slowly toward the Rocky Mountains.

Forests lie even at the farthest reaches of the Midwest, in the arid lands of the Nebraska panhandle, where it is difficult to distinguish West from Midwest. The terms have little meaning in such wild, raw places. Here, isolated black tendrils of two-lane snake across a landscape that rolls with low grasses. On this spare scene a few forested ranges stand out: the clutch of Wildcat Hills and the great, dark arc of Pine Ridge. Pine Ridge forms a crescent with its cousin, South Dakota's Black Hills, named for its somber forests. Like the Black Hills, the dark brows of Pine Ridge are crowned with evergreen ponderosa pine—and intimations of the West.

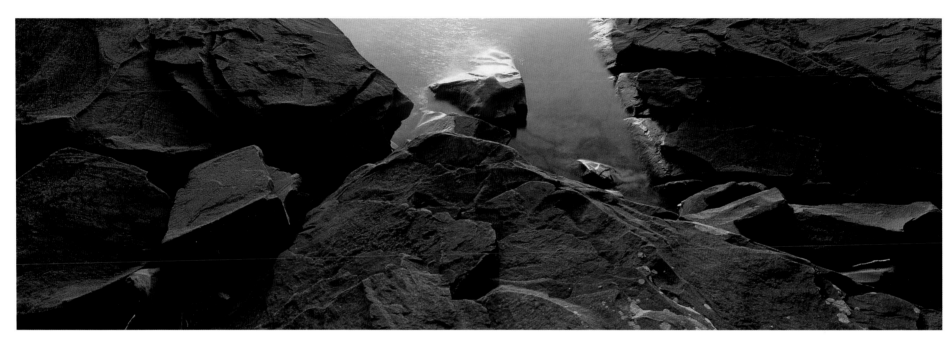

Rocks along Lake Superior, Upper Peninsula, Michigan

WATER AND WETLANDS

If water is life, the Midwest has more of it than anywhere else in America. Within its boundaries is the most lake-dense region on earth, the nation's largest number of blackwater rivers, the broadest freshwater marshes, and the birthplace of the continent's greatest river. Most obviously, it is also home to the world's premier inland seas: four of the five Great Lakes. Superior, Huron, Michigan, and Erie are among the world's nine largest lakes, with Superior first on the list. Yet, it is easy to take all of this water for granted because it is always part of the background pattern. Sometimes it takes another person's eyes or a different perspective to see it.

Great Lakes: The Inland Seas

A friend from the East Coast, who knew little about the middle of America, stood on the banks of Lake Michigan for the first time, watching the surf, astonished. "I've never seen anything like this that wasn't an ocean." Mildly surprised, I answered, "Well, yes . . ." as if the lake were a given.

But I had grown up near Lake Michigan and its size had never occurred to me. It was the place where I, a bold ten-year-old, took my little brother and sister on a hike at the Indiana Dunes and got all three of us lost in the forested backdunes. It was the place where, as teenagers with new drivers' licenses, my friends and I splayed ourselves on the beach in hormone-giddy girl-boy groups. Lake Michigan was just the backdrop for these simple dramas.

Although the four lakes include more than a thousand miles of beaches and sixty-five hundred miles of shoreline, Lake Michigan is the only Great Lake to lie wholly within the United States. Twinned with Lake Huron in size, the two would be one broad inland sea were it not for mitten-shaped lower Michigan, which thrusts a bulky divide of land between them. The western shore-lines of Lake Michigan and Lake Huron are much the same: grassy banks and low bluffs interspersed with modest sand or gravel beaches and broad rock shelves.

The eastern shores of Lake Michigan, however, are unique. From Wilderness State Park at the northwestern tip of lower Michigan to where the state's shoreline meets Indiana, the banks of Lake Michigan are piled with dunes: from golden mountains of sand, among the tallest in the nation, to rank upon rank of smaller dunes marching inland to meet the forest. The most extensive freshwater dunes in the world—hundreds of miles of them—are, for the most part, protected as national and state parks.

Geologists say the Great Lakes were once broad river valleys that drained toward the Mississippi River. During the Ice Ages, the weight of the glaciers scoured the valleys, creating bowls rimmed by moraines of glacial debris. When the climate eventually warmed, the bowls filled with the waters of melting glaciers. The last Ice Age, which ended a little more than ten thousand years ago, rerouted lake waters once bound toward the Mississippi. Spilling from one lake to another, water now pours from Superior to the Michigan-Huron basin, then to Lake Erie, over Niagara Falls to Lake Ontario and, eventually, to the St. Lawrence River and the Atlantic Ocean.

As large as the lakes are now, their predecessors—formed during interglacial periods—were larger. Even the present versions have shrunk some since the last Ice Age. Rock ledges that once overlooked Lake Superior are a few miles inland. The southern shores of Lake Erie were fringed by marsh and swamp forest. These wetlands were the soggy remnants of a larger lake, and home to countless waterfowl, fish, and amphibians . . . as well as mosquitoes.

In order to reach the good fishing of Lake Erie, the Miami and other native groups crossed the malarial swamps on trails that followed the backs of moraines. European settlers called Erie's

sodden southern lip the Great Black Swamp before they drained most of it in the late 1800s. Though today the Great Lakes are continually being recharged by about thirty inches of precipitation a year, their volumes are nothing like the enormous, long-gone seas created by melting glaciers.

Floating in Lake Michigan, on swells rhythmic as the sway of a hammock, the hot sun sapping all energy, one can contemplate geology in a sleepy sort of way. Gently lapping summer waters glow turquoise against a sandy bottom that's easy on the feet. Equally pleasant are the warm beds of golden sand where all thought simply drains away into the heat of the beach. Rimming this scene at Indiana Dunes National Lakeshore are two-hundred-foot dunes that hide behind them some of the greatest botanical biodiversity in the nation.

Sands nearest Lake Michigan are bare. As dunes progress inland, marram grass and beach pea take hold, sparsely covering the sand. Where the dunes become stabilized by grasses, low shrubs take hold. Finally a scattering of trees appears on the deepening soils. In the 1890s, the University of Chicago's Dr. Henry Chandler Cowles observed this progression on the Indiana Dunes and proposed the theory of plant succession, thus opening the era of modern ecology.

People who venture to the back sides of the dunes find them covered with oaks. Farther inland and parallel to the dunes is another line of dunes representing an older shoreline. Those dunes are completely forested. Between their ranks lie long, low swales, often filled with water or marsh. The glaciers also left peat bogs here. And some of the open sands that were once beach have filled in with prairie. This patchwork of ecosystems yields tremendous diversity, everything from prickly-pear cactus to boreal tamarack to prairie wildflowers.

Winter transforms the lakes. The tranquil, yielding waters of summer are replaced by a hard, icy face. Along rocky ledges, waves freeze in spikes and stack up against the rocks in slushy, gray mounds. Lake winds howl at the shore, piercing the air with minute shards of ice, which glitter like crystal when the sun sud-

denly bursts through a bank of heavy clouds. Winter, with its shifting moods, is a fine time for lake viewing, not for lake travel. From December through March lake travel halts because ice bars all ships but icebreakers. Thick shelves of ice reach from the shoreline into the lakes. Even giant Lake Superior completely freezes over about once a decade.

The transition from summer to winter is the most treacherous time on the Great Lakes. Waters that have been storing the sun's energy all summer begin releasing their heat into the cooler air of autumn. When a storm whips in from the west, the turbulence of crashing, twisting columns of air creates seas of ghastly proportions. These monster storms are the most malignant result of the formidable "lake effect."

In 1842 a storm destroyed 50 vessels on the Lakes. In a 1913 storm, 235 people went down. Many more died between and since these two catastrophes. In 1975, after two days of fighting storm and blinding snow, the *Edmund Fitzgerald* and its 23 men were nearing Whitefish Bay and safety when a trio of 30-foot waves flung the 729-foot ship to the bottom of Lake Superior. The captain of a nearby freighter, also struggling against the storm, said one minute he had contact, the next minute the *Edmund Fitzgerald* was gone.

Years later, I saw one of the freighters that had searched through the night for the *Edmund Fitzgerald*. As large as a skyscraper lying on its side, the ship was edging its way through the Soo at Sault Sainte Marie, a close fit even in those wide locks. I walked the length of the locks—a few blocks—shadowed the whole way by the freighter. It was hard to imagine the force that had tossed the *Edmund Fitzgerald*, a similar giant.

I learned to appreciate the enormity of the lakes the day I traveled across Superior. The seaplane held six, with our knees and arms crushed together in a space no bigger than a taxi. We had waited five hours on the dock at Houghton, Michigan, for fog to lift. Finally aloft above the lake, we could see the plane's shadow—the size of a dragonfly—against all that sun-riffled indigo water. We saw a few freighters en route, similar to the

one at the Soo, yet they looked no more significant than the plane's small shadow on that vast seascape.

As we flew between the Keweenaw Peninsula and Isle Royale, protected only by the thin skin of the plane, the pilot mentioned, offhand, that Lake Superior was too broad, too deep, and too far north to ever really warm up. Its temperature never climbs much above forty degrees. A comforting thought, knowing that even if we survived a fall from the sky, the lake would freeze us—in the middle of a fair summer day—within about twenty minutes.

Superior remains so cold year-round that it supports little life. Most of the eighty million pounds of fish taken from the Great Lakes each year comes from Lakes Michigan and Erie, but the catch has changed over the years. Atlantic Ocean lampreys, once blocked by Niagara Falls, entered the lakes after locks and canals were constructed. Lampreys made themselves at home, breeding and sucking the life from lake trout. People depleted sturgeon populations.

Now the majority of the catch is herring, a commercial fish not native to the lakes. The lakes are better known for whitefish. Along with wild rice and game, whitefish formed the base of Algonquian diets. Today, it's still traditional fare on Wisconsin's Door Peninsula, famous for its whitefish boils and its cherry pies.

The lakes provide the whitefish, and the lake effect's benign aspect delivers the cherries. The moisture-laden breezes of the lake effect keep fruit tree buds cool so they do not open until after spring's last frost. Then, in early fall, warm humidity from the lake effect helps ripen the fruit and sustain a healthy orchard industry in Wisconsin and Michigan.

The Great Lakes are also fringed by hundreds of islands, whose names reflect a history of native peoples, French *voyageurs,* and English settlers: Isle Royale, the Apostles, and Grand Island in Lake Superior; Beaver and North and South Manitou in Lake Michigan; Drummond, Mackinac, Bois Blanc, and Les Cheneaux in Lake Huron; and the archipelago that includes Kelleys Island in Lake Erie.

The Father of Waters and Other Rivers

Nicolet National Forest, in northern Wisconsin, is often called the "cradle of rivers" because of the number of rivers that rise there, but the term suits the entire region. Between the Appalachians and the Rockies, the Canadian border and southern Missouri, the Midwest is etched by every sort of river: from rocky southern rivers that rise in the Ozarks to black-water boreal streams in the north to placid rivers of the midlands and sun-shriveled rivers coming from the West. One river dominates the rest: the Mississippi.

Overwhelming in every respect, the Mississippi flows 2,400 miles from northern Minnesota to its delta in Louisiana, the third longest river in the world. Counting its length from its longest branch, the Missouri, the river flows 3,700 miles.

The Mississippi drains the entire middle of the country, nearly half of America. The Allegheny Plateau in Pennsylvania delivers the waters of the Ohio River, broadened by the Tennessee and Cumberland Rivers from the southern Appalachians. The Rocky Mountains send the waters of the Missouri, Platte, and Arkansas. The Wisconsin, St. Croix, Wabash, and Illinois pour in from the Great Lakes region. Approximately 250 rivers and streams add their waters to the great river's flow.

The Mississippi's origins give no clue to how large it becomes. Like most rivers, it begins modestly: a small stream, no more than a dozen feet across, flowing from Lake Itasca in Minnesota's Lake Itasca State Park. By the time the Missouri River has added its ocher waters, the Father of Rivers stretches more than a mile wide.

Through much of the Midwest, the Mississippi River Valley is bordered by ancient, big-shouldered bluffs that have been worn down, rounded, and incised by streams. Below the river's confluence with the Ohio, the river valley spreads out wherever it will along an alluvial plain that reaches to the Gulf of Mexico. These lowlands were once the gulf of an ancient sea, but over millennia the Mississippi has annually deposited millions of tons of soil

along its southern banks and delta, creating itself as it creates land on either side.

My first sight of the Mississippi was during a childhood vacation to the Rockies. My parents had packed the car with vacation gear and us kids and we set out on two-lane U.S. 30, then a main artery across the country. I had seen the Fox and Illinois Rivers, good-sized rivers both. But when signs alerted us of the Mississippi's imminence, I experienced the same tingling sensation as I did standing in line for the old Riverview rollercoasters.

We arrived without fanfare, and the bridge went on and on across the wide river. I kept expecting some sort of peak, like fireworks, not merely the other bank. Nothing tangibly momentous had occurred, yet I began anticipating the return crossing in the middle of Iowa.

I still anticipate every meeting with the Mississippi, but it is hard to find a way of wrapping a feeling around the river. Too many locks and dams bind its width, too many lines of barges pack the main channel, too many towns and industries get in the way of seeing the river itself. One resource manager called it a series of large, managed ponds. Oh, yes, this is a working river.

There is another river, though, where natural action takes place. Along side channels, in the sloughs, ox-bows, and flooded forests that scallop its edges, the Mississippi is busy with birds, fish, trees, otters, and muskrats—not commerce.

Softened by ferns and vines and shaded by sumac, the bluffs of Pikes Peak State Park in Iowa look across the Mississippi to headlands on the other side. The far bluffs stand sentinel above the entry of the Wisconsin River, which is broad and full of itself in spring, shrunken and twisting past sandbars in the heat of summer. Deep side valleys divide the bluffs on either side of the rivers into rounded fists and knuckles. Here and there, outcrops interrupt the tree-hung slopes and from these rocky knobs raptors launch themselves, spiraling upward on the thermals.

Below, cormorants and precise lines of white pelicans wing downriver, paralleling the barges. This is, after all, one of the major flyways for North American birds. An angler, hidden in reedy backwaters, casts his line. The big, lazy flap of a bald eagle signals that the symbol of America is reclaiming its territory. All is orderly. Yet, when the Mississippi surges, floodwaters can ravage its alluvial valley. Towns and cornfields in Iowa, Illinois, Missouri, and Wisconsin disappear under what seems another inland sea, proving that this long muscle of water does what it wants.

The rivers that feed the Mississippi from the east are, for the most part, broad and placid. The Ohio loops in graceful curves along the southern borders of Ohio, Indiana, and Illinois, fed by dozens of rivers that score the unglaciated hills of those states. The Wabash, Illinois, and Wisconsin—all fed by many tributaries, all working their way southwest—pass a mix of bluffs, forests, and fields on their journeys to the Great River. Illinois's Rock River, Indiana's Blue, and Ohio's Little Beaver Creek are among the smaller scenic rivers, carving pretty valleys spangled by trees.

Rivers that pour into the Great Lakes tell a different story. Most are born in northern marshes as streams that cut quietly and smoothly through the dense shade of conifers and northern hardwoods, absorbing dark tree tannins leached into the water.

These northern rivers are home to trout and other cold-water fishes who feast on dobsonflies and mayflies come summer. Clear and shiny one morning, northern waters may be covered with a fine layer of mayflies the next. With arched, balletic bodies and split, thread-thin tails, these ephemeral insects cover everything: water, banks, even people. Caught in one such magical moment at the edge of a stream—my hair, clothes, and arms covered by mayflies—I felt wrapped in a golden living mesh, and I knew the trout would eat well.

Gaining strength, the cognac-colored rivers that flow toward Lake Superior reach the hard inland rim of the Superior Basin where they burst over the rim's rocky ledges in luminous, copper-colored waterfalls. Then, foaming, they continue their wild race toward Superior. Most of these rivers rise in the Upper Peninsula of Michigan, which has more nationally designated scenic rivers than any contiguous state but Oregon.

More sedate, Michigan's Au Sable and Wisconsin's Name-

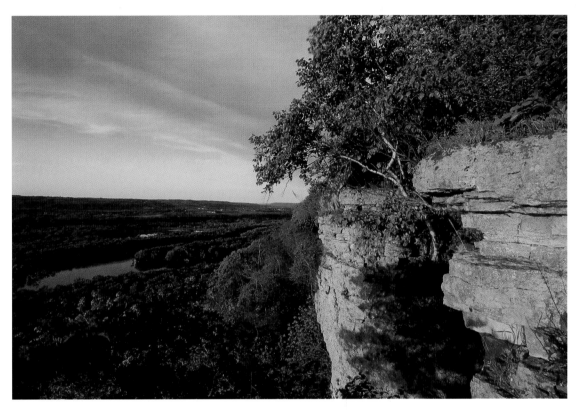

Bluffs along the Wisconsin River, Wyalusing State Park, Wisconsin

kagon are perfection between two banks. Elegant rivers, they curve fluidly through northern woods to their destinations: one to empty into Lake Huron, one to merge with the St. Croix on its way to the Mississippi. Lower Michigan's Pere Marquette is another matter. Among the nation's premier trout streams, it can also be a crazy, corkscrew ride in a canoe.

I learned to canoe as a Girl Scout in Manistee National Forest. Just north of there—and many years later—my husband and I took our first canoe trip together on the Pere Marquette: I in the bow, he in the stern. Neither trusted the other's skills, so the river had fun with us. Named after the French Jesuit who explored this region with Joliet, the Pere Marquette coils around curve after curve, tight as a spring. Working through the narrow, linked curves is like negotiating a downhill slalom course.

Big limbs overhung everywhere, so we shouted at each other, ducked, and furiously swung our paddles from side to side like dueling conductors. Great blue herons fled in front of us. Rare wood turtles, fearing they might become rarer, dove to the depths. A gang of buzzards looked down from a bare tree as we swept by. Their impassive faces seemed gravely disdainful in the wake of our chaos.

West of the Mississippi, the rivers of Missouri's Ozarks—Jacks Fork and the Current, in particular—have a lot in common with the rivers of the southern Appalachians: limestone bluffs densely hung with trees and shrubs and sparkling, spring-fed waters racing over occasional gravel bars.

The river that shares the state's name, however, has more in common with the West. The Missouri River evokes some of the most poignant collective memories of the American frontier. One of the earliest of our national visions was the extraordinary journey Lewis and Clark took to find a water route to the Pacific. Even when their feet were on the ground, their eyes were definitely on the stars. Working their way upriver, the explorers traveled across Missouri, past Kansas, Iowa, and Nebraska, headed toward the northern Rockies. The land they traveled through on their quest was still called the Louisiana Territory; the river still flowed big and muddy, and the Plains through which it passed was thick with antelope, elk, and bison.

Some of the Midwest's major cities grew up along this riverine highway: Omaha, Kansas City, and St. Louis. More deliberately planned are the dams that now girdle the Missouri, creating "lakes" of backed-up waters, making the river look like a snake that's swallowed a rat. But where the river runs free, the dusty scent of the Plains hangs in the air. From a bluff, the river seems backlit by the visions of Charles M. Russell, George Caleb Bingham, and others who painted our images of the frontier.

The Niobrara, which empties into the Missouri in northern Nebraska, redeems that vision of frontier freedom. River purists make pilgrimages to the Niobrara, where bison and bobcat still roam its banks as the river passes through wildlife refuges and other natural lands. Along the Niobrara near Valentine, Nebraska, north, east, and west meet. Paper birch, at the southernmost edge of its range, stays cool in the river's south-side canyons. Eastern deciduous forests, which grow no farther west, rim the riverbanks. And ponderosa pine reaches its eastern extreme on north-side bluffs. Beyond the river corridor lies a world of prairie.

At dawn, turkey hens peck along the Niobrara's banks, barely seen through scarves of mist that ride the river. At dusk, roosting herons overlook deer that come down to drink. In winter the river freezes over and blue ice sheets down from sandy bluffs where, in summer, waterfalls tumble into this classic river of the Great Plains.

The Platte and Arkansas Rivers make their way from the Rocky Mountains to the Mississippi, one through the dry reaches of Nebraska, the other through similar terrain in Kansas. They are the largest of the rivers that etch the western half of the Midwest like lines on old, leathered skin. This land *is* the earth's old skin, already ancient when the Rocky Mountains rose.

During summer's heat, even these broad rivers shrivel, puddling meagerly across the Plains. Although it is the Missouri's biggest tributary, the Platte is known as a river that's "a mile wide and an inch deep" as it braids through Nebraska's panhandle. Not for nothing did the French give this flat-as-a-plate river its name. It becomes a welcome companion along I-80 and, as it gains

volume flowing east through Nebraska, the Platte's course is marked by ranks of cottonwood, one of the few trees willing to grow on the prairies, but only near water.

At the eastern edge of the Plains, some rivers work their way into Canada. One, the Red River of the North, which separates Minnesota from North Dakota, cuts through rich soils that once formed the bed of glacial Lake Agassiz, named for the Swiss-born scientist who helped establish the theory of the Ice Ages. Most of Minnesota's rivers, however, form a fretwork of small channels across the state. These veins and arteries of water are everywhere. The big aorta is Rainy River, which divides Minnesota from Canada and connects Lake of the Woods with the linked lakes that mark the North.

Lakes and Marshes: Wettest Land in the World

Land and water merge in so many ways across the Midwest as to nearly defy categorization. Cedar swamps and cypress swamps seem more forest than water, despite the pan of dark liquid that surrounds the trunks of the trees. Bogs and shrub swamps are dense with squat, shrubby plants whose feet are bathed by water and whose heads are bathed by sun. Marshes, full of wildflowers and reedy plants, are always open to the sun and thrive where currents flow slow but steady. The most renowned of midwestern wetlands, however, are its myriad lakes.

A beer company, advertising that it was from the "land of sky-blue waters," accompanied its logo with images of a tree-rimmed lake. When I first noticed the ads I was too young to be interested in beer, but I was captivated by the luminous lake and its diadem of evergreens: Minnesota, as it turned out, whose name means "sky-clouded waters."

This image recurs tens of thousands of times through the lake country of Minnesota and Wisconsin, the most lake-crowded region in the world. The lakes are mostly the result of Ice Age glaciers that thoroughly pitted the region with basins of all sizes and shapes. When the ice retreated, glacial meltwaters filled countless basins.

From Kabetogama to the Boundary Waters, Minnesota is a maze of lakes, a world of water rimmed by balsam and spruce. Wisconsin's Northern Highlands, too, are stippled by lakes large and small. Often, land seems a mere skein connecting shimmering, sky-clouded waters.

The most distinctive are the Midwest's many kettle lakes, glacial landmarks named for their shape. These deep round kettles of water were formed when glaciers drove gigantic chunks of ice deep into the earth. As the glaciers retreated, the ice melted, creating kettle lakes that stud landscapes from Wisconsin south into Illinois and Indiana. Prairie potholes—wetlands found in western Minnesota, northern Iowa, and elsewhere in the Midwest—were probably once kettle lakes that filled with sediment. Because relatively few lakes and rivers water the prairies, prairie potholes are crucial watering stations for birds on long migrations.

Whatever their shape, the northern lakes create exceptional habitat for fish, fowl, and fur-bearing species. In the summer, young bald eagles with brown-streaked heads wheel and chase each other in play above North Woods lakes—preparation for more serious contests that will determine adult territory. With an abundance of fish and lakeside nesting territory in massive white pines, the lake region supports one of the largest bald eagle populations in the nation.

On a midsized lake, wild white swans preen and poke among the reeds, mergansers float by in pairs, and a lone loon dives again and again, its mate sitting unseen on a nest at water's edge. Moose, otter, and muskrat center their lives on these northern waters. Beavers not only live in the landscapes, they rearrange them. It does not take long for a family of beavers to build a stick-and-mud dam across a small channel, creating an instant lake.

For dam-builders, to create lake from land takes but a moment. To create land from lake takes time, yet its ongoing evidence is everywhere in the North. Where glacier-gouged lakes are not continually fed by streams or springs, sediment accumulates, transforming a shallow lake into a shrub swamp.

Looking across the low, green tangle of a northern shrub swamp, it is hard to tell that the plants stand in a foot or so of

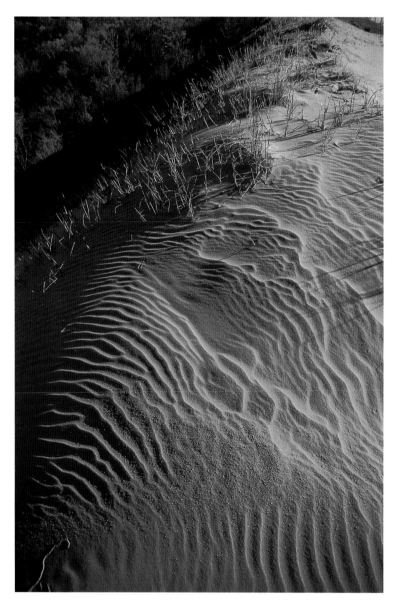

Dune Crest, Sleeping Bear Dunes National Lakeshore, Michigan

water. Leatherleaf, bog rosemary, and sheep laurel—these handsome shrubs with delicate bell flowers form the foundation of shrub swamps lush with orchids and other wildflowers. Wild cranberries, too, form vast, swampy beds. As shrubs drop leaves and limbs into the watery stew, eventually enough organic matter collects so that the swamp may evolve to a sphagnum peat bog. Trees then colonize this loose land, firming it up with roots and more detritus. And the slow process from lake to forest is complete.

Marshes are yet another variation of midwestern water. Gathering in shallow waters around springs and at the edges of lakes and rivers, marsh reeds and rushes provide cover where waterfowl nest and hunt, where fish and amphibians breed.

Yet the face of every marsh is matchless. In the north country, marshes form at the headwaters of streams in places washed with watery sunlight, places with a glow so primeval they seem to whisper "here life began." In such marshes slow but steady currents cut through the thick vegetation, and along these watery channels wild rice grows. Perhaps it is the nutty odor of wild rice when it ripens or the look of the primeval headwaters where wild rice hides—there is something evocative about wild rice. Most of America's wild rice grows in Minnesota, both naturally and in commercial paddies.

Where this member of the grass family grows naturally, it is still harvested from a canoe using ricing sticks to knock the ripened grains into the bottom of the canoe. Once gathered, wild rice must be hulled—hard work because of its long-tailed, tough husk. The Menominee, People of the Wild Rice, have a ceremony for hulling rice, a river outfitter told me, adding, "Anything that hard needs ritual."

In the midsection of the Midwest, you can hear a marsh before you see it: the rustle of reeds, the rival songs of redwing blackbirds, the plashing and flapping of ducks in open waters. From the shores of Lake Erie to Nebraska, the midsection is strewn with broad marshes that edge open pools. Crowded with sedges, rushes, cattails, and reeds, marshes attract flurries of birds looking for fresh water and a broad assortment of food.

Herons, egrets, and other wading birds stalk frogs and fish. Ducks dive and dabble for fish and water plants. Long-legged cranes stir up fallen grain, insects, whatever presents itself. A variety of smaller birds—redwing blackbirds the loudest, most prominent among them—pick at seeds, fruits, and insects. Harrier hawks cruise for prey.

Midwest marshes include Indiana's Jasper-Pulaski wildlife area, the country's crane capital during spring migration. The broad sink in the middle of Kansas known as Cheyenne Bottoms is a way station for nearly half of North America's shorebirds. In Nebraska's Sand Hills, dozens of pools rise from springs in Valentine National Wildlife Refuge, providing succor for lark and upland piper, kingbird and killdeer, ducks of every sort, turkeys strutting fantails of dark feathers, and white pelicans on their way to Florida. And in the sand country of central Wisconsin lies Horicon, the world's largest cattail marsh.

The most unexpected wetlands in the Midwest flourish where the Wabash River meets the Ohio and where the Ohio joins the Mississippi. In these lowlands, people's accents shift from flat midwestern to a southern lilt. The landscapes adopt a southern accent, too. Few in Chicago or Indianapolis would guess that they do not have to travel to Louisiana to see a bald-cypress swamp.

Beginning around Rend Lake in southern Illinois, tall bald-cypress trees rise at the edges of shallow lakes, even from mucky, roadside ditches. Bald-cypress swamps fill the waterlogged lowlands of southern Indiana and places such as Cypress Creek National Wildlife Refuge at the southern tip of Illinois. Where Missouri's bootheel borders the Mississippi River lies Mingo National Wildlife Refuge, the largest federally protected cypress-tupelo swamp in the Midwest.

Of all the water in the Midwest, perhaps the largest body is found west of the "dry line" in Kansas and Nebraska. The vast lake of water is not visible on the parched prairie, nor is it a mirage. It is the High Plains Aquifer: billions of acre-feet of pure, filtered water—all underground.

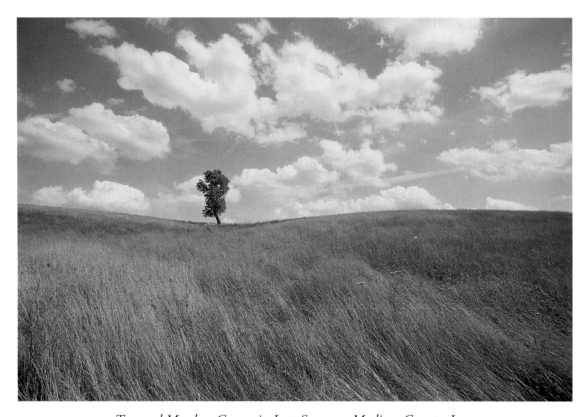

Tree and Meadow Grasses in Late Summer, Madison County, Iowa

PRAIRIES

I grew up thinking corn formed the natural landscape of the Midwest. To the north grew forests, here and there lay lakes great and small, and fields of wheat, onions, and soybeans played backup roles. But mostly there was corn. I would ride my bike on dirt roads through canyons of corn, the familiar sound of husks rustling in the wind, tassels tossing, their job of pollination complete. Ahead I could see the tallest forms on the horizon: silos—silvery cylinders capped with red. This vision resonates as midwestern mythology as well as real landscape.

Yet, for thousands of years the land was filled with more natural patterns. Eventually I learned what lay on the land, and now my dream—more than seeing Samarkand—is to see what the first settlers saw: a copper-and-gold tallgrass prairie shimmering under the sun from horizon to horizon.

A vast patchwork of prairie covered the Midwest in the early 1800s, when European settlers first arrived. By the hundreds, they loaded their possessions in covered Conestoga wagons and set out looking for a bit of land to call their own. When they reached the vast grasslands the French called "prairie" they stopped, awed and intimidated. To them, so unfamiliar with such a view, the grasslands looked like the ocean, featureless and endless, a place that could swallow a person. This sense of being overwhelmed was especially true on moist, rich tallgrass prairie, where big bluestem grass grew as much as ten feet tall and could hide a person on horseback.

Patches of grassland existed over much of America, but settlers started encountering big prairies in western Indiana, where grasslands begin challenging forests for ecosystem dominance. Two critical elements—water and fire—determine which will rule the land. Although a forest requires only a few more inches of precipitation per year than a tallgrass prairie, those few inches make the difference. Once a forest is established, its thick foliage helps hold in moisture.

Prairies are more drought-tolerant than woody forest plants, and they are also adapted to fire. Most of the biomass of a prairie plant is underground, so if fire sweeps through, plants merely resprout from their roots. Before fire control, lightning-caused fires used to sweep through regularly.

The roots of big bluestem, the monarch of the tallgrass prairie, can reach six to seven feet deep. The roots of most prairie plants, however, intertwine in the top two feet of soil so densely that busting through prairie sod is like trying to cut through steel mesh with a shovel. Diaries and journals from the homesteading period tell how hard it was to make a home on the prairie. Pried from the earth in blocks, sod was the most abundant—and often the only—building material. Settlers collected barrows of bison or cow chips as fuel to warm their sod houses when the wind blew. And the wind always blows.

John Deere helped transform the Midwest with his 1837 invention of the steel mold-board plow, which could bite through prairie soils like nothing before it. By the late 1800s, much of the prairie was plowed and planted with cultivated grasses: corn and wheat.

The natural grasslands of America extend from western Indiana to the foot of the Rockies, but a prairie in Illinois is nothing like a prairie in western Nebraska. From lowlands along the Mississippi River the Plains rise to more than five thousand feet—nearly a mile high—at the southwestern corner of Nebraska's panhandle.

Not only do the Plains become higher as they rise toward the Rocky Mountains, they become drier. The high wall of mountains traps moist air carried from the West Coast, leaving the western Plains in the "rain shadow" of the Rockies. Stripped of moisture, with little to block them, desiccating winds sweep across the Plains as constant as a heartbeat.

Shortgrass prairies live on the high, dry side of the Plains,

where tan grasses, less than a foot high, sheath the parched land as closely as pelt on a pronghorn antelope. Mixed-grass prairies covered most of Kansas and Nebraska while, to the east, the land was mantled by stately tallgrass prairies.

Heart of the Tallgrass

Once I learned about tallgrass prairies, I could not wait to see the colorful diversity that fluttered gracefully in my imagination. So, early one April, I drove excitedly to a nearby prairie park in northwestern Indiana. Blocked on one side by an ugly trucking distribution center, the place touted as a pristine prairie remnant looked more remnant than prairie. Gray, tangled, twisted stalks of last year's grasses and wildflowers had strewn themselves around muddy fields anchored by a few bedraggled oaks. As far as I could tell, I was looking at a large, rancid vacant lot.

My timing was terrible—that's how little I knew about prairies. Although forest floors are colorful in spring as wildflowers rush to bloom before tree leaves unfurl, early spring is the worst time to see a prairie. Prairies wait for sun to heat the soil before they make their moves. A woman involved in prairie restoration at Wisconsin's Chiwaukee Prairie, which lies along Lake Michigan south of Milwaukee, gave me a good timetable for visiting tallgrass: Memorial Day, Fourth of July, and Labor Day.

Sometime around Memorial Day, when native grasses are just beginning to emerge, a healthy tallgrass prairie will put on its first show. A flush of pink-and-white shooting stars lights up the prairie in huge drifts. Wispy tendrils of purple prairie smoke add their soft glow and hoary puccoon pops up in patches of outrageous orange-gold. Small flocks of bobolinks flash by in brilliant black and white, burbling, chittering, throwing their voices across the fields like joyful ventriloquists. These birds, which are losing winter habitat in South America and summer habitat on North American prairies, are harbingers of spring on a healthy prairie.

By the Fourth of July prairie grasses rise in clumps nearly waist

high and the parade of wildflowers is in full stride. Monarch butterflies flirt with the brilliant orange flowers of butterflyweed. The yellow daisies of compass plant stand above big, scalloped leaves so dependably oriented north-south that wagon trains used the plant as their compass across the Plains. Rattlesnake master begins as clusters of gray-green leaves that look like yuccas. Settlers mistakenly believed the plant cures rattlesnake bites, but the plant's name remains beguiling.

Spires of elegant white baptisia, purple coneflowers, black-eyed Susans, crowns of pink monarda, deep blue gentian—nowhere do tall, colorful wildflowers put on a more diverse show. Every week the cast is different. The incredible variety of flowering plants attracts an equally incredible variety of butterflies.

Prairie flowers use the same strategy as woodland wildflowers, but with a different timeframe. Prairies bloom in summer to beat the canopy of grasses that overarch in fall. By Labor Day, tall grasses reign. When wind whips these six-foot seas into waves, the undulating grasses of a tallgrass prairie are as hypnotic as a true sea. And a human visitor, secreted in the grass like a meadowlark, can allow the whispering white noise of the prairies to wash over.

Red, gold, bronze, maize—autumn prairies are quilted with color, but three grasses, in particular, distinguish tallgrass. Big bluestem, named for the red-blue color at the base of its stem, is also called turkey-foot because its three-part seedhead resembles the splayed foot of a turkey. The tall, golden plume of Indiangrass and the maize-colored panicles of airy switchgrass complete the tallgrass triumvirate. Among them grow goldenrods, purple ironweed, and other flowers of fall. As the seasons progress, prairies become bleached, turning bone-white in winter.

Trees take decades to reach full growth while grasses mature each season. This disparity leads some to think that, although it takes old-growth forests a few hundred years to develop, a tallgrass prairie can mature in just a few seasons. In northeastern Iowa lies a prairie—Hayden Prairie—that had been mown

for hay but never plowed. Thanks to Ada Hayden the mowing ended and preservation began. That was in 1945 and Hayden Prairie, with its sumptuous black soils, is just beginning to reach true maturity again. The mix of plants on a prairie is subtle, intricate, and closely tied to insect and animal life. We humans cannot "make" an old-growth prairie any more than we can make an old-growth forest.

This most recent of earth's ecosystems was unknown to European settlers and what is not familiar often is not cherished. At the same time, the black soils of tallgrass prairies, plunging thirty feet and more, are the richest in the world: perfect for agriculture. As a result, natural grasslands were stripped for farmland and now tallgrass prairie is America's rarest ecosystem. Centered in the Midwest, tallgrass once covered most of Iowa and Illinois and parts of Indiana, Missouri, Minnesota, Kansas, and Nebraska. Presettlement Illinois was covered with twenty million acres of prairies. Fewer than three thousand acres are left.

Fortunately, this most underappreciated of America's great landscapes is finally getting some recognition. Scientists are compiling research that shows what mix of plants makes up the healthiest prairies, and tallgrass preservation and restoration are underway.

Enough acreage at Prairie State Park in southwestern Missouri has been set aside to support herds of bison and elk. Gooselake Prairie, a grand sweep of wet meadows and tallgrass along the Illinois River, is maturing. Nachusa Grasslands, within the Rock River Valley of northwestern Illinois, shows off eleven distinct natural communities: from fens edged by angelica and prairie rose to savannas of old oaks. It's a prairie restoration project large enough to support badgers, squat predators that look like undulating squares of carpet as they race across the ground, here near the eastern edge of their range.

Bluestem Prairie in western Minnesota is broad enough and pristine enough to support prairie chicken booming grounds, where male prairie chickens dance and "boom" advertisements of their availability in early spring. Even near a Chicago freeway

researchers have found forgotten plots full of swirling manes of dropseed grass—an indicator of high-quality prairie.

Too rocky to plow, the Flint Hills of eastern Kansas protect much of the best of what's left. This forty-mile vertical band of low, flinty benches attracts pronghorn antelope and the exquisite scissor-tailed flycatcher, whose long, trembling tail feathers look like Chinese kites in flight. The Flint Hills hold cloud-chased vistas of such longing beauty that it is easy to be homesick for them even if they are not home.

On the Tallgrass Prairie National Preserve's broad grasslands, a killdeer leads her string of foolishly fearless young—miniatures of mom even to the black-and-white neck rings—down an old two-track while an unseen meadowlark sings a prairie song. In another section of the Flint Hills lies Konza Tallgrass Prairie, the nation's tallgrass laboratory, one of eighteen long-term ecological research sites nationwide. The dickcissels and pocket gophers do not know this, but they know a high-quality prairie when they see it. Although the slopes and bottomlands at Konza are tallgrass, the tops of the flint benches that run north and south are held in the grasp of mixed-grass and shortgrass—a preview of what lies to the west.

The Great Plains

Politicians cast Peoria, Illinois, as the psychological center of the country, asking, "How does it play in Peoria?" Lebanon, Kansas, lies at the geographical center of the contiguous United States. Just west of the Flint Hills lies the hundredth meridian, another marker. The hundredth meridian, the so-called dry line, distinguishes the moist eastern half of the country from the dry western half. The dry line, perhaps as much a psychological dividing line between east and west, marks the end of tallgrass and the beginning of mixed-grass prairies. From here to the Rockies the land is called the Great Plains.

A great chunk of American mythology centers on the mixed-grass prairies that once were home to millions of bison, elk, and

antelope. When we imagine herds of bison thundering across the Plains or elk by the thousands grazing brush along rivers, we are imagining Nebraska and Kansas as well as the Dakotas and states farther west. (Kansas, after all, was the setting for the song "Home on the Range.")

As in any ecosystem, the Great Plains herbivore populations were kept in balance by predators: in this case, wolf, bear, and cougar. Like elk and bison, the predators have been extirpated from most of their former range. Antelope, the fastest mammal in the Western Hemisphere and perfectly matched to prairies, exist now mostly in shortgrass prairies, the least populated parts of the country. As western settlement continued, Cheyenne and Sioux were pushed out too, and the Plains became cowboy country. In some respects, it still is.

But the dry line is a guide, not an absolute. Trying to line up ecosystems in some kind of neat order is like trying to track a con artist's shell game. Depending on climatic change and other variables, the target keeps moving. Actually, mixed-grass prairies begin somewhere around the Loess Hills of western Iowa.

The Loess Hills lie along the western borders of Iowa and Missouri, lining the eastern banks of the Missouri and Sioux Rivers. Unlike the flat plains to east and west, these hills roll and twist alongside the two rivers. The word "loess," derived from the German for "loose" or "crumbly," refers to the fine, crumbly soils blown eastward from the Missouri River Valley, piling up like dunes—some two hundred feet thick—on the far banks.

Like the Flint Hills, the Loess Hills contain remnant prairies because they were too difficult to farm. Unlike the Flint Hills, loess is not so much rocky as it is unstable. Where a river or stream has cut through a grass-covered hill, exposing a cross section, loess has the color and texture of a cocoa layer cake. Where rounded loess hills catch moisture, their unstable weight causes them to slump in "catsteps," series of stairstep, narrow terraces. Where exposed to the baking rays of the western sun, loess hills stand firm and support a broad range of native spe-cies, including prairie rattlers, spadefoot toads, and other rare species.

While tallgrass prairies sustain rattlesnake master with its yucca-like leaves, mixed-grass prairies sustain the real thing: spike-leaved yuccas whose creamy, big-bell flowers belie the plant's dry character. Skeleton-plants show up, with leaves so constricted they look like green sticks—the better to conserve water in dry soils.

To the west across Kansas and Nebraska, the patches of un-tilled prairie grow larger as soil moisture and fertility decrease. The lower the land's profit margin, the less high-intensity culti-vation. And the larger the prairie, the greater number of species that will inhabit it. Not only more species, but larger species: bison, antelope, badgers. Which raises the question, How large is a true prairie?

The cornfields near where I grew up are disappearing, replaced by strip malls. Between a Wal-Mart and a home-supply store the size and grandiosity of St. Peter's, civic-minded retailers have in-stalled a "prairie." This strip of ground, planted with big bluestem and wildflowers, is about the size of a suburban sidelot. It's pret-tier than asphalt, but these are "caged" plants, not a prairie.

Even ten acres may not make a prairie. Dan Janzen, an ecolo-gist, calls such sites "the living dead" because they are too small to hold the genetic diversity necessary for a healthy prairie.

Some say one test of adequate size is if a prairie is large enough to support a population of prairie chickens, which need a mini-mum of about a thousand acres. Or, perhaps a prairie should be based on the territory needed by its presettlement inhabitants. Bison come to mind. These one-ton mammals need a lot of graz-ing room.

Yet certain butterflies may need as much territory. And butter-flies are critical to a prairie. Grass flowers need not be showy because wind serves as their pollinator. Prairie wildflowers, how-ever, must attract butterflies and other pollinators with flowers that promise sweet nectar. As one researcher put it, it's a food-for-sex exchange.

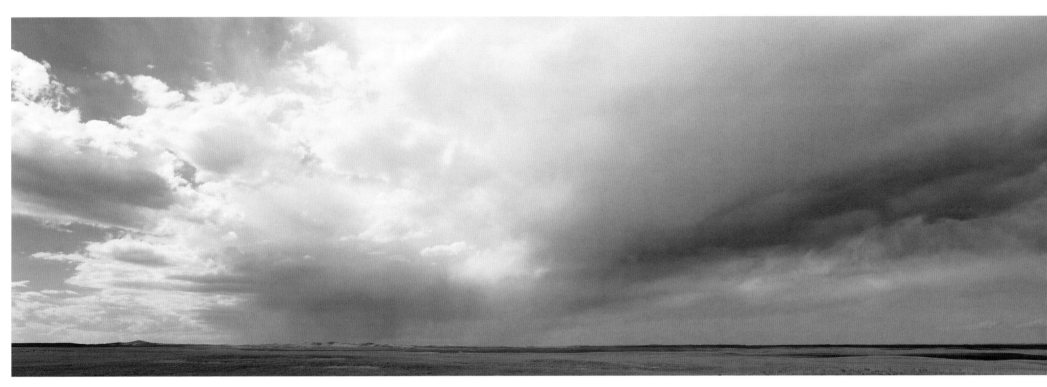

High Plains, Western Panhandle, Nebraska

Butterflies are critical to a healthy prairie, but bison may be, too. As they migrated across a prairie, banding together in the thousands, bison broke up and aerated the dense grass with their hooves and fertilized the soil with their droppings. Even gophers help keep the prairie healthy: flower seeds gain footholds where burrowing gophers break up the matrix of grass roots. The relationships among the thousands of species on a prairie are intricate. And the making of a prairie ecosystem—any ecosystem, really—is an exceedingly subtle and elegant process.

Mixed-grass prairies, a blend of tallgrass and shortgrass species, stretch from Iowa's Loess Hills to the Gypsum Hills of south-central Kansas and the Sand Hills of north-central Nebraska. On moist, low-lying lands Indiangrass and big blue find succor. On sun-warmed slopes knee-high grasses take hold, grasses such as little bluestem and blue grama, with seed heads like combs. At the top of arid ridges, short, scruffy buffalo grass—the mainstay of the shortgrass prairie—keeps a low, dry profile.

From afar, a prairie may appear as a clean sweep of grass. Close up, a healthy prairie is full of clumps: clumps of grass and clumps of wildflowers. Exploring prairies is much like exploring tide pools. It's an up-close treasure hunt: bottle-blue prairie gentian hidden among the grass; a monarch butterfly caterpillar munching on a milkweed leaf; nighthawk eggs lying on bare rock, eggs so artfully mottled that you can look away, look back to where you've spotted them, and find they have disappeared, blending seamlessly into the rock background.

Great Plains skies add another element. Because most of Kansas and Nebraska is open and uncrowded, almost any road except the interstate seems scenic. At dawn, the sun crests the horizon, spraying the sky with pink, splashing peach and gold above the vast, tan grasses of summer. Each time I see such a scene I am reminded of the evocative opening of Aaron Copland's *Billy the Kid,* music that must have been written with the symphony of a Plains sunrise in mind.

Just as dramatic, but more ominous, are the black, evil-looking screws that twist across summer skies. Dark storm clouds take on a greenish cast, the wind picks up, the air smells of ozone, and against the horizon a phalanx of thin tornadoes sweeps like a line of storm troopers.

In Nebraska's Sand Hills, the terrain changes, becoming a rollercoaster of grass-covered dunes. Spreading across more than nineteen thousand square miles, the Sand Hills are the largest area of dunes in the Western Hemisphere. But they look nothing like the Sahara. In fact, in spring, when grasses that lightly cover the dunes are newly green, the Sand Hills look more like a gigantic golf course, with sandy blowouts doubling as sand traps and limpid pools as water hazards. Pools such as those at Valentine National Wildlife Refuge collect in low spots where springs bubble to the surface, creating oases for sandhill cranes and myriad other birds.

Within Nebraska's Fort Robinson State Park and Fort Niobrara National Wildlife Refuge, herds of bison graze and wallow, their shaggy brown presence a sharp contrast to the lavender-pink trumpets of shell-leaf penstemon that decorate the grasslands. Overlooking the western edge of the Sand Hills are the ponderosa pine forests of Pine Ridge.

Where mixed-grass prairies start giving way to shortgrass prairies, odd towers of sedimentary rock rise from the Plains: Monument Rocks and Castle Rock in Kansas, Chimney Rock and Scotts Bluff in Nebraska. These formations anchor the landscape and gave Indians and pioneers alike a focus point on the vast Great Plains.

Shortgrass: In the Rain Shadow of the Rockies

This is a land of bad Dust Bowl memories. Unforgiving in the best of times, shortgrass prairies that lie at the western edge of Kansas and Nebraska blow acrid dust devils across the Plains just to remind you how mean they can be. Yet, here lies some of the most luminous, heartbreak landscapes.

Grasses lie close and golden upon the land and a small herd of pronghorn blends into the light-streaked scene until a noise

or movement startles the animals into flight across landscapes empty of any human intrusion. Where stark buttes break the horizon line, raptors circle on thermals. At ground level, extravagant wild begonias, the color of dusky roses, frame dirt roads.

In these arid lands, buffalo grass and blue grama grass dominate. Only in low washes do a few junipers and cottonwoods make a stand. Where trees are so rare, animals must live underground, in burrows. The most obvious are prairie dogs, small rodents that look like squirrels designed by Dr. Seuss.

Naturalists estimate that approximately five billion prairie dogs lived on the prairies in the late 1800s, some in "towns" as big as one hundred square miles. Habitat destruction, poison, and prairie-dog shoots have reduced their numbers, and as prairie dogs declined, so did predators such as the black-footed ferret, now an endangered species. Prairie dogs provide food for some and homes for others. The burrowing owl can dig its own hole, but why, when abandoned prairie dog burrows are available?

Unlike more nocturnal owls, burrowing owls stand by their burrows in plain day surveying their domain. Small and sand-colored, the owls blend perfectly into the background and their long legs allow them to scan for prey above the short grasses. Owls, ferrets, and prairie dogs are not the only ones that burrow. Snakes, toads, badgers, and long-legged swift foxes also seek shelter underground. Even humans have tried it. Because wood was in such short supply, some early settlers dug homes in the sides of hills. And they fashioned fenceposts and other uprights from blocks of limestone instead of wood.

Covered by a layer of low grasses that can survive alkaline soils, shortgrass prairies receive as little as ten inches of precipitation a year. By comparison, some tallgrass prairies of Illinois and Iowa luxuriate in nearly forty inches a year. Despite severe conditions, or perhaps because of them, the shortgrass prairie offers refuge for the spirit. Its austere geometry and monochrome vistas enhance rather than reduce vision, perhaps because on the shortgrass prairie a person experiences few banal distractions.

A shortgrass prairie is not all minimalist aesthetics, however, especially just after a wet spring. Small seeps, patches of gravel among the clay soils, slight slopes, sheltered niches—all create micro-environments where an amazing diversity of grasses and wildflowers bloom. Silver sage, fuzzy pussytoe, little and even big bluestem grass, yellow primrose, Easter daisy, blue flax, red gaura, fragrant yellow wallflower, pink phlox, and plenty of sunflowers (the state symbol of Kansas) are among the hundreds of vascular beauties of the prairies.

To my mind, the loveliest of all lives in some of the most miserable soils imaginable—gumbo soils, they are called. Solid as dun-colored brick when dry, gumbo becomes demon soil when wet. Find yourself on a gumbo road during a downpour, and you can watch as the soil turns to a thick, greasy stew. Your car slips and slides, and you're lucky to break loose of gumbo's sticky grip.

Yet, in these soils lives the gumbo lily, *Oenothera caespitosa*, the lily of the West. I've memorized most of the places I've seen it. One day, near the foot of Nebraska's low-slung Fossil Hills, sun rays seared though charcoal-gray thunderheads to pick out the fluttering, eggshell-white cups of the lily, illuminating a plant that manages to appear fine and fragile in the most evil of soils.

Not far from the Fossil Hills, the northwest corner of Nebraska is filled with the Oglala National Grassland, named for the Oglala band of Lakota Sioux whose reservation lies just north of the state line in South Dakota. Although much of the natural landscape has been given over to cattle grazing, the Oglala National Grassland and the Cimarron National Grassland in southwestern Kansas are quintessential shortgrass prairies. Cimarron, the single largest public land in Kansas, is one of the few places to see lesser prairie chickens and relatively large herds of pronghorn antelope. Pronghorn also roam the Oglala National Grassland.

Pronghorn once ranged in abundance over most of the prairies. Tens of millions of them were reduced to about thirteen thousand in the early 1900s, but protections have allowed a re-

surgence to more than a million nationwide. The only species in its genus and the only genus in its family, this unique animal can sprint at speeds of more than sixty miles per hour, yet when it stands still, its tawny colors meld into the landscape, making it nearly invisible.

In the prehistoric boneyard that is western Nebraska, the pronghorn, whose lineage dates back a million years, is a true survivor. Most of the animals that roamed these lands in the Age of Mammals are gone. The Hudson-Meng Bison Bonebed in the Oglala Grassland holds the greatest number of extinct bison remains in the Western Hemisphere. Nearby Agate Fossil Beds National Monument protects numerous other fossils, including those of prehistoric beavers that dug corkscrew burrows.

The landscape of western Nebraska is full of the old: fossils of three-toed horses the size of collies, small camels, horned rodents, fierce flightless birds, rhinoceroses large and small, saber-toothed tigers, and strangely shaped mammals that look designed by committee.

As the animals evolved, so did the landscape. By the Miocene, a recent epoch that began about twenty-five million years ago, grasses grew up and colonized the vast middle of North America. As diverse as any forest, these new grasslands were perfectly suited to the vast herds of hoofed grazing mammals that grew up with them. Both were new to the earth's array of life.

Unlike trees, whose growth slows when a species reaches maximum height, grass grows continually, accommodating grazing herds. Unlike trees, which can be devastated by sweeping fires, grass thrives on fire, growing from buds protected among its fibrous mat of roots and stems.

Here at the western limits of America's middle, in midsummer's blazing heat, the land looks burnt it is so parched. Yet, the grass endures: brown, short, and brittle. The ground holds so little moisture that the rounded tops of rolling prairie look like thinning hair, the scalp of the earth plainly visible between blades. The rib of a cow gleams bright and bleached near the side of a narrow road to nowhere. The land is like bone, spare and hard. But the structure is sure.

RECOVERING THE WILD

For many of us, our views of the Midwest are the long, wallpaper views from the high-speed lanes of I-80, I-70, and other highways that cross the region. On local routes, we are usually engaged in getting from here to there, our minds occupied with purpose. But even when we would like to look at natural midwestern landscapes, most are long gone.

The people who came from the eastern seaboard in the 1800s cleared and plowed and planted, intent on survival, not aware that land has its limits. Behind them came those with more commercial goals in mind: timber, iron, coal, and copper. By the late 1800s, when Congress began preserving this country's natural treasures in national parks, much of the Midwest was already reconfigured for human use.

Exceptions existed. E. K. Warren, a shopkeeper, protected Warren Woods in Michigan; Ada Hayden, a botanist, saved a prairie in Iowa; and dozens of others throughout the region had enough vision to set aside the natural. Eventually, the calculus of supply and demand changed. The natural lands that were once in great supply and therefore cheap are now rare, thus increasingly valuable.

Local, state, and national agencies and conservancies are engaged in saving the best of what is left. But now that wolves are gone from most woods and bison from the prairies, how can we know what intricate marriage they had with the land? In many cases, the woods and prairies themselves are gone. How can we recreate them?

Enough midwestern forests have survived that, even filled with second-growth trees, they will eventually sort themselves out— with some help. Ecologists reintroduce wild turkey, tinker with ways to keep deer populations in check in the absence of predators, work at removing purple loosestrife and other alien plants that bully out the natives. We are just beginning to learn the intricate, millennia-old balances attained by the hundreds of plant and animal species in each natural area.

So little is left of the prairies, however, that most must be re-created from abandoned fields, remaindered military bases, and the like. At the same time, interest in prairies and prairie restoration is flourishing at midwestern universities and arboreta, among gardeners, conservationists, and people with a yen for the sight of the real Midwest.

Botanists, such as Floyd A. Swink and Gerould Wilhelm, have begun the task of understanding prairie composition. Swink and Wilhelm, associated with the Morton Arboretum, have counted the species found on Chicago-region prairies and tabulated the frequency with which each species appears. Wilhelm then ranked each species. Common milkweed, for instance, rates a zero because it is found in great numbers on low-grade, disturbed prairies. Prairie dropseed grass rates a ten because it is found only on high-quality, "old-growth" prairies.

Once prairie restorationists determine what species lived on prairies in particular areas, then comes the arduous task of collecting seed to replant the prairies. The job is complicated by the lack of prairies. Little more than remnants in cemeteries and along railroad right-of-ways have remained undisturbed over the years.

Occasionally the wild shows up unexpectedly. Driving south through Illinois's Grand Prairie—a biogeographic designation, not a description—I had a 360-degree view of agribusiness: corn, soybeans, the usual. The road parallels the Illinois Central rail-road tracks, so I mused about the City of New Orleans, the train that took African Americans north to jobs in Chicago during the early 1900s.

As I imagined all the anticipation that was felt in those train cars, a shiny gold something caught my eye. It was a bright clump of hoary puccoon snugged up against the tracks. As I drove I saw more gold bouquets, plus flaming orange sprays of butterflyweed, then the pale purple of the season's first coneflowers. A linear prairie fringed the train tracks as far as I followed them. I felt a little thrill of the wild in a huge surround of the sown.

For ordinary people, there are few truly wild places left to explore, much less pioneer. Even extraordinary people must look hard: deep ocean trenches and outer space. Oh, and a few high mountains whose peaks are not cluttered with power bar wrappers, tuna tins, and other climber detritus. Perhaps we can recycle our desires and reverse the concept of "pioneering" by bringing back lost lands like the prairies and other ancient wild landscapes.

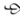

On a summer's night, somewhere on the vast plains that band the Midwest, the horizon is low and dark against the great bowl of starlit sky. Heat lightning ripples from a central point, netting the sky with white fire. Earth's visible thin plate looks even thinner. Yet, that low, midwestern plate seems stable and tenacious. Even as we have changed it, so it has changed us.

Places of Grace:
The Photographs

GARY IRVING

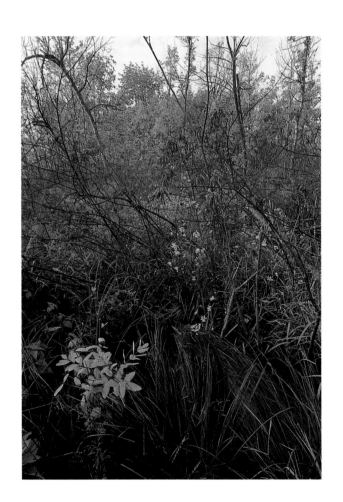

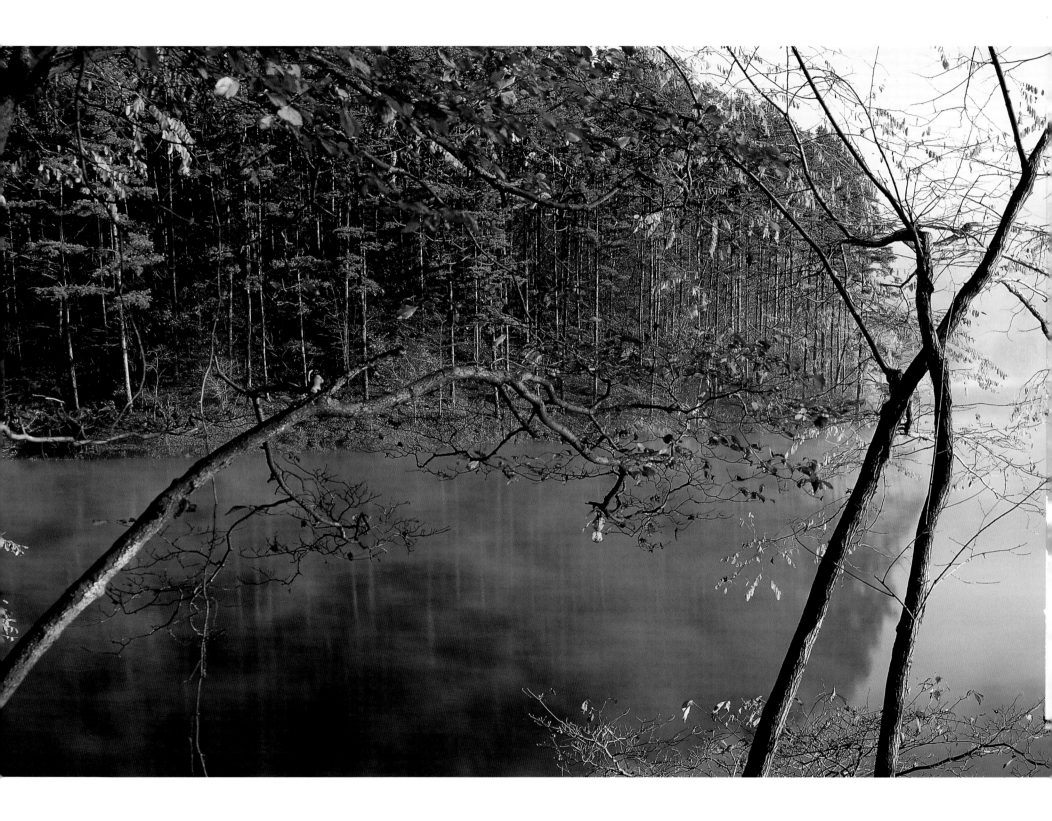

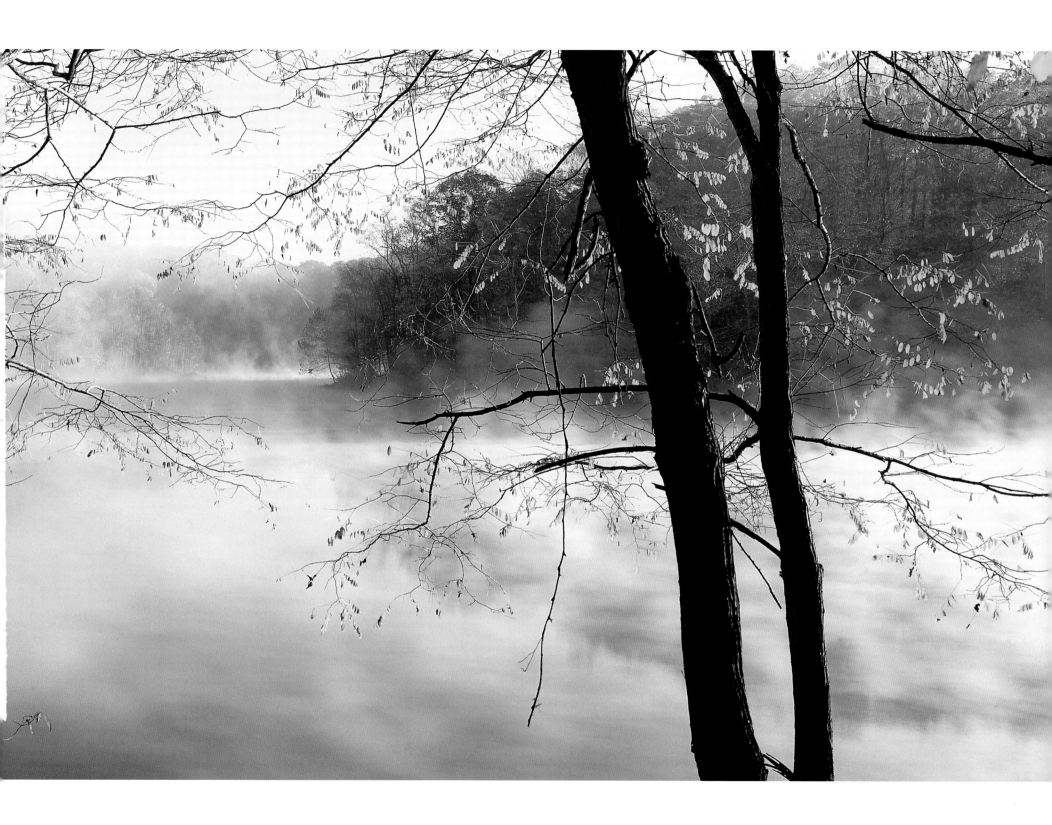

PLATE 1 *Autumn, Lake Vesuvius, Ohio*

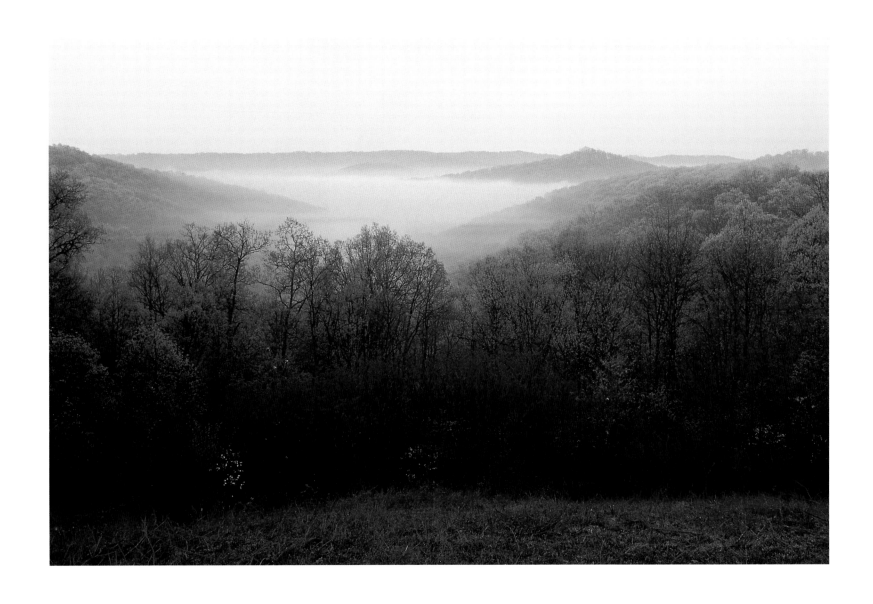

PLATE 2 *Spring, Scioto Trail State Forest, Ohio*

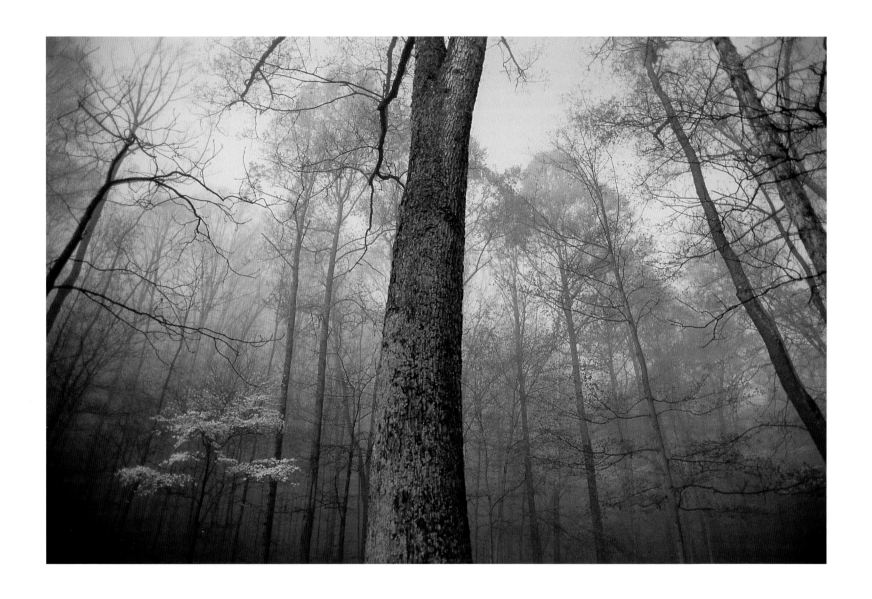

PLATE 3 *Spring, Tar Hollow State Forest, Ohio*

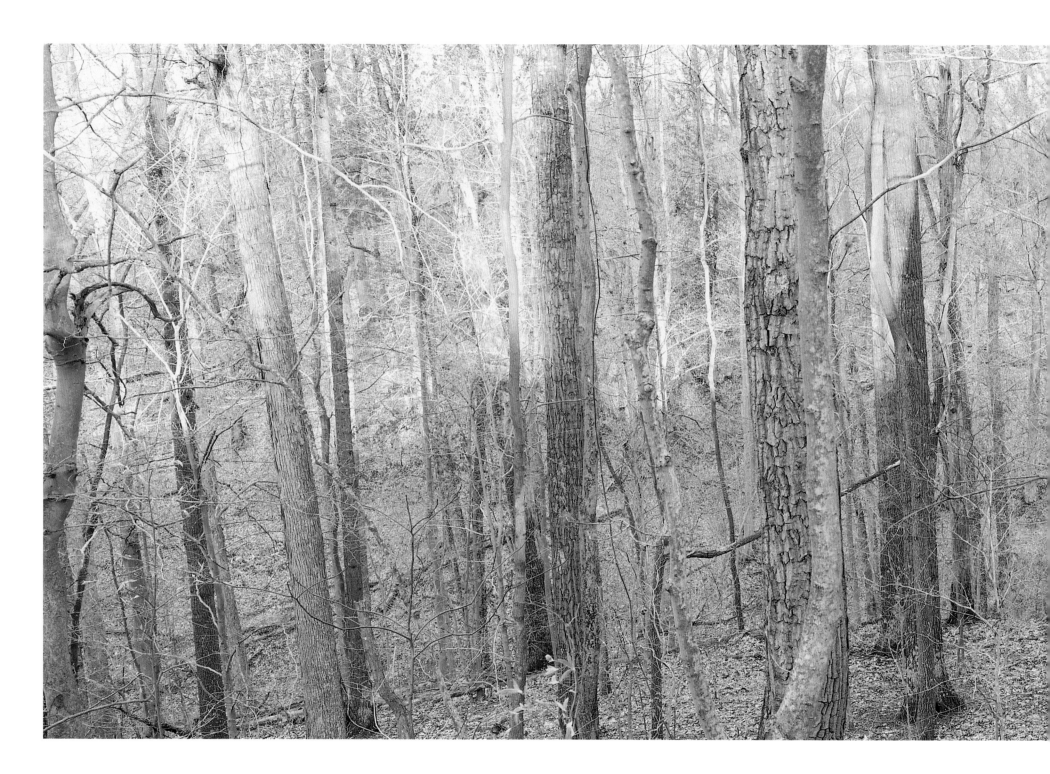

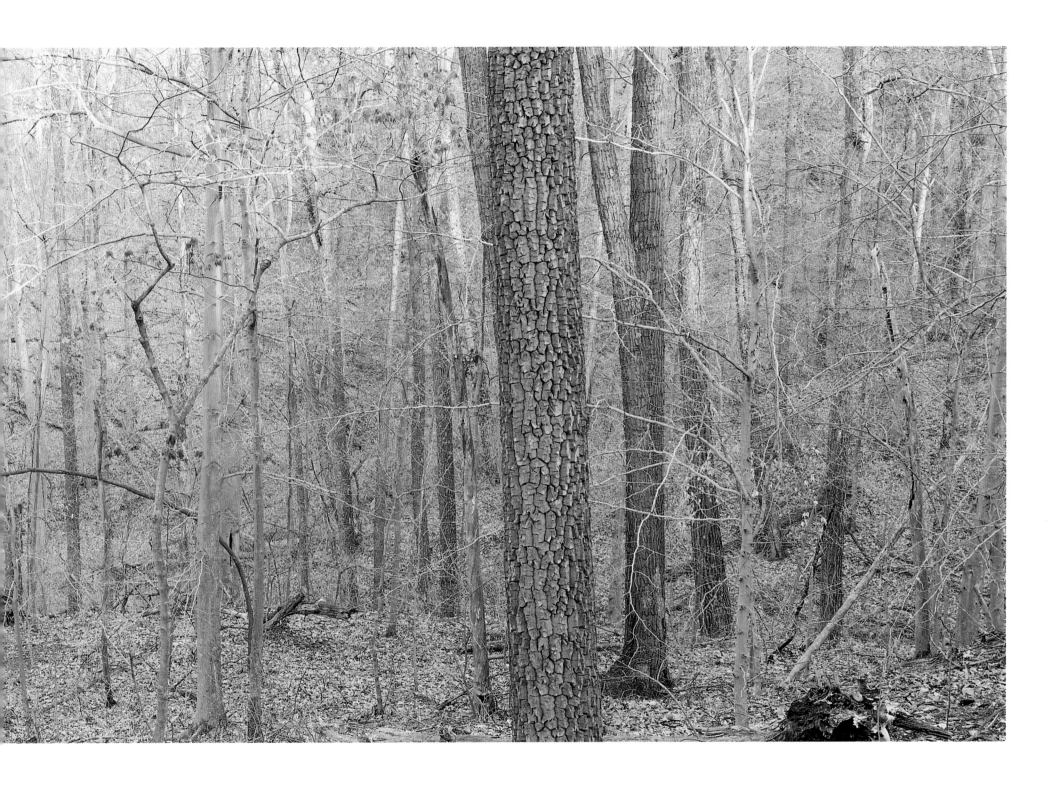

PLATE 4 *Early Spring, Wayne National Forest, Ohio*

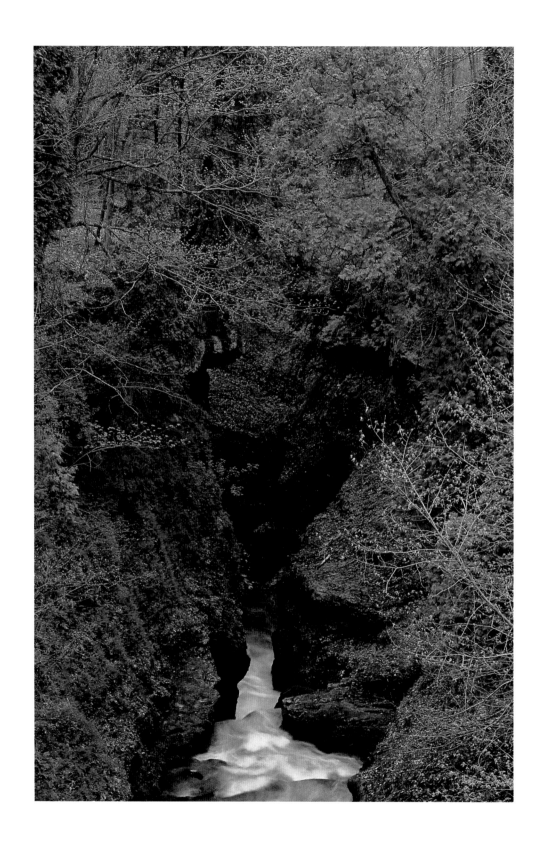

PLATE 5 *Clifton Gorge, Little Miami River, Ohio*

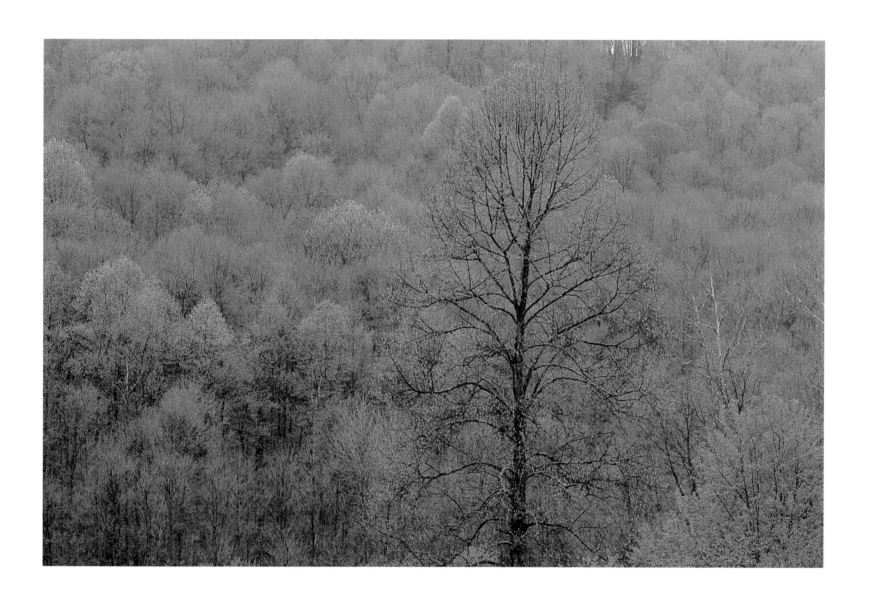

PLATE 6 *Hillside in Early Spring, Tar Hollow State Forest, Ohio*

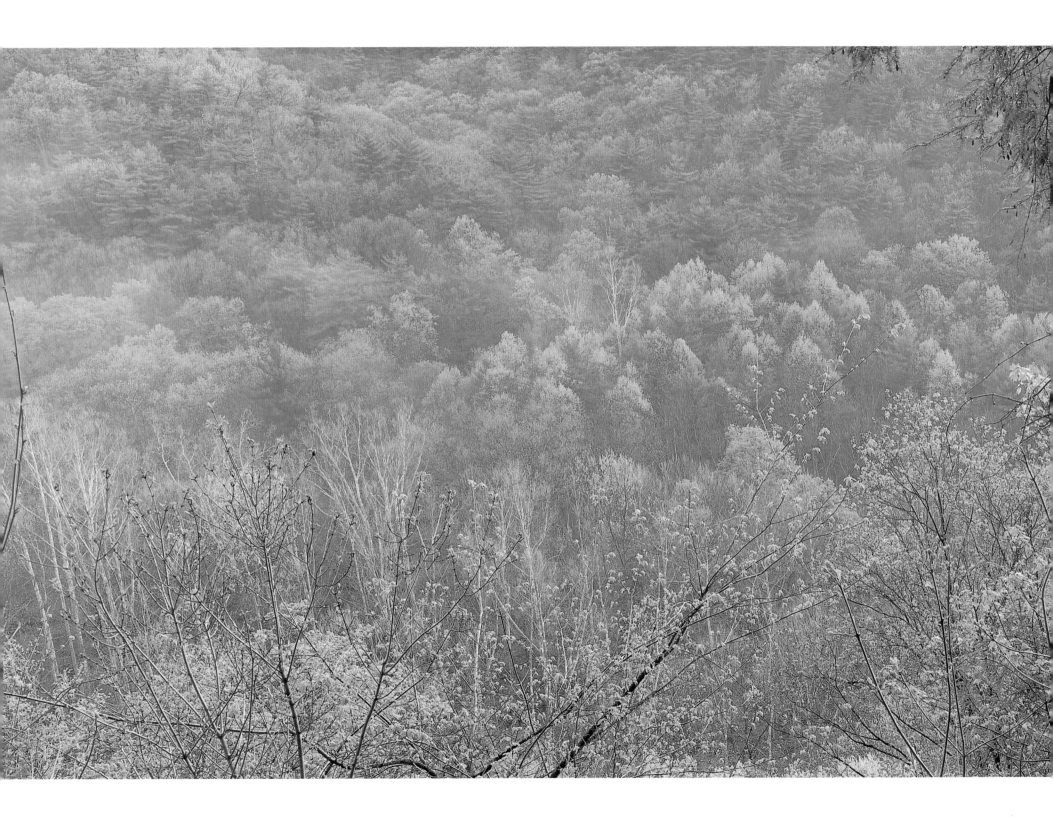

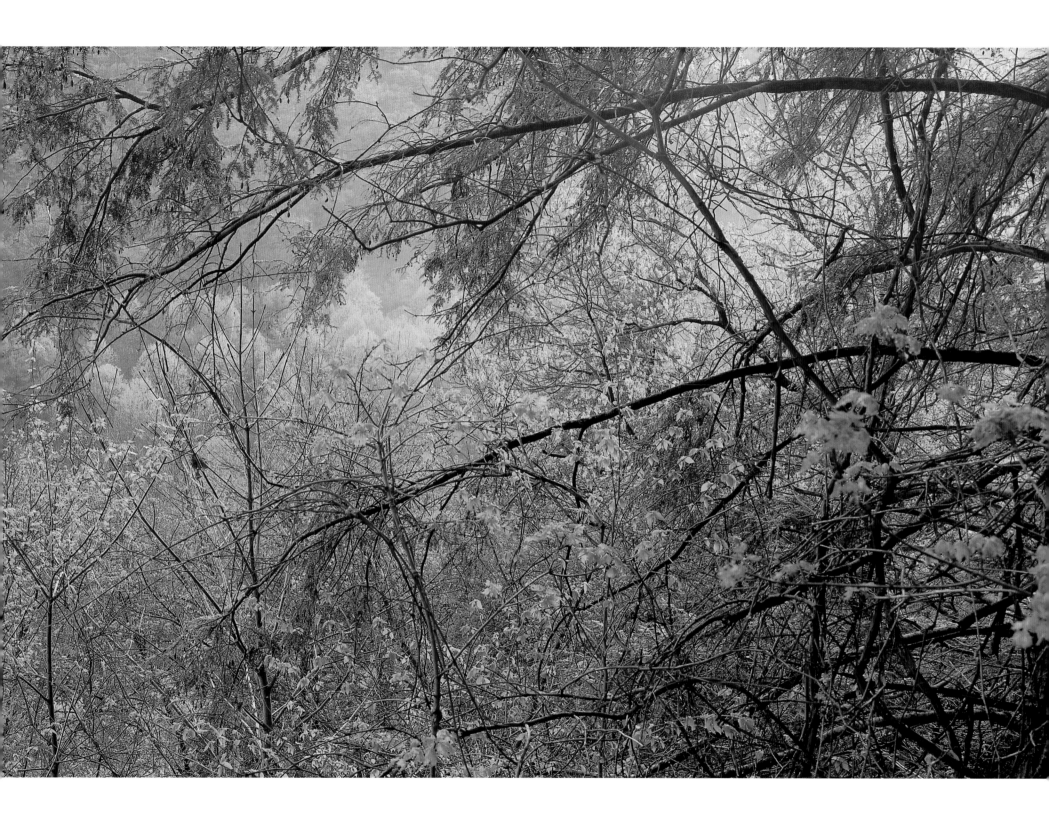

PLATE 7 *Clearfork Gorge, Mohican State Forest, Ohio*

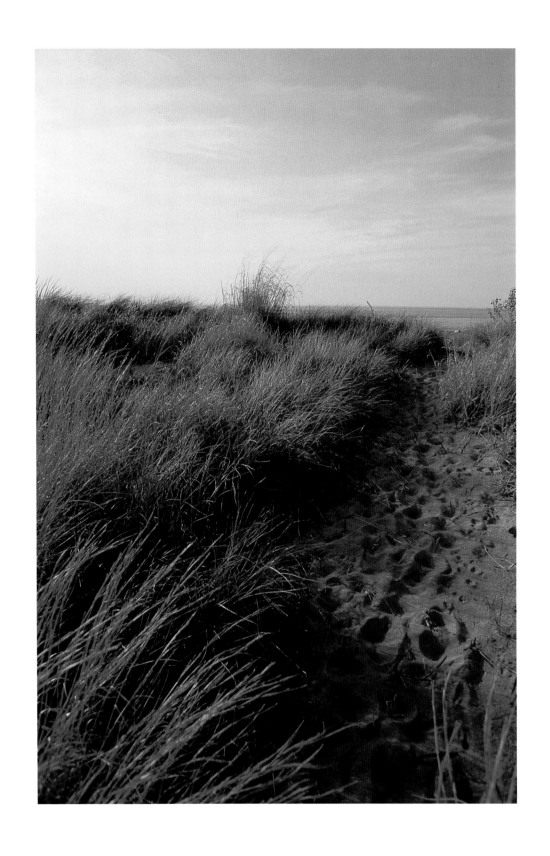

PLATE 8 *Headlands Dunes, Lake Erie Shoreline, Ohio*

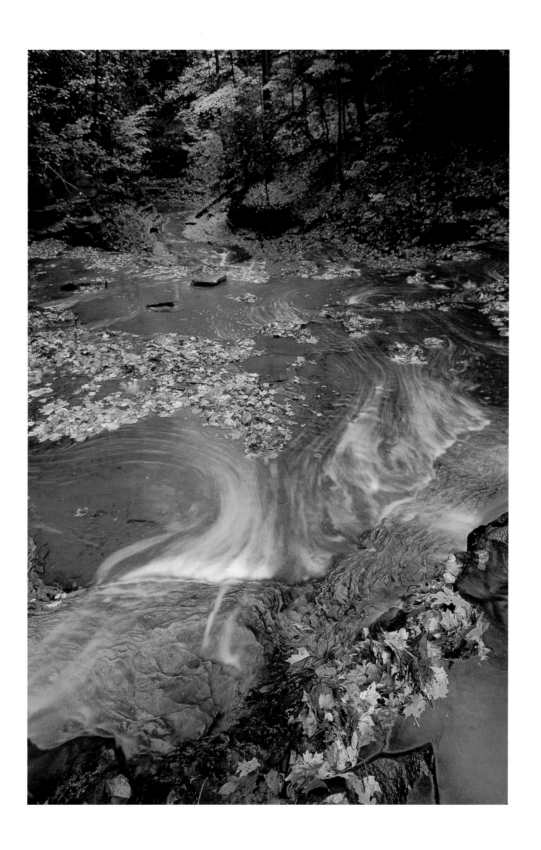

PLATE 9 *Tinkers Creek, Cleveland Metropark, Ohio*

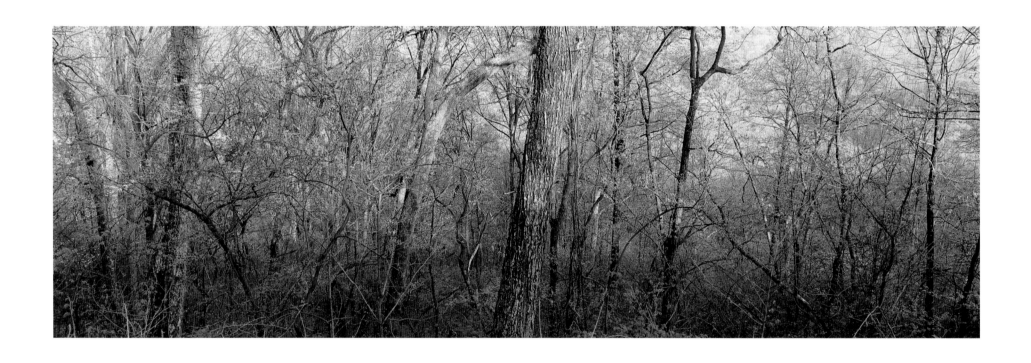

PLATE 10 *Redbud, Shawnee State Forest, Ohio*

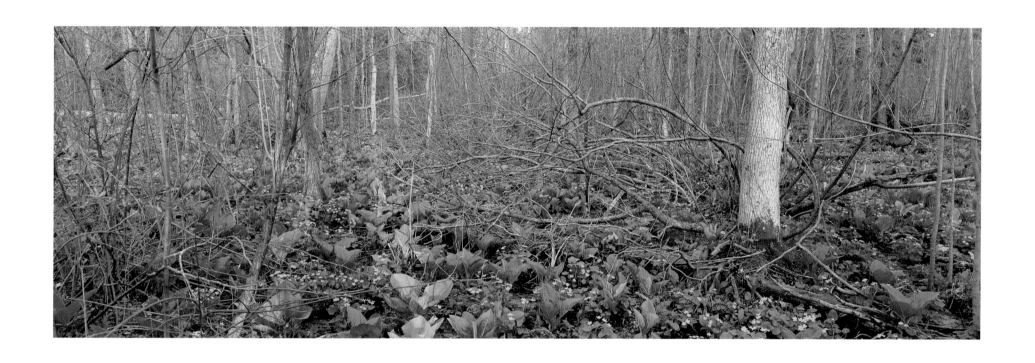

PLATE II *Marsh Marigolds, Cedar Bog State Nature Preserve, Ohio*

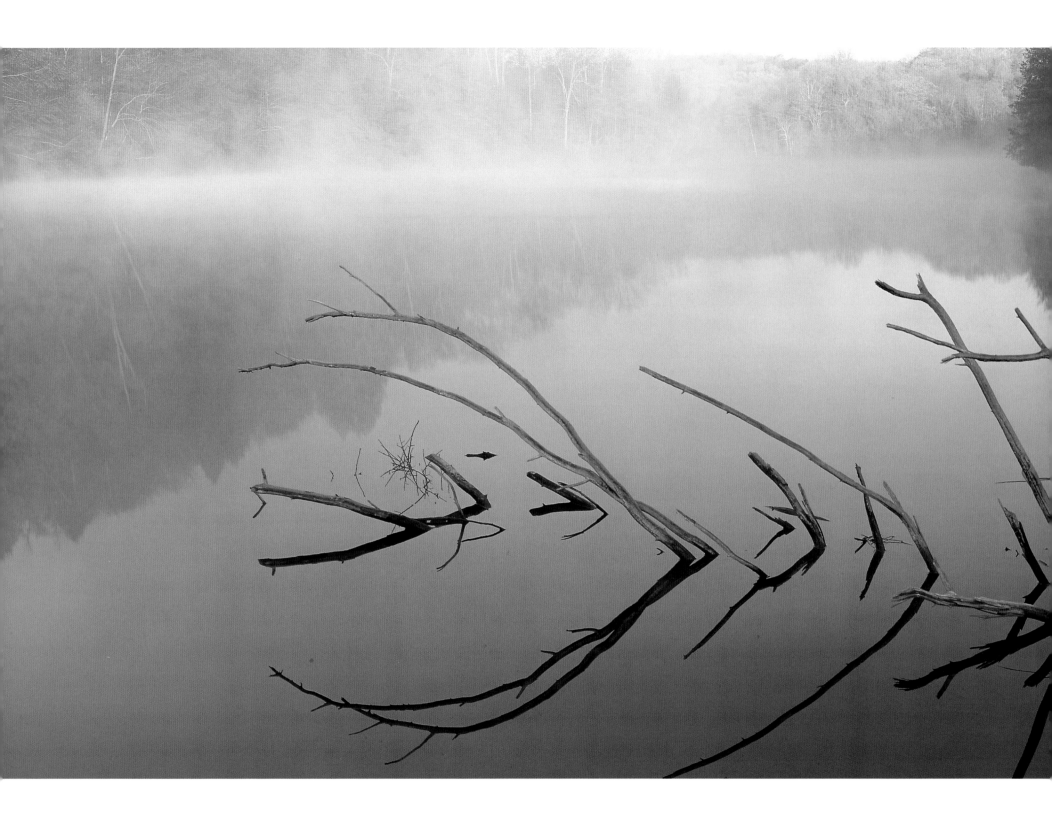

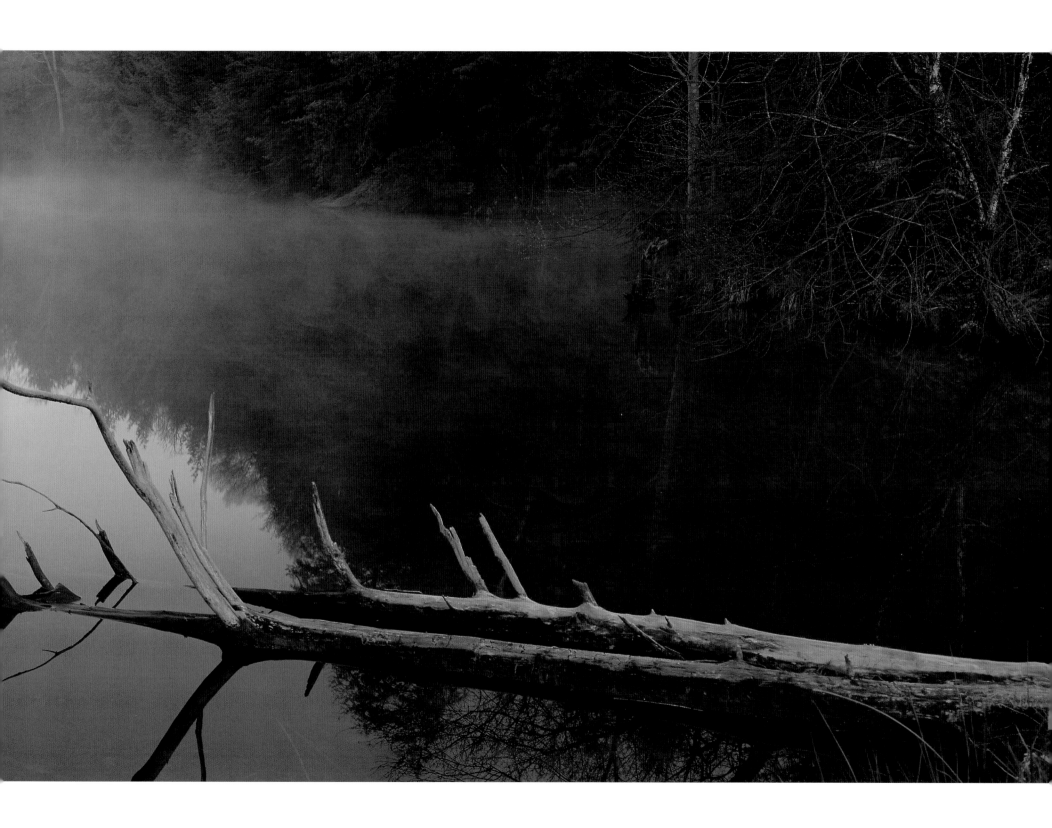

PLATE 12 *Fallen Tree, Lake Katherine, Ohio*

PLATE 13 *Spring, Hoosier National Forest, Indiana*

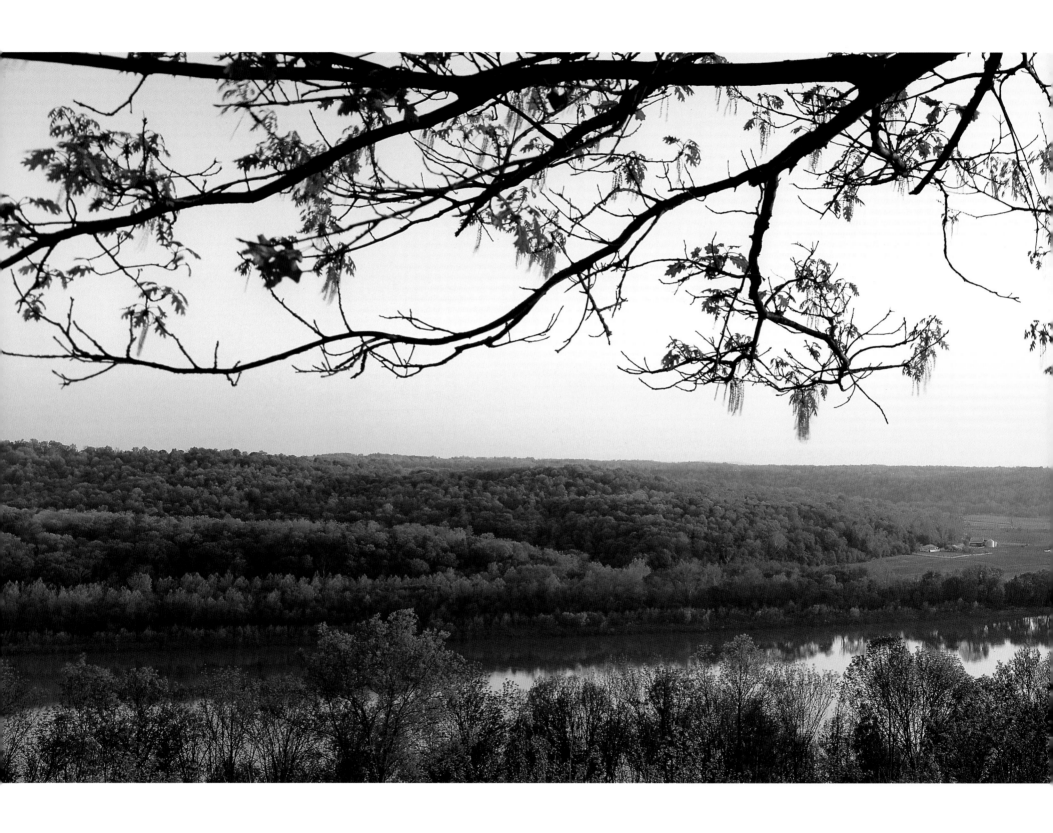

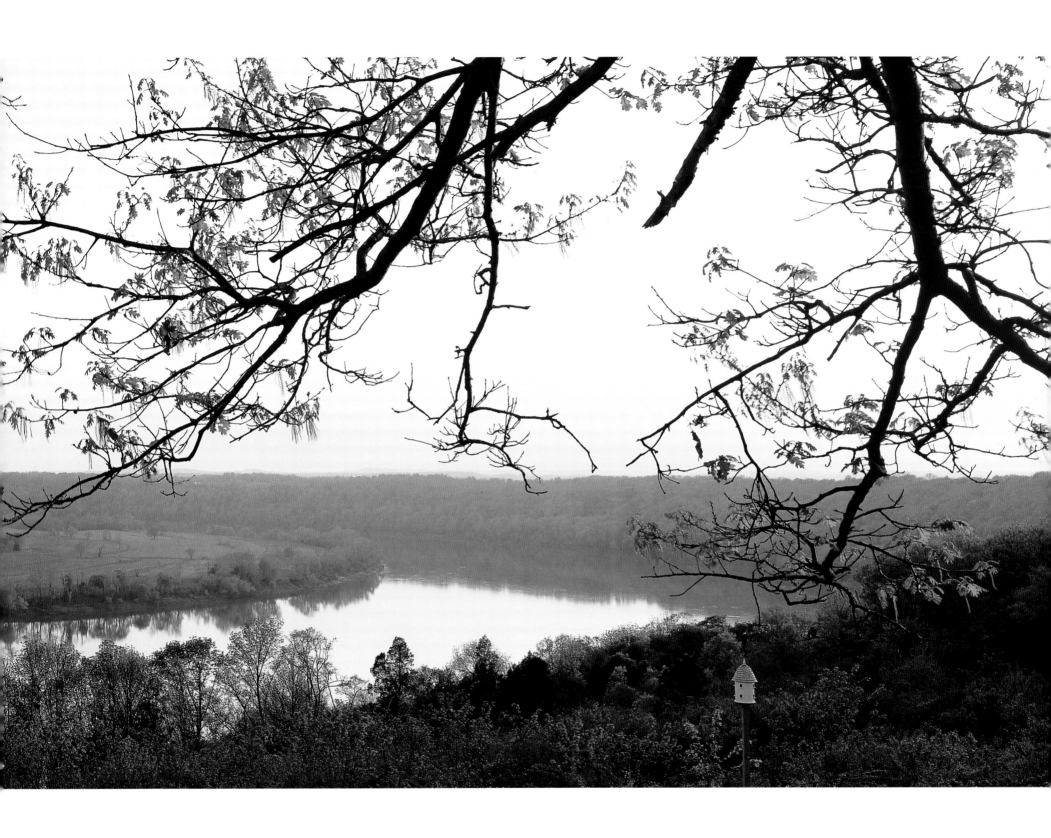

PLATE 14 *Bluffs along the Ohio River, Hoosier Heritage Trail, Indiana*

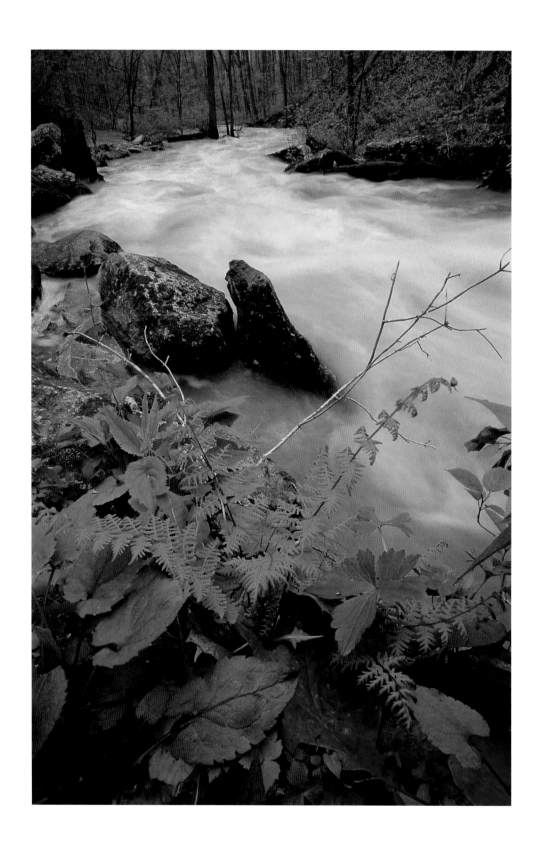

PLATE 15 *Near Donaldson Cave, Spring Mill State Park, Indiana*

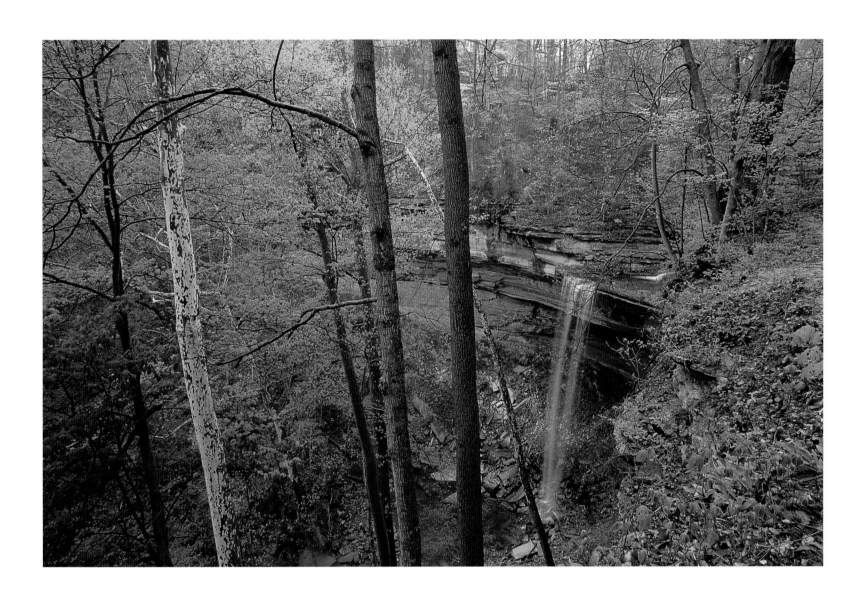

PLATE 16 *Waterfall, Clifty Falls State Park, Indiana*

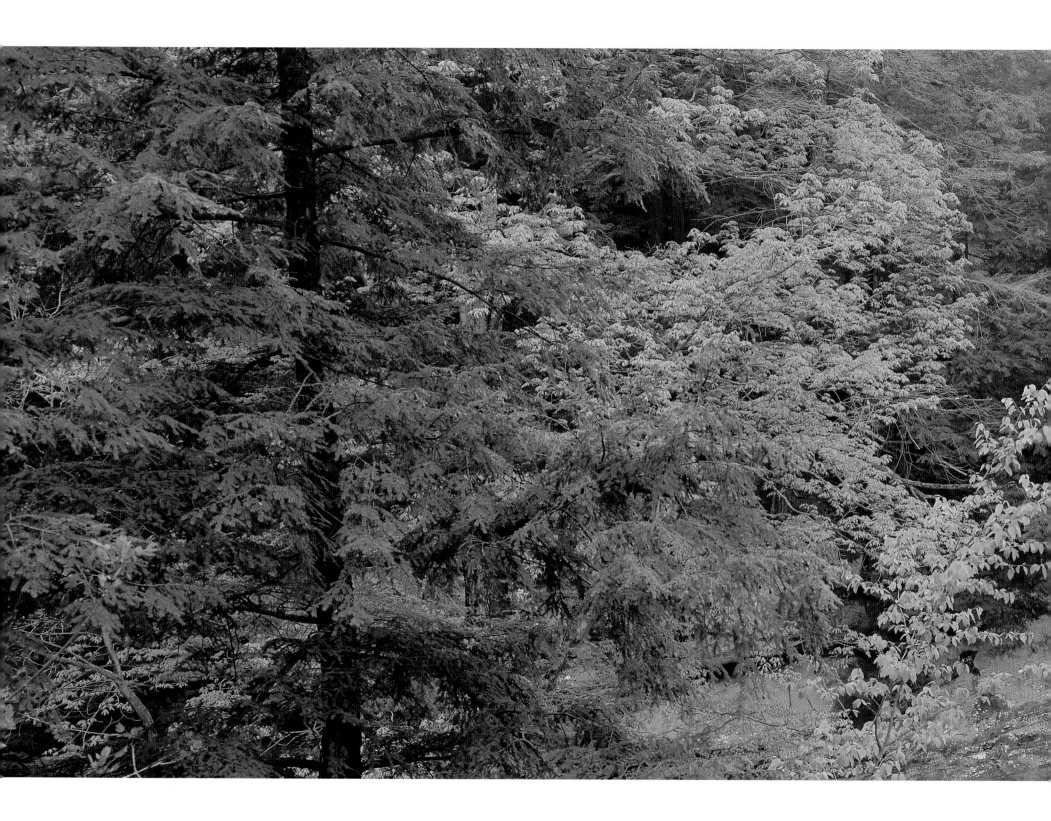

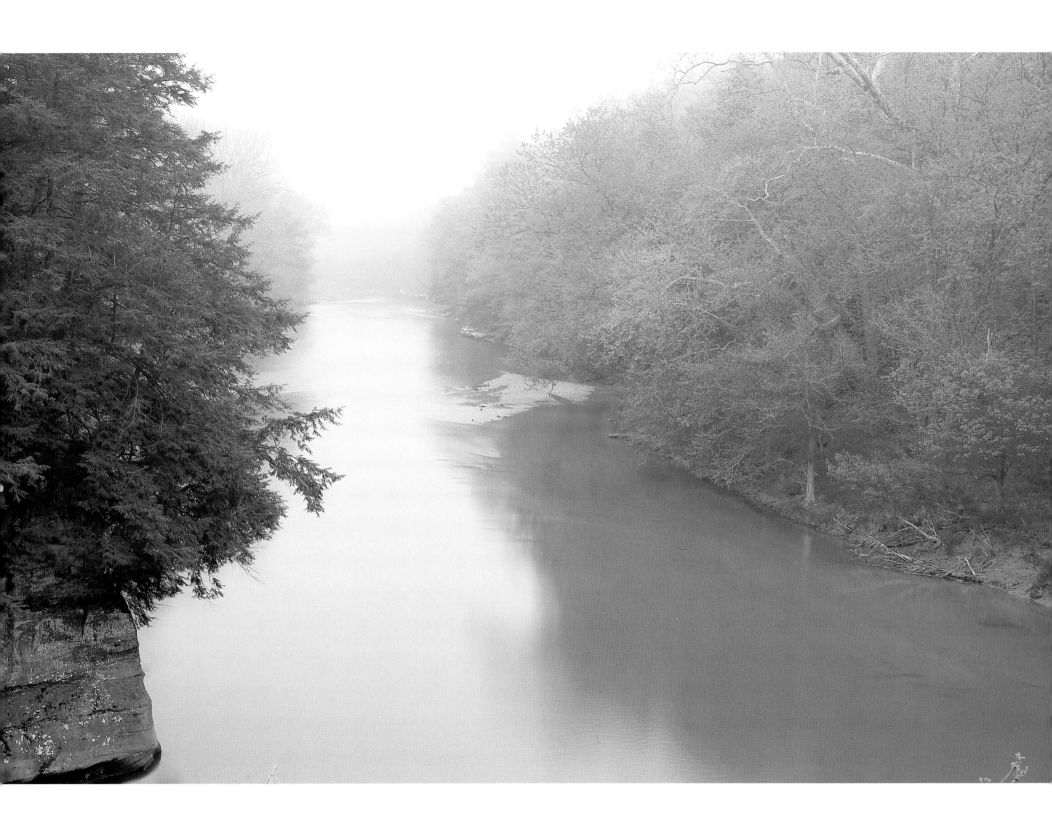

PLATE 17 *Sugar Creek, Turkey Run State Park, Indiana*

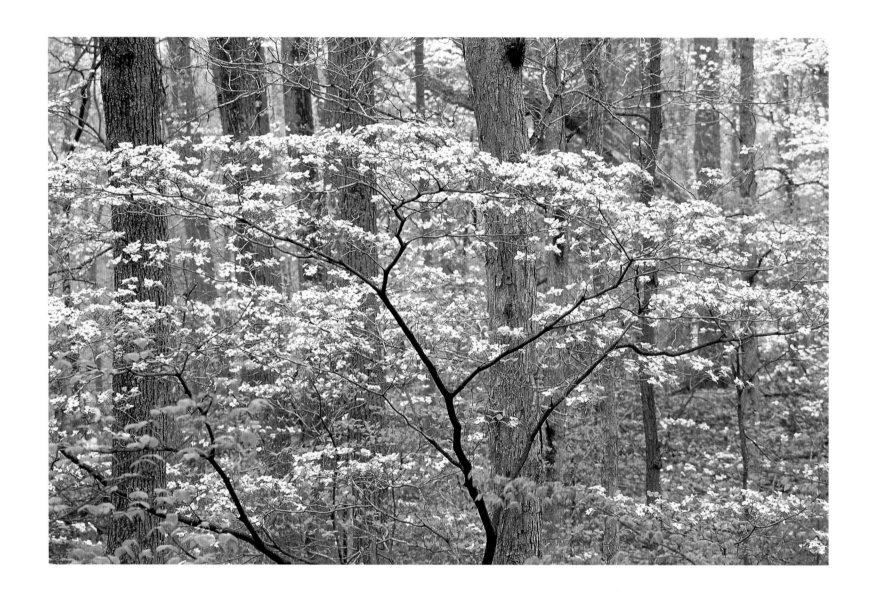

PLATE 18 *Flowering Dogwood, Brown County State Park, Indiana*

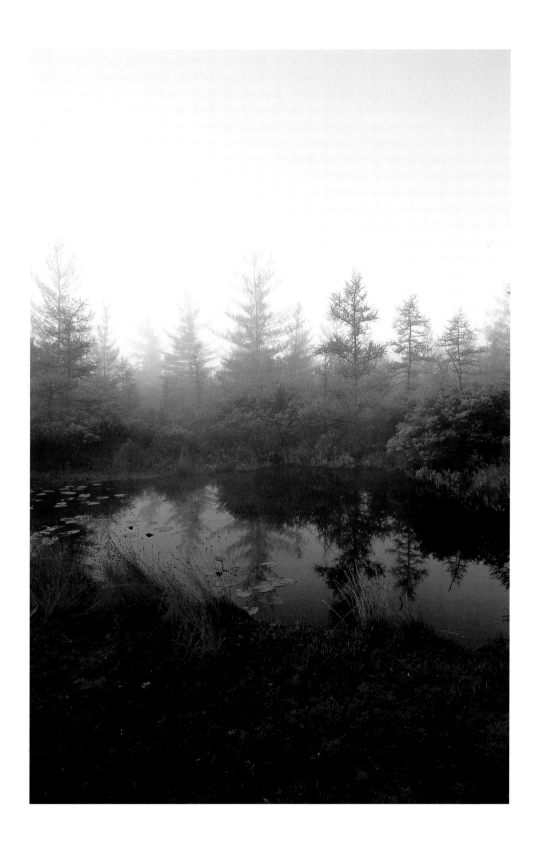

PLATE 19 *Tamarack, Pinhook Bog, Indiana Dunes National Lakeshore, Indiana*

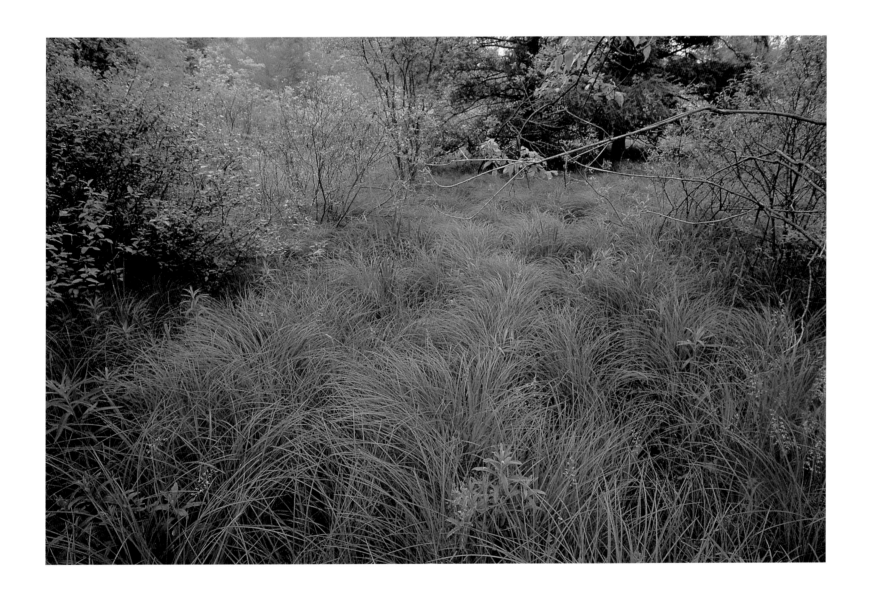

PLATE 20 *Grasses, Highland Recreational Area, Michigan*

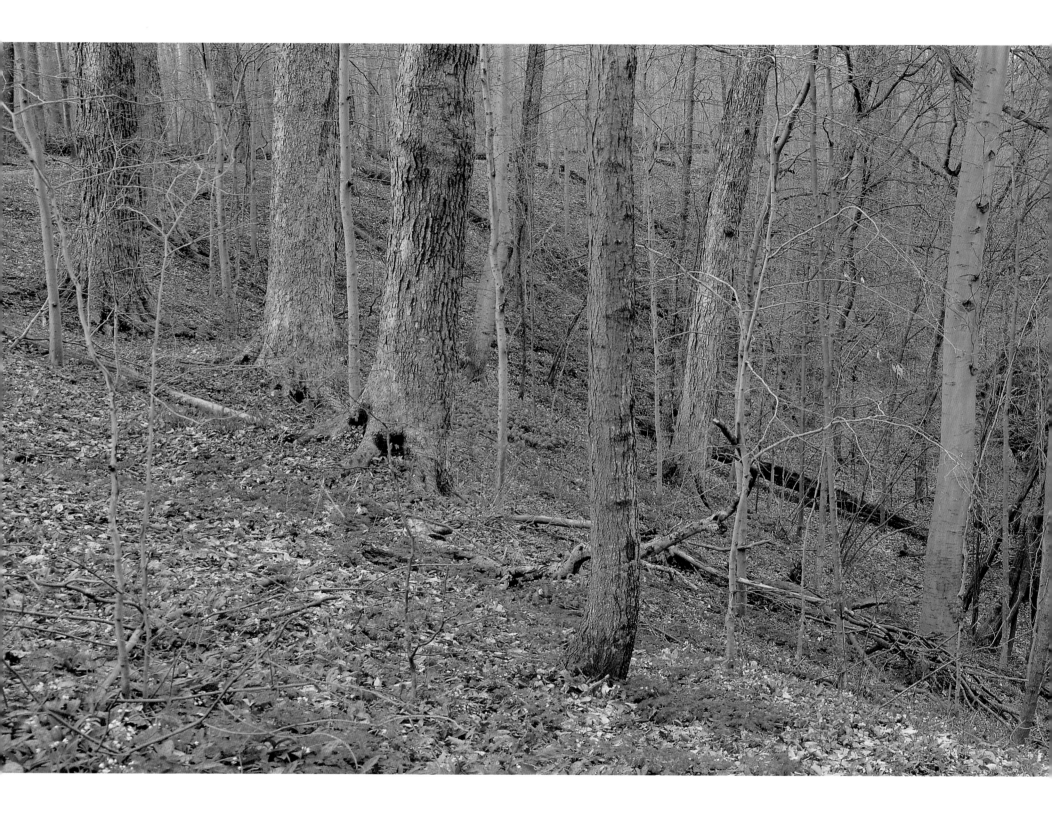

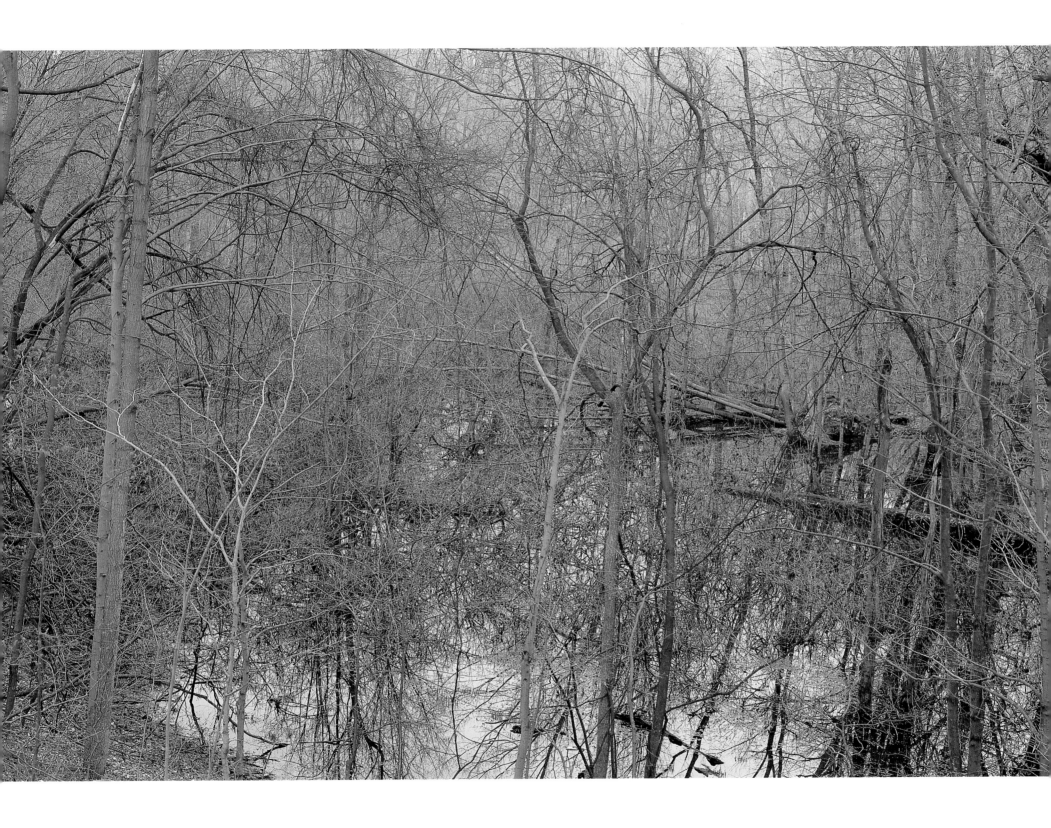

PLATE 21 *Early Spring, Warren Woods, Michigan*

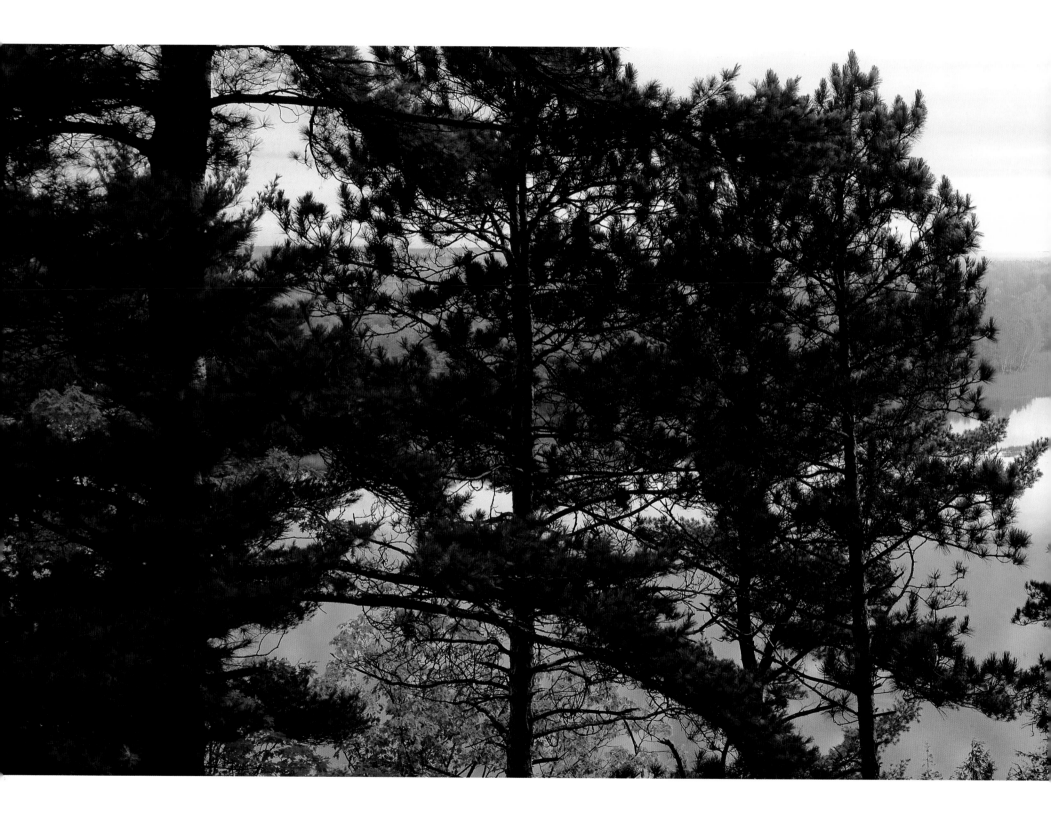

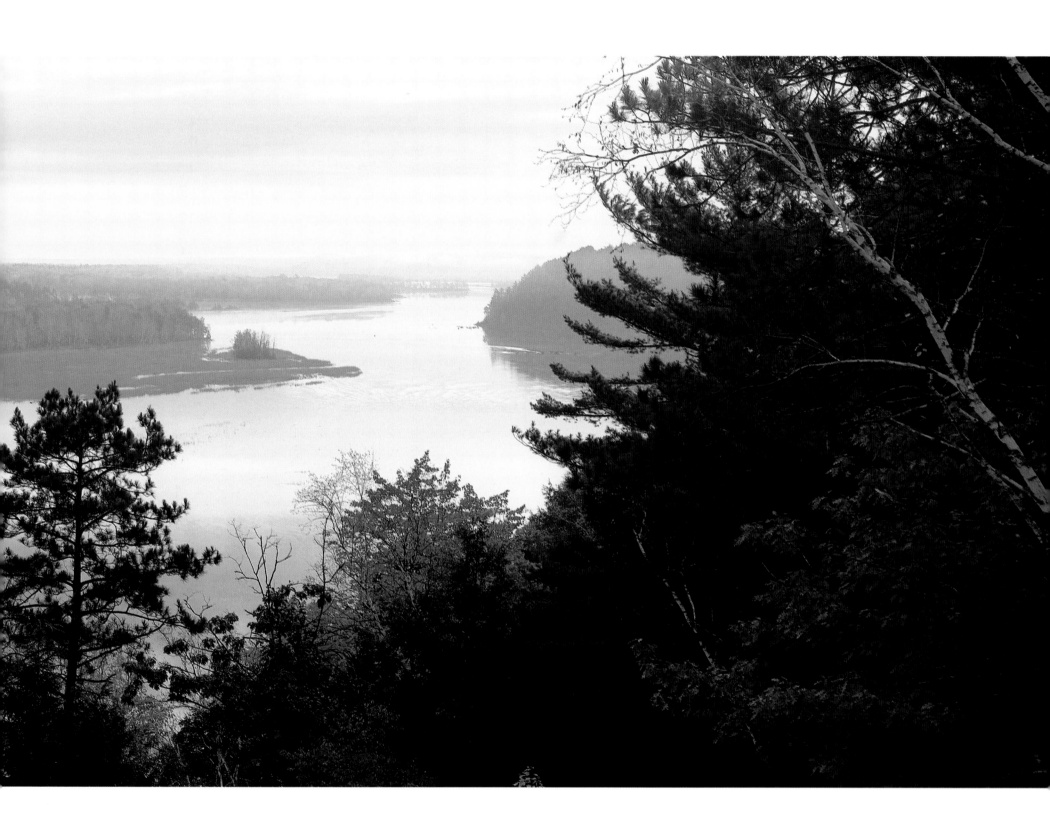

PLATE 22 *Autumn, Au Sable National Riverway, Michigan*

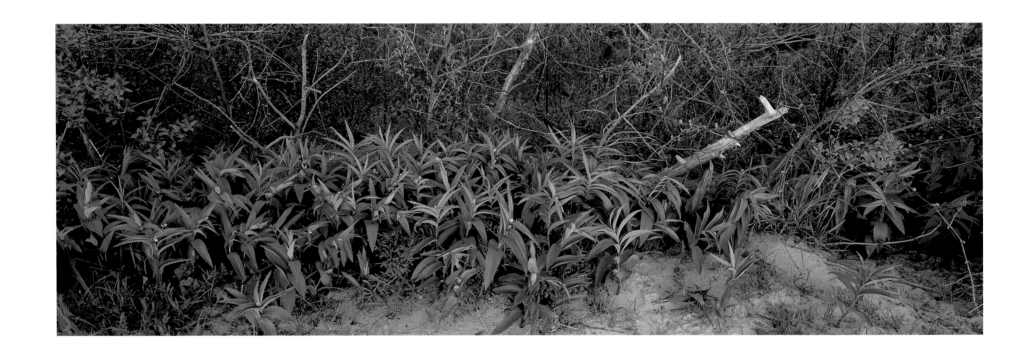

PLATE 23 *Dune Flora, Sleeping Bear Dunes National Lakeshore, Michigan*

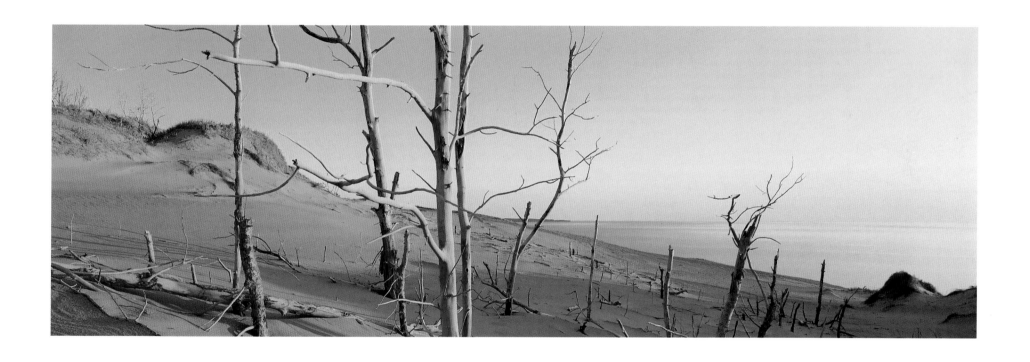

PLATE 24 *Ghost Forest, Sleeping Bear Dunes National Lakeshore, Michigan*

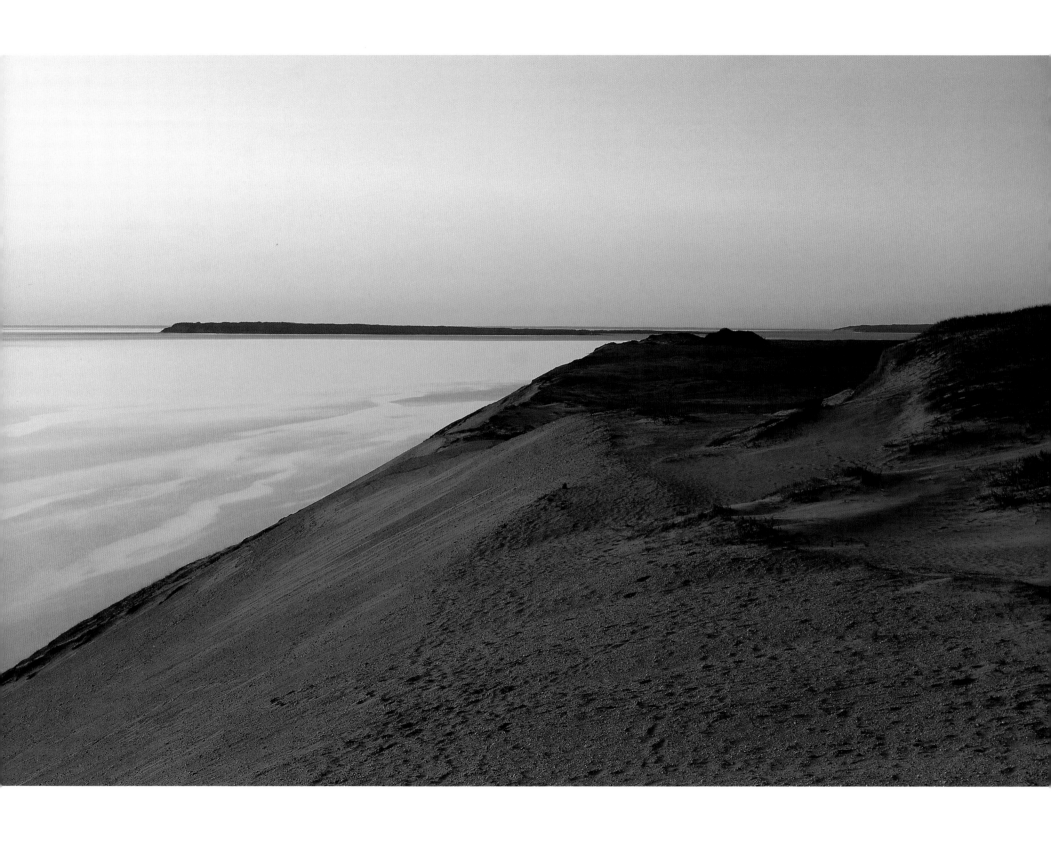

PLATE 25 *Sunset Afterglow on Lake Michigan, Sleeping Bear Dunes National Lakeshore, Michigan*

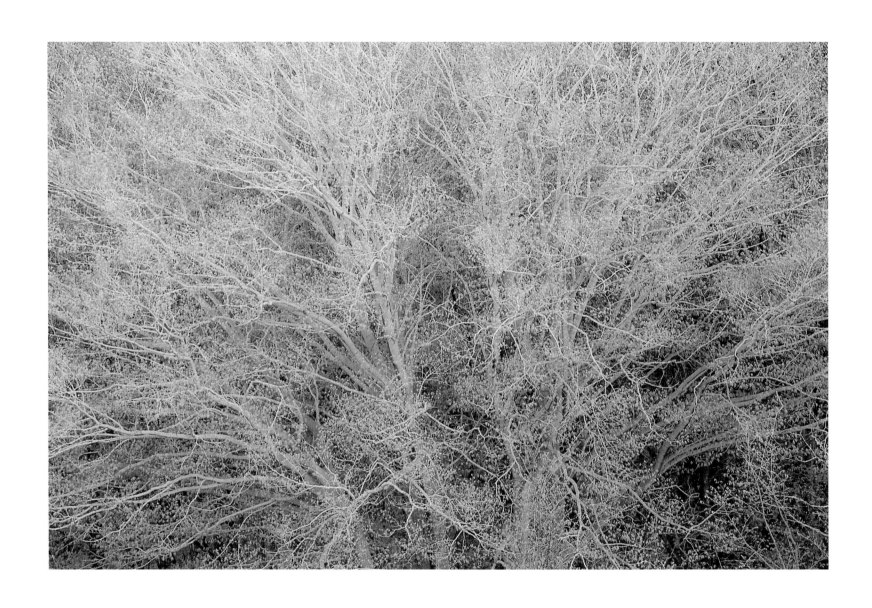

PLATE 26 *Beech in Early Spring, Warren Woods, Michigan*

PLATE 27 *Autumn, Manistee National Forest, Michigan*

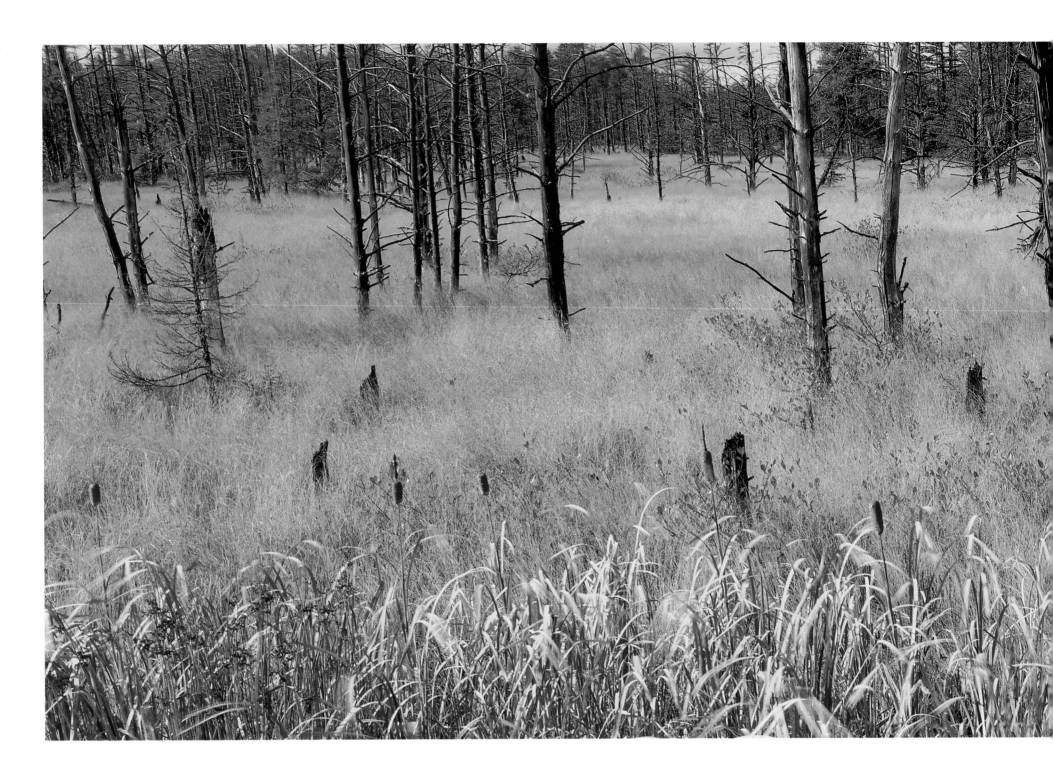

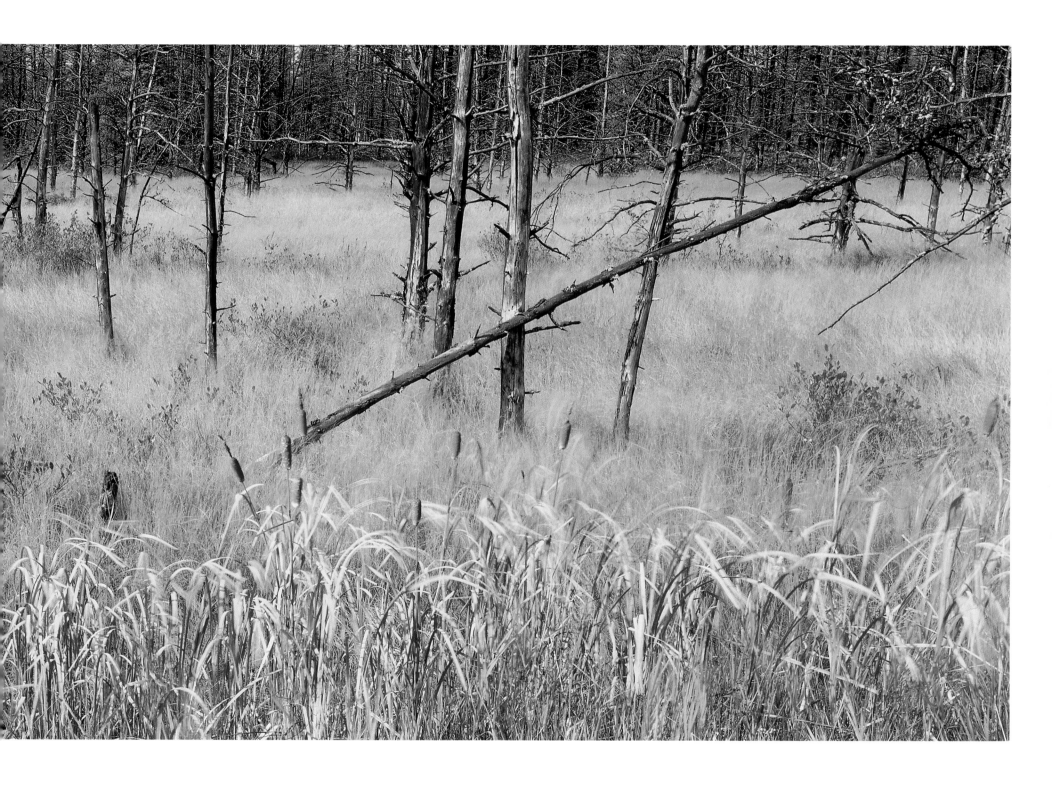

PLATE 28 *Marsh Grasses in Autumn, Lake Superior National Forest, Upper Peninsula, Michigan*

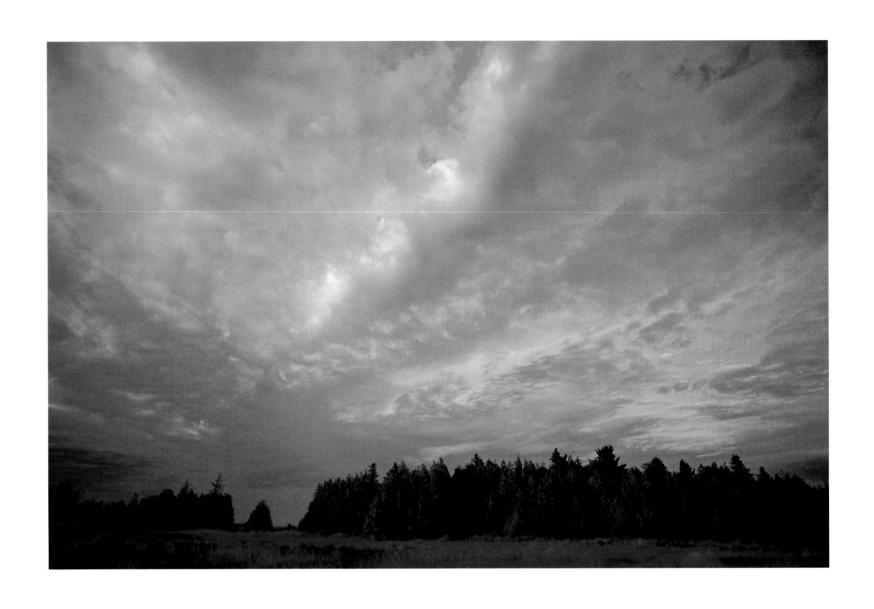

PLATE 29 *Waugoshance Point, Wilderness State Park, Michigan*

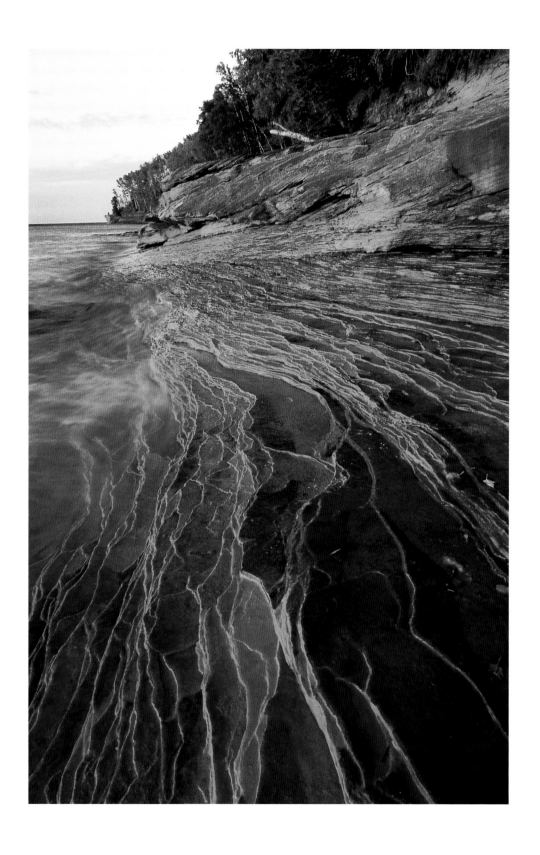

PLATE 30 *Pictured Rocks National Lakeshore, Upper Peninsula, Michigan*

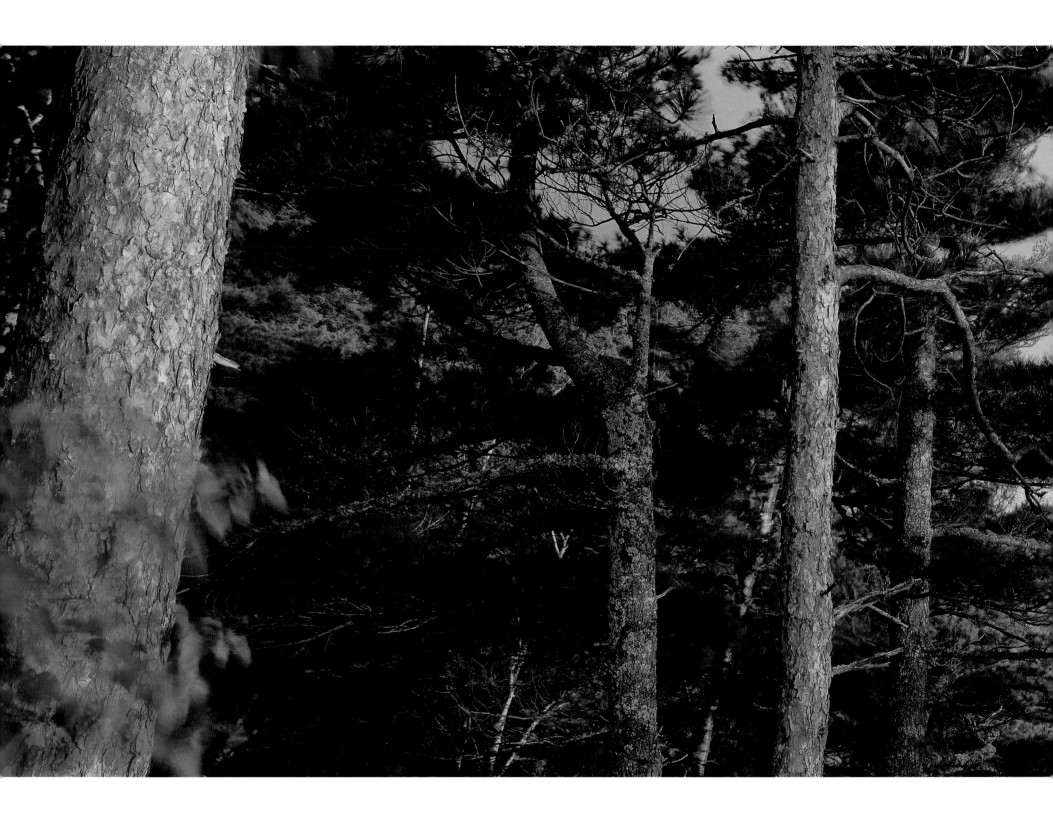

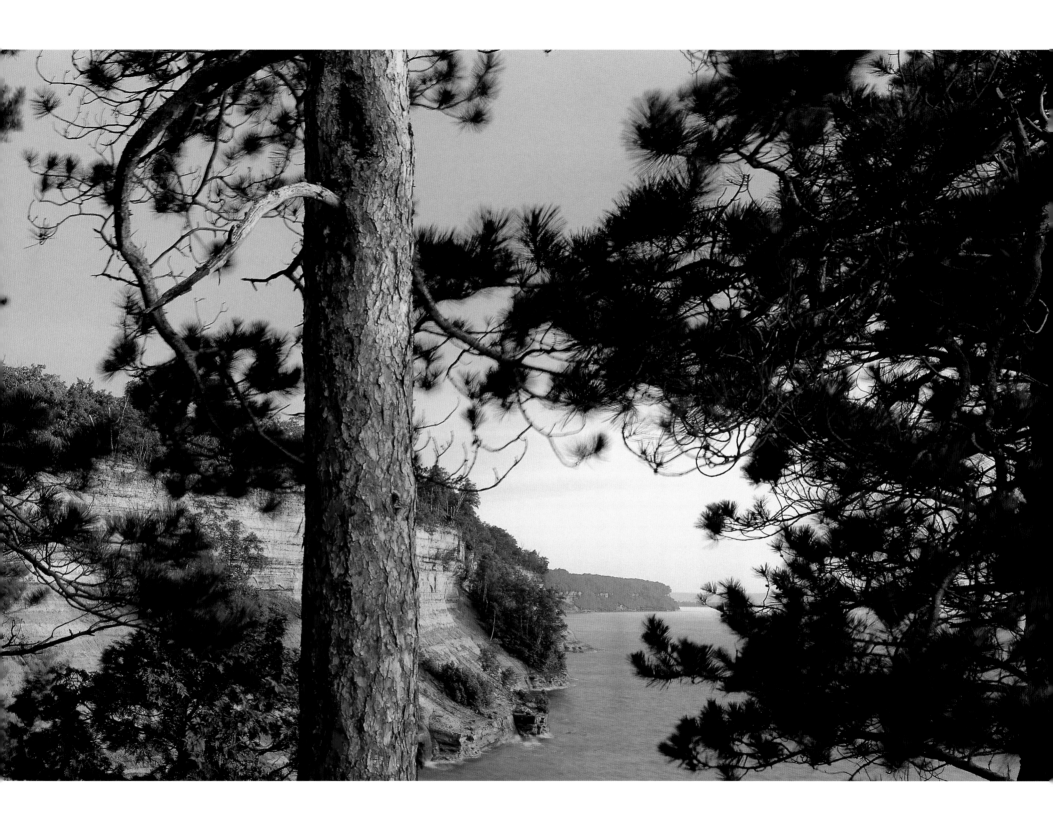

PLATE 31 *Cliffs, Pictured Rocks National Lakeshore, Upper Peninsula, Michigan*

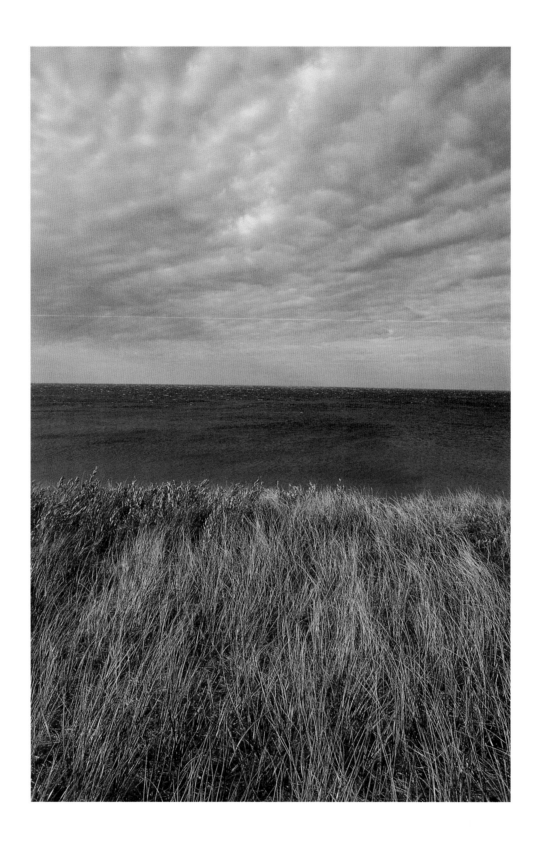

PLATE 32 *Grasses, Lake Superior Shoreline, Upper Peninsula, Michigan*

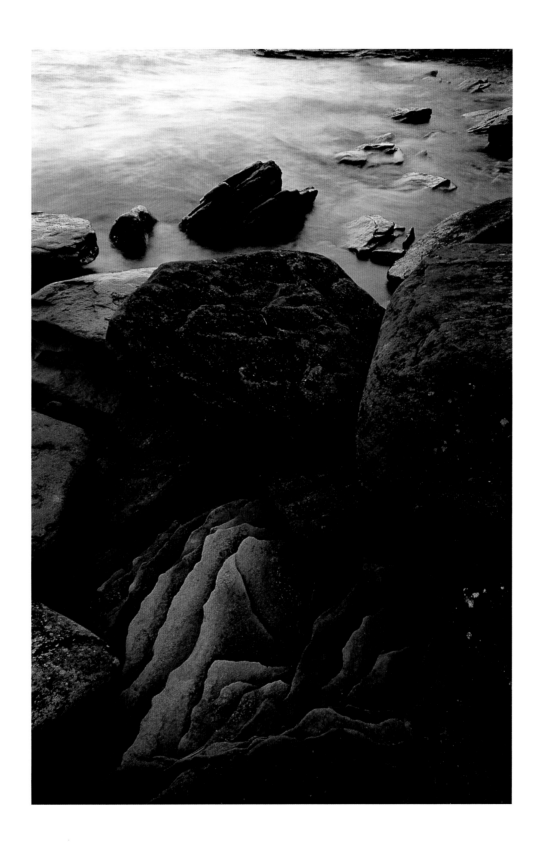

PLATE 33 *Rocks, Point Abbaye, Upper Peninsula, Michigan*

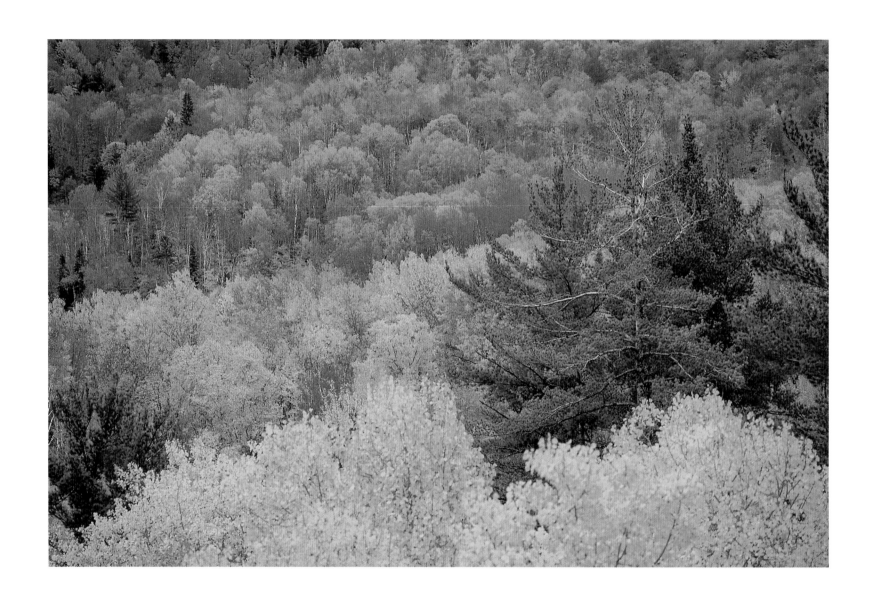

PLATE 34 *Autumn, Ottawa National Forest, Upper Peninsula, Michigan*

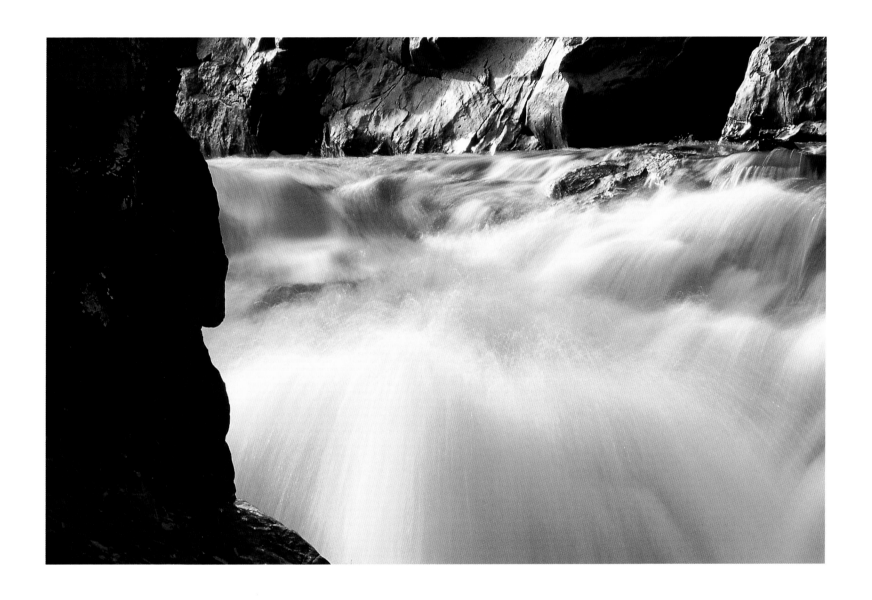

PLATE 35 *Sturgeon Gorge, Upper Peninsula, Michigan*

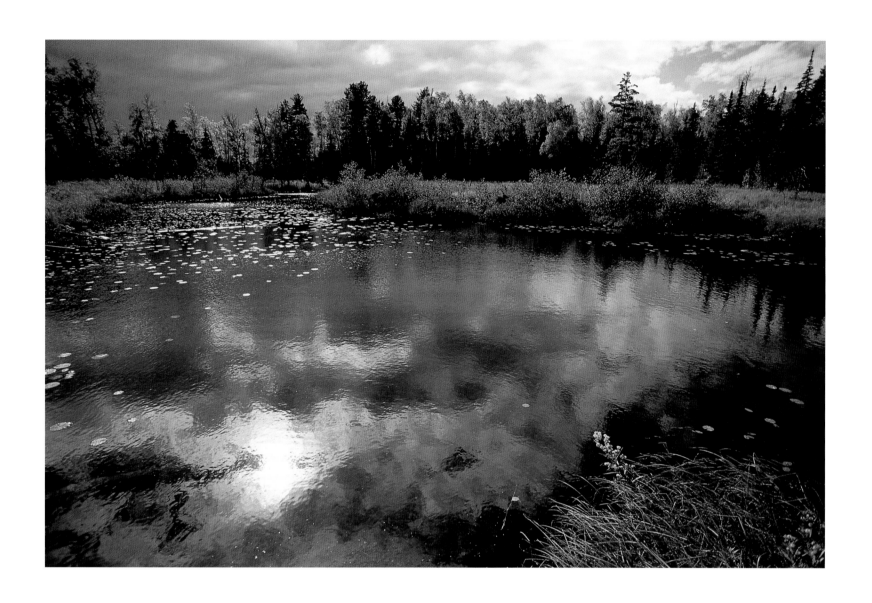

PLATE 36 *Pond, Voyageurs National Park, Minnesota*

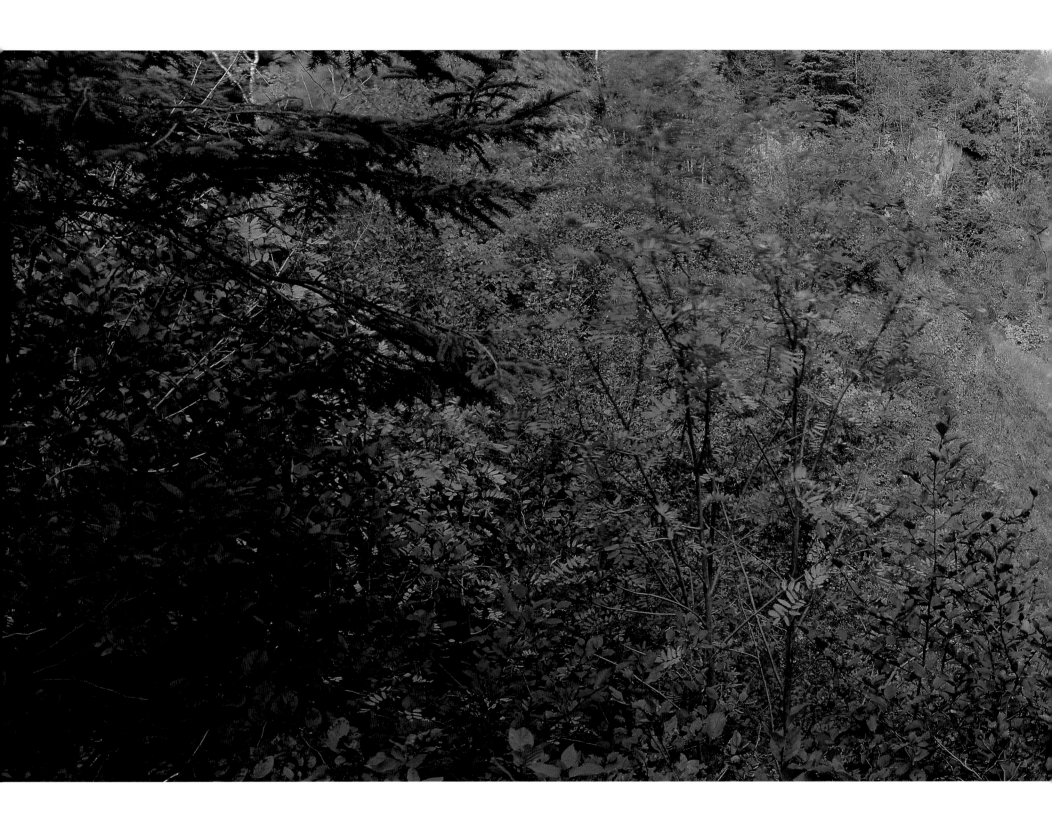

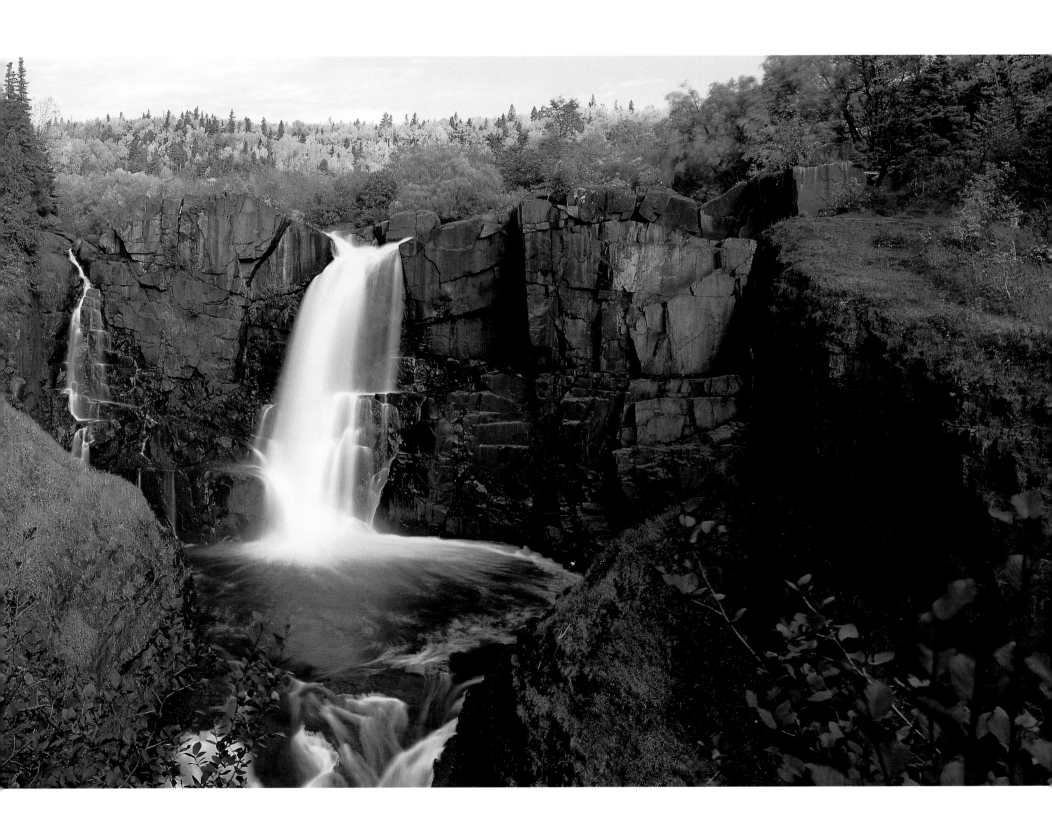

PLATE 37 *Pigeon Falls, Pigeon River, Minnesota*

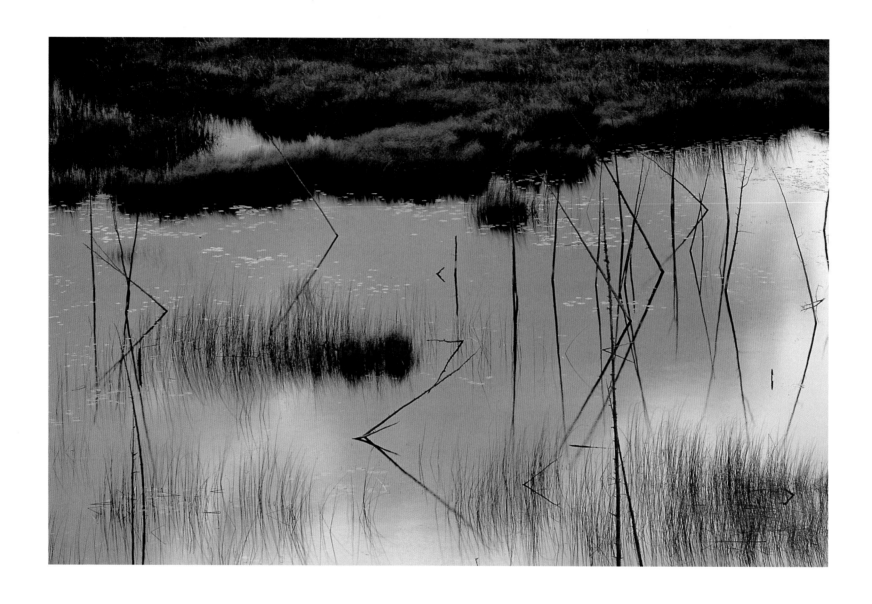

PLATE 38 *Evening Reflection with Grasses, Bear Lake State Forest, Minnesota*

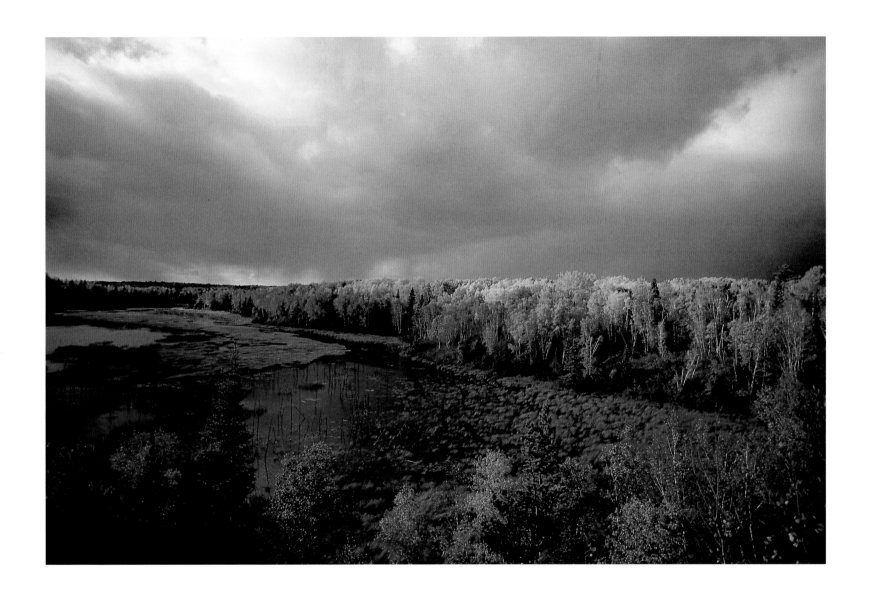

PLATE 39 *Clearing Storm, Superior National Forest, Minnesota*

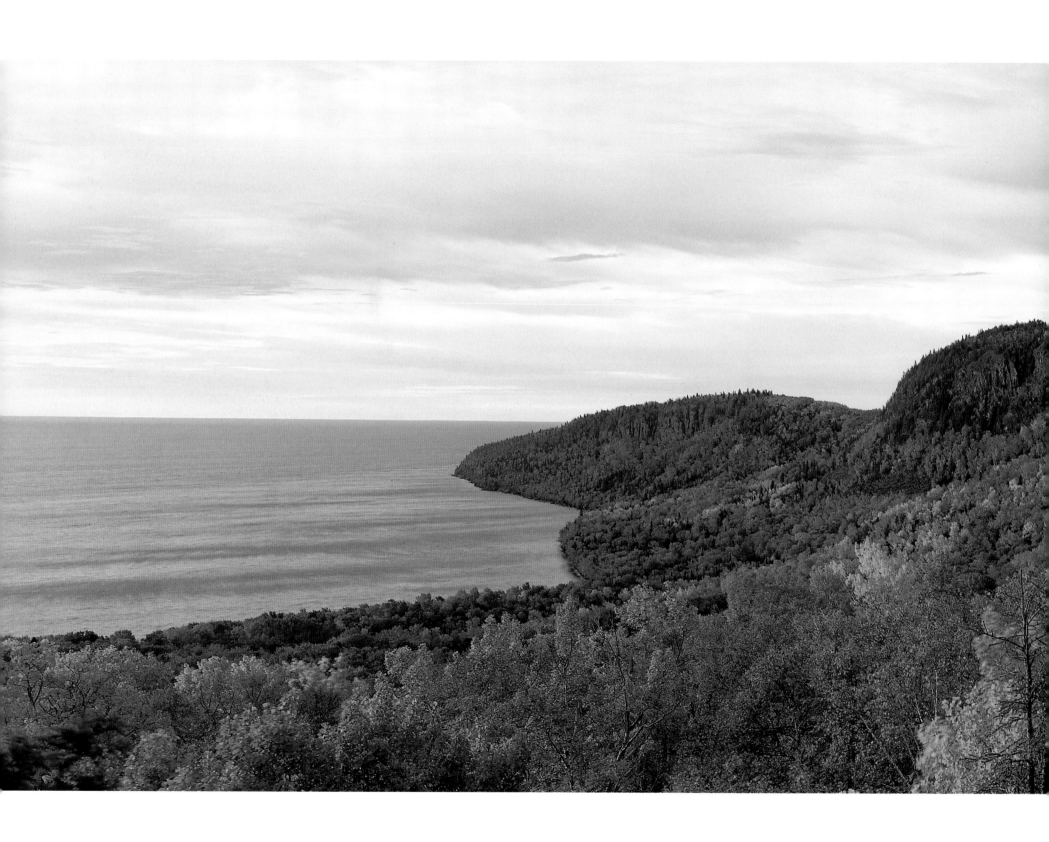

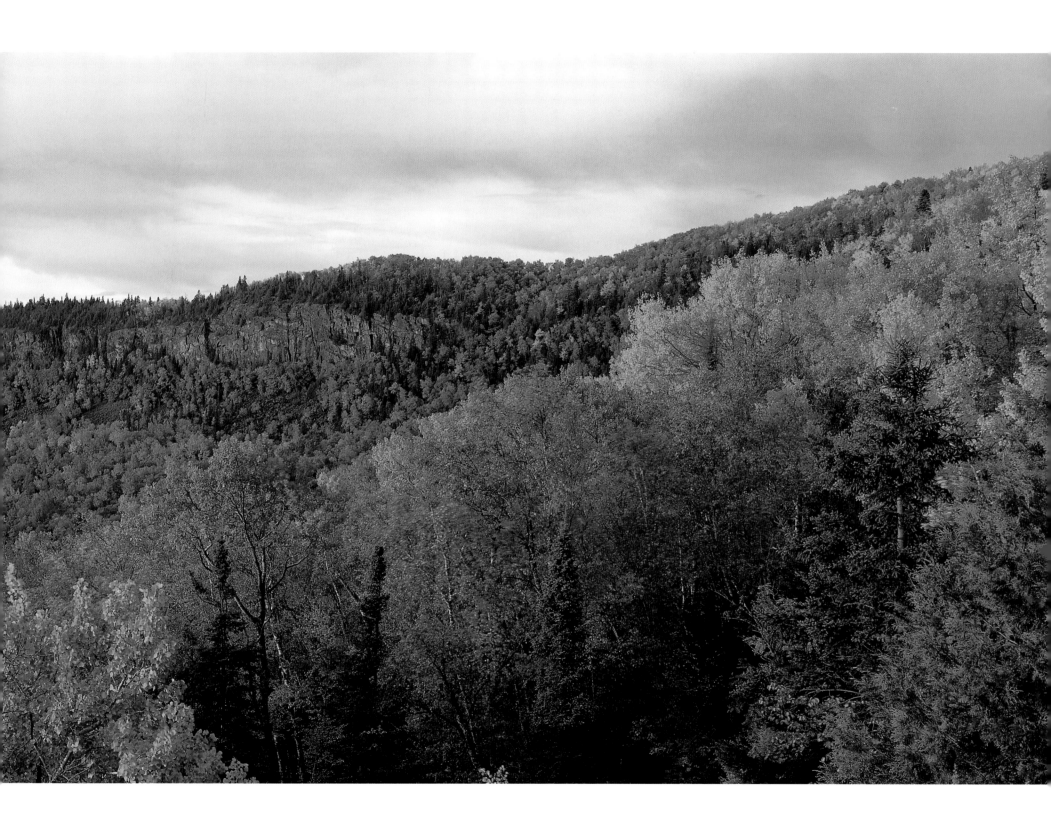

PLATE 40 *Autumn, Wauswaugoning Bay, Lake Superior, Minnesota*

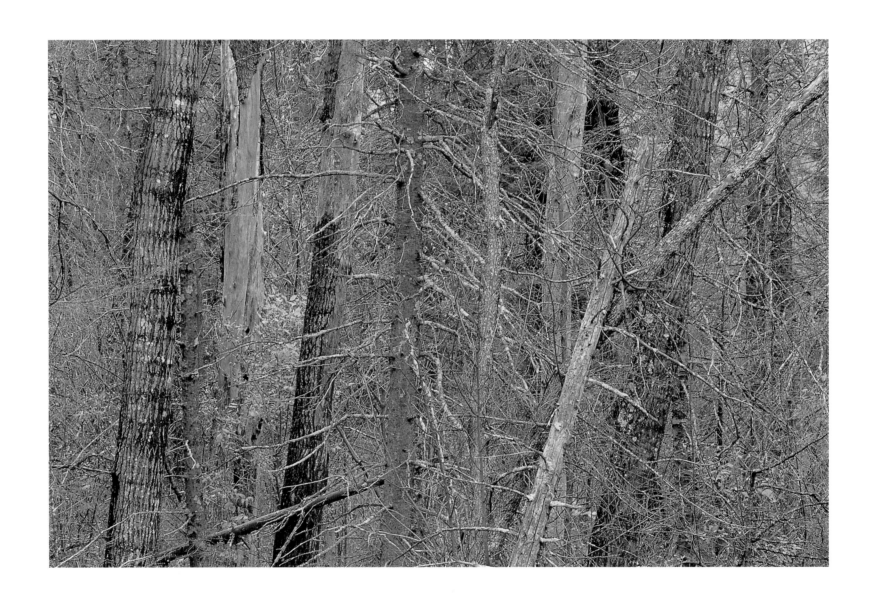

PLATE 41 *Interior, Chippewa National Forest, Minnesota*

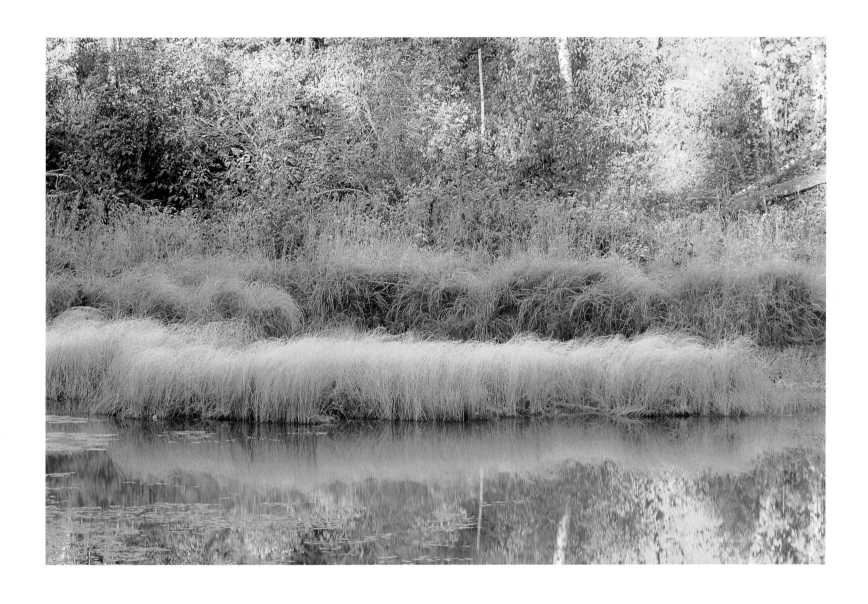

PLATE 42 *Morning Frost on Pond Grasses, Superior National Forest, Minnesota*

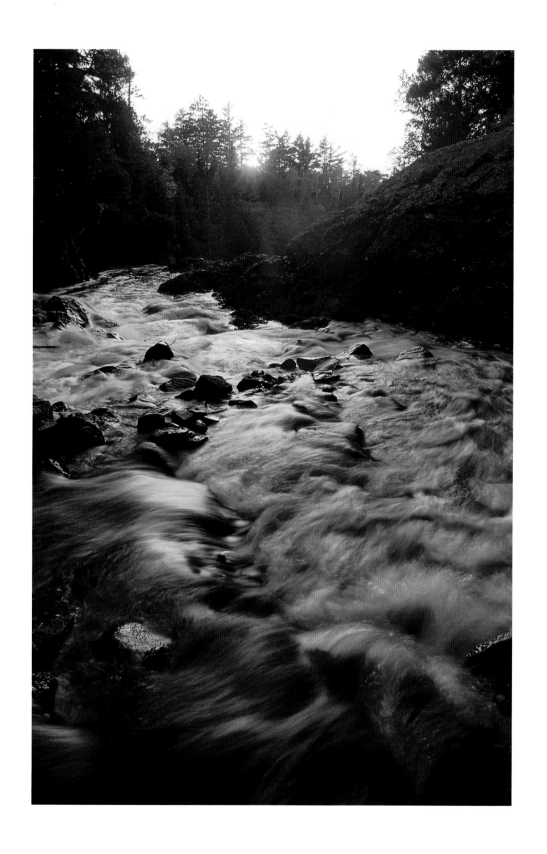

PLATE 43 *Rapids, Pattison Falls, Wisconsin*

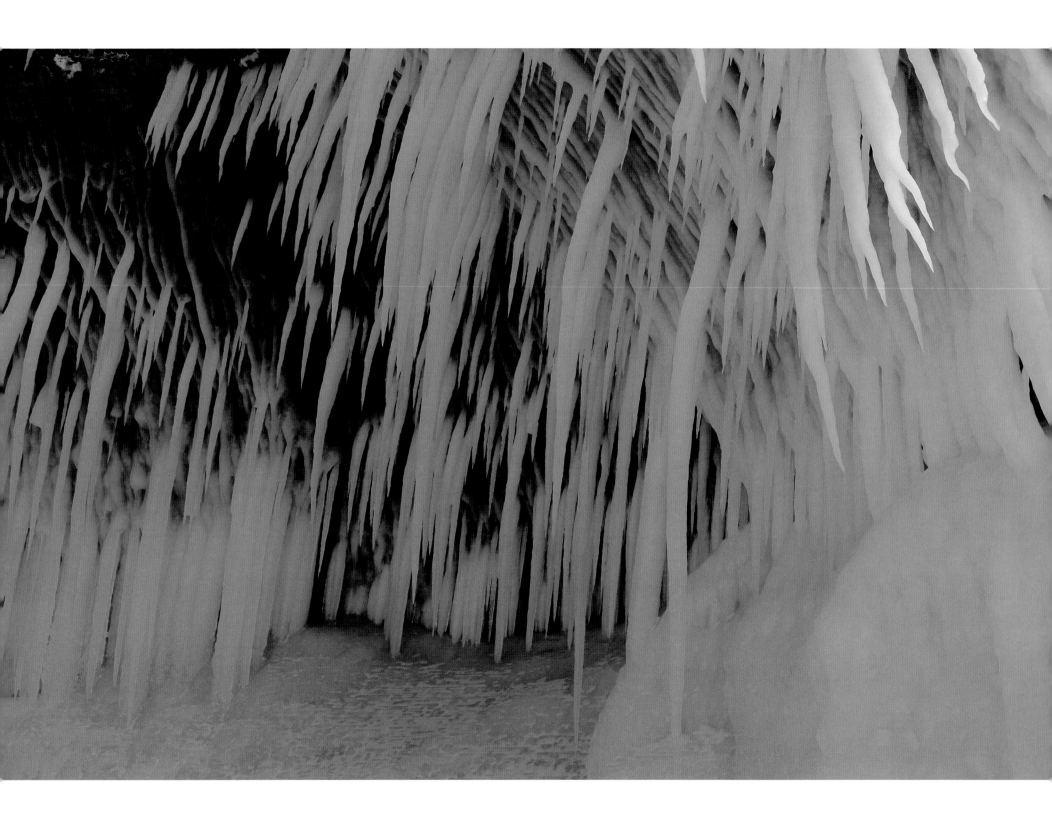

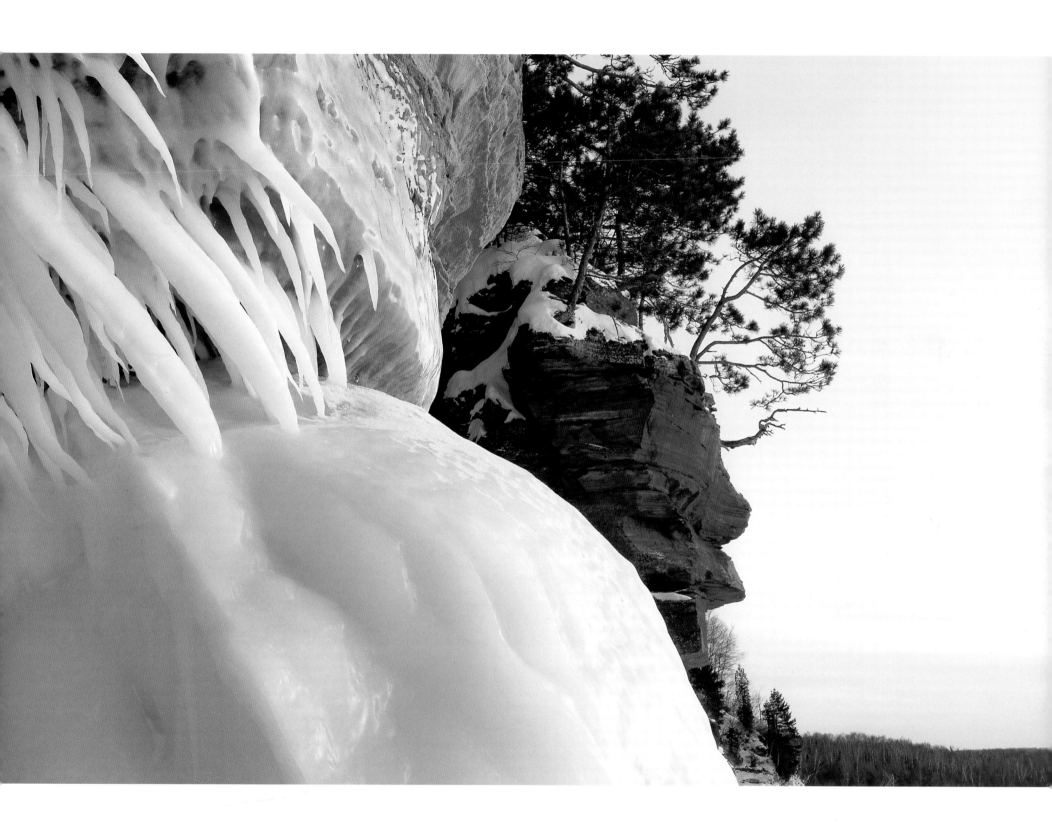

PLATE 44 *Iceflow, Apostle Islands National Lakeshore, Wisconsin*

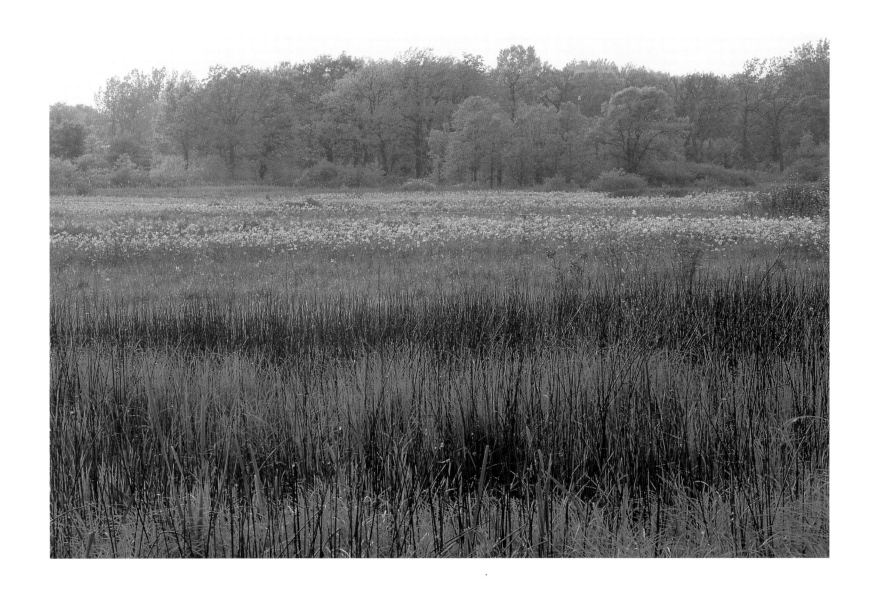

PLATE 45 *Wetland with Shooting Stars, Chiwaukee Prairie, Wisconsin*

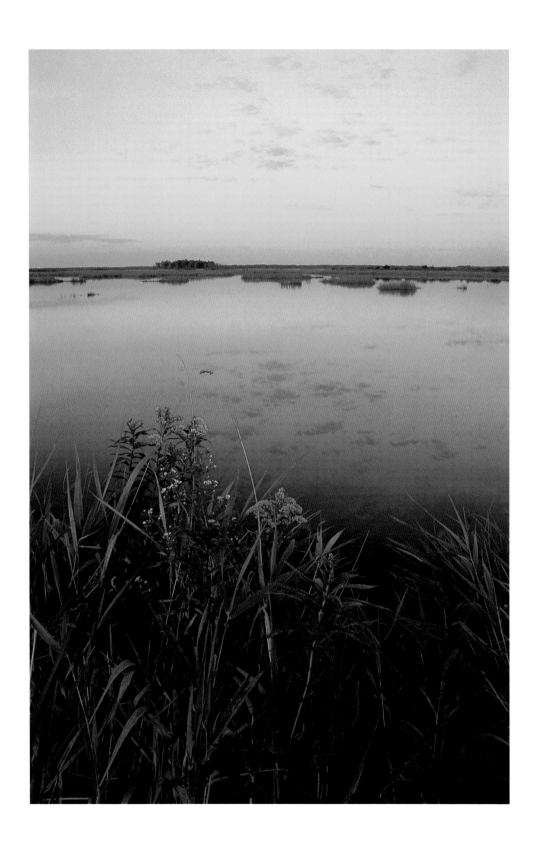

PLATE 46 *Evening, Crex Meadows, Wisconsin*

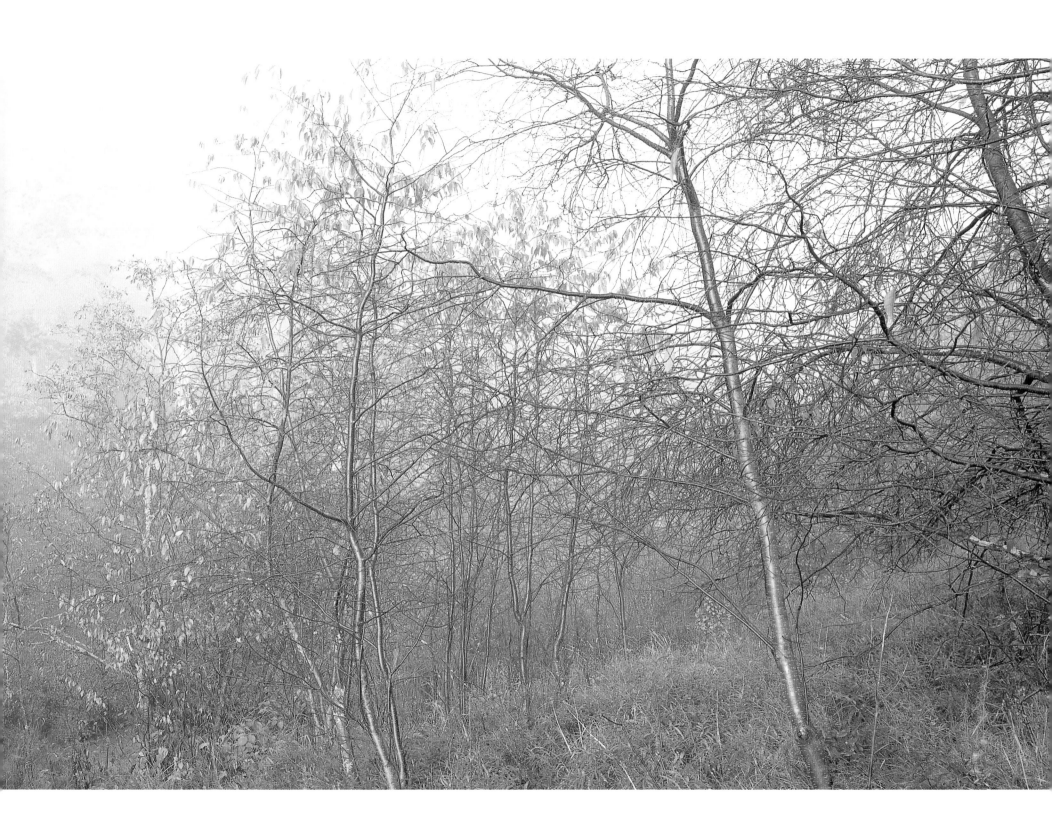

PLATE 47 *Autumn, Chequamegon National Forest, Wisconsin*

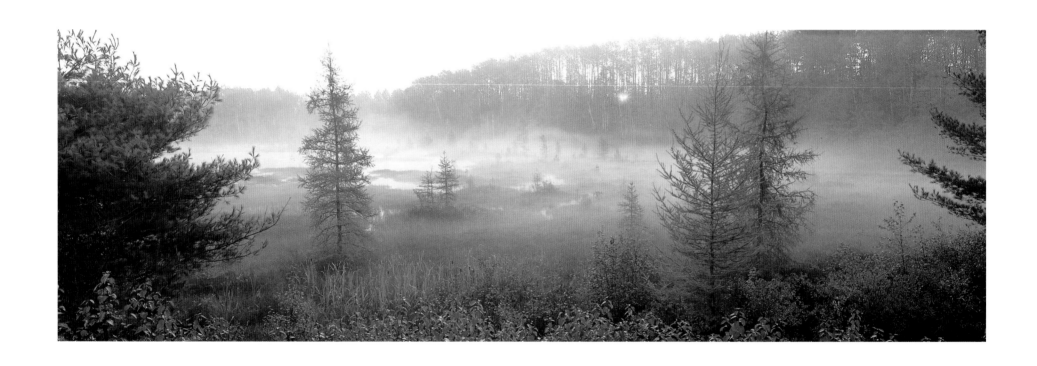

PLATE 48 *Sun and Mist, Northern Highlands State Forest, Wisconsin*

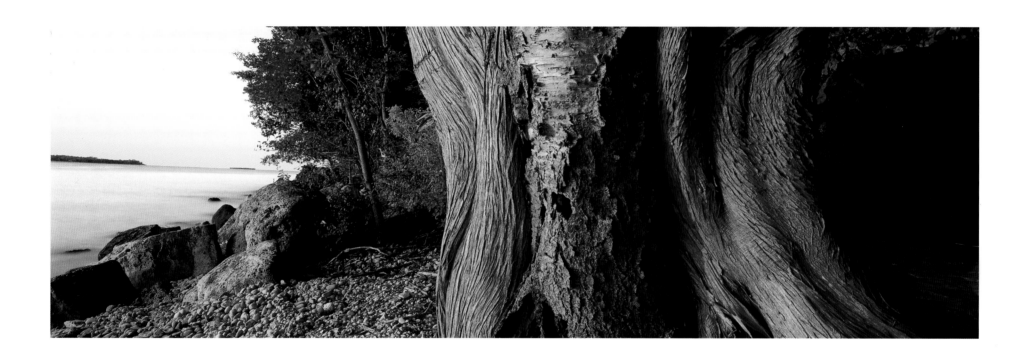

PLATE 49 *Sunset, Peninsula State Park, Door County, Wisconsin*

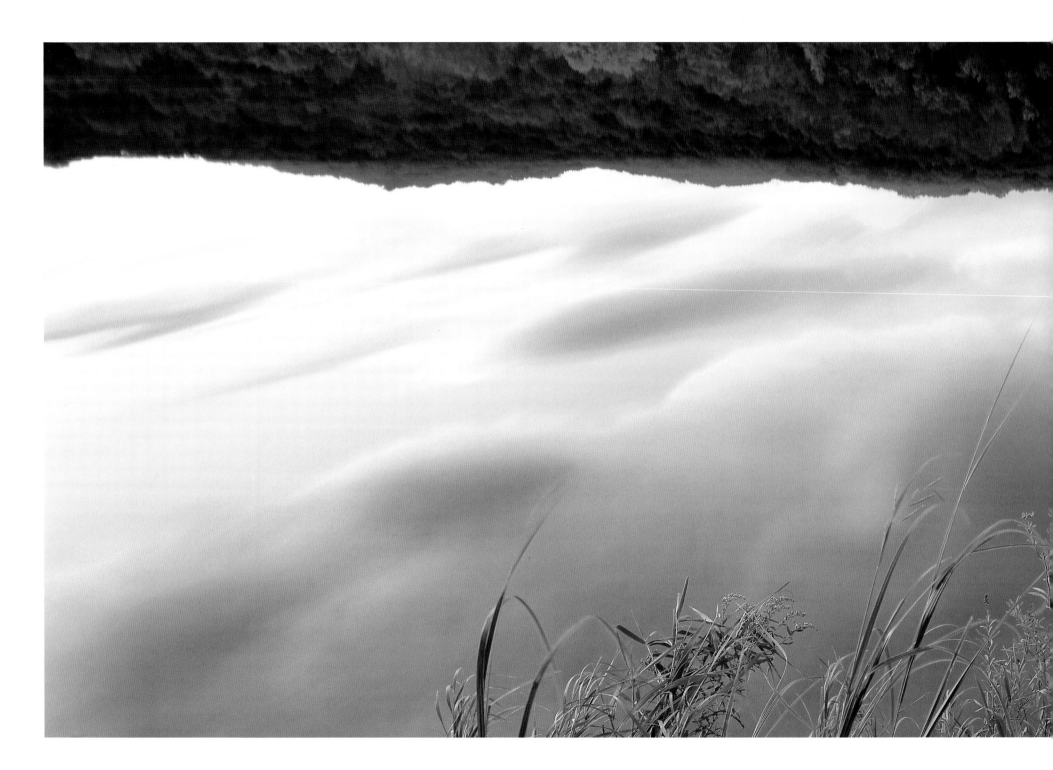

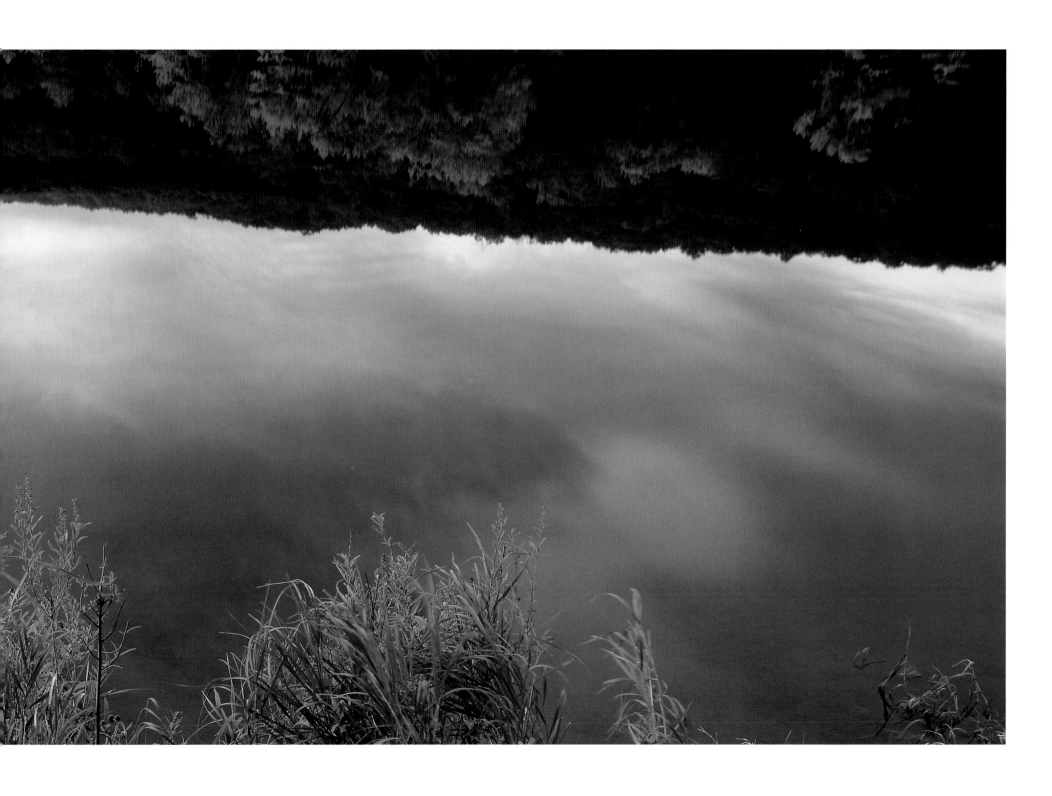

PLATE 50 *Reflection along the Riverbank, St. Croix National Scenic River, Wisconsin*

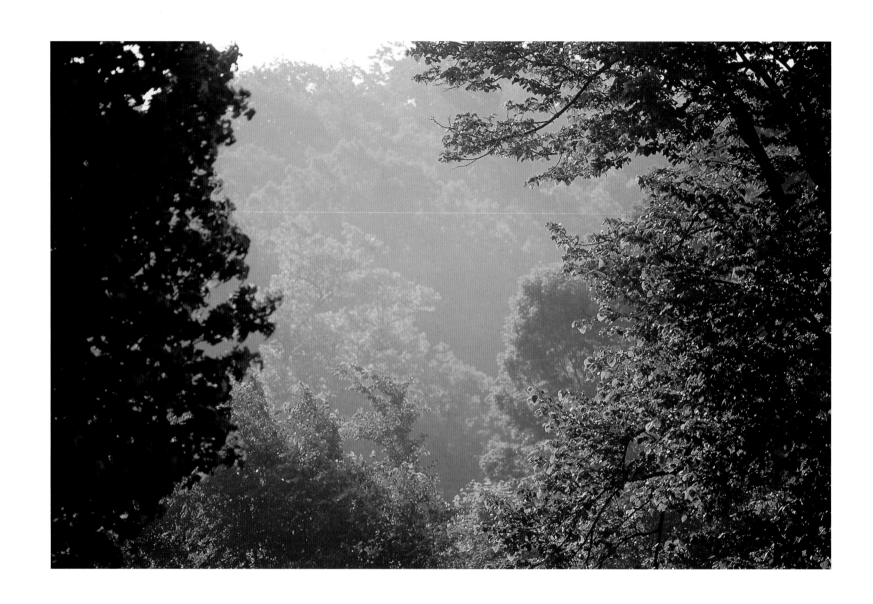

PLATE 51 *Forested Bluffs, Devil's Lake State Park, Wisconsin*

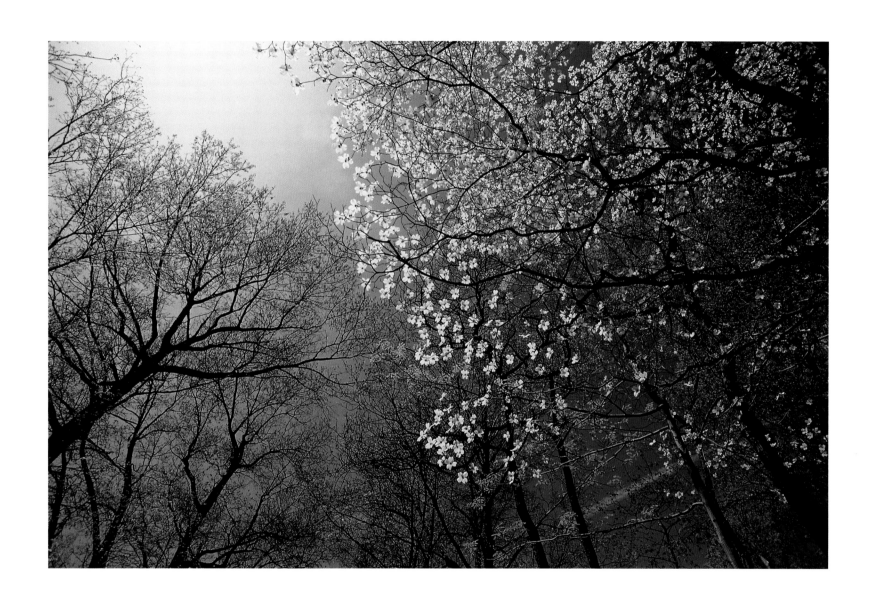

PLATE 52 *Flowering Dogwood, Shawnee National Forest, Illinois*

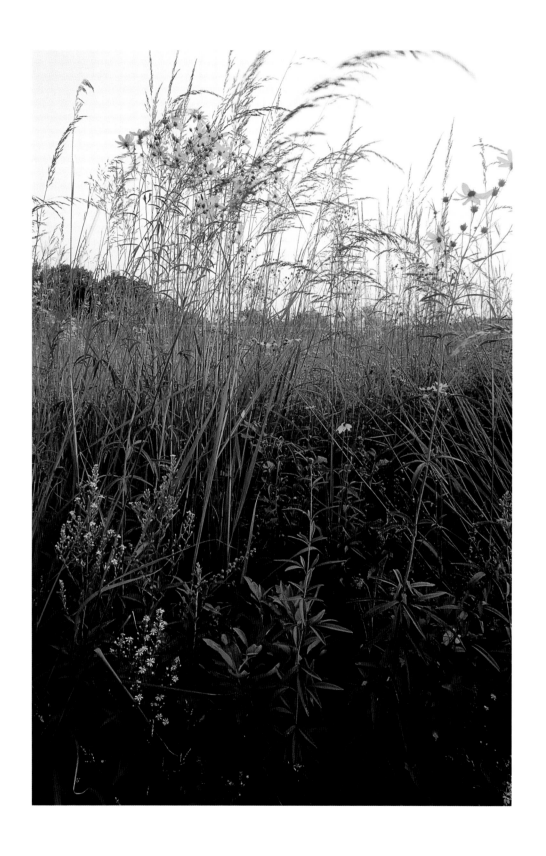

PLATE 53 *Tall Grasses, Wolf Road Prairie, Illinois*

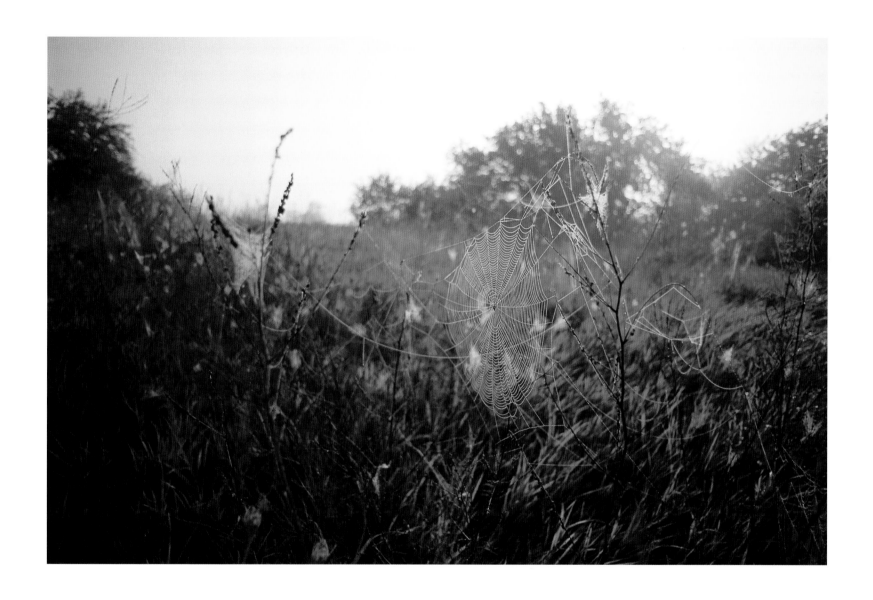

PLATE 54 *Field of Spiderwebs, Du Page County Forest Preserve, Illinois*

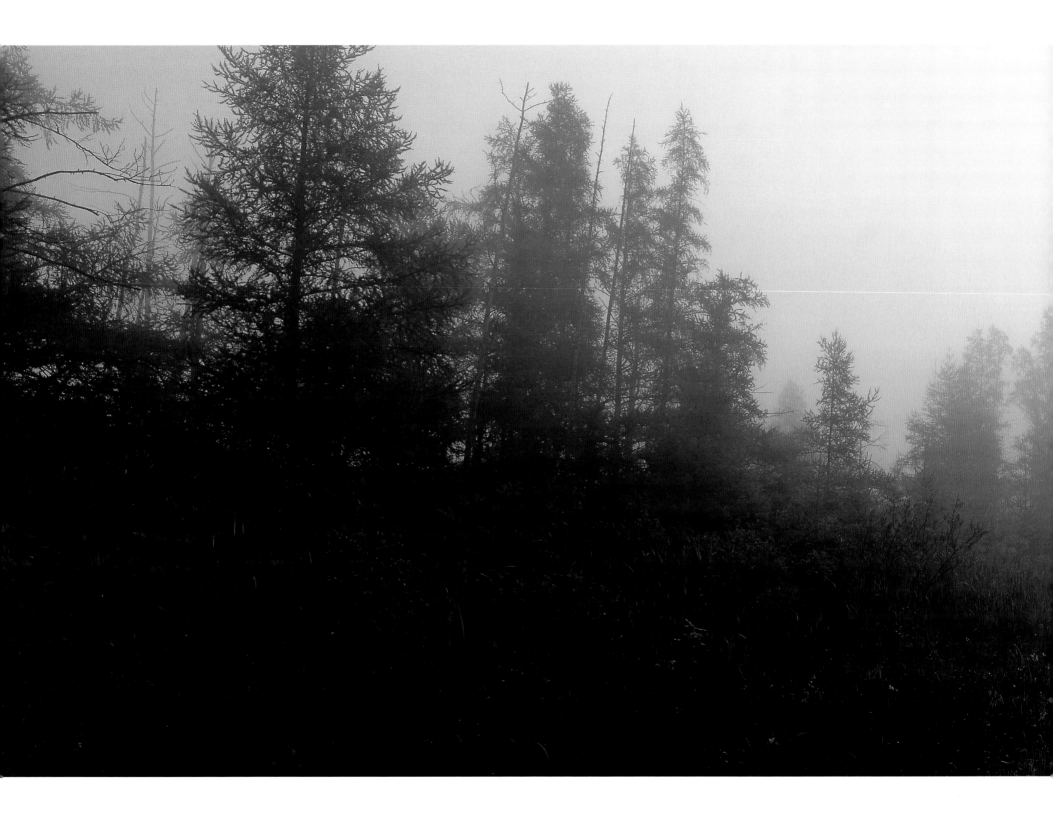

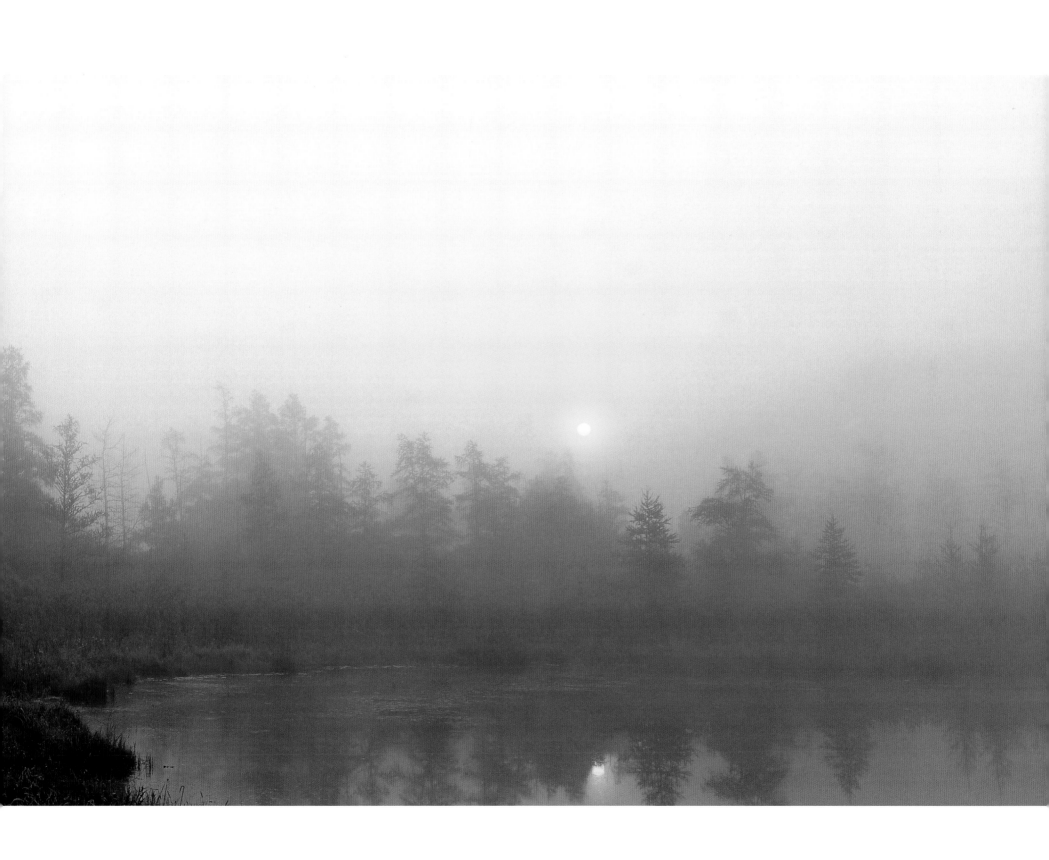

PLATE 55 *Mist at Sunrise, Volo Bog Natural Area, Illinois*

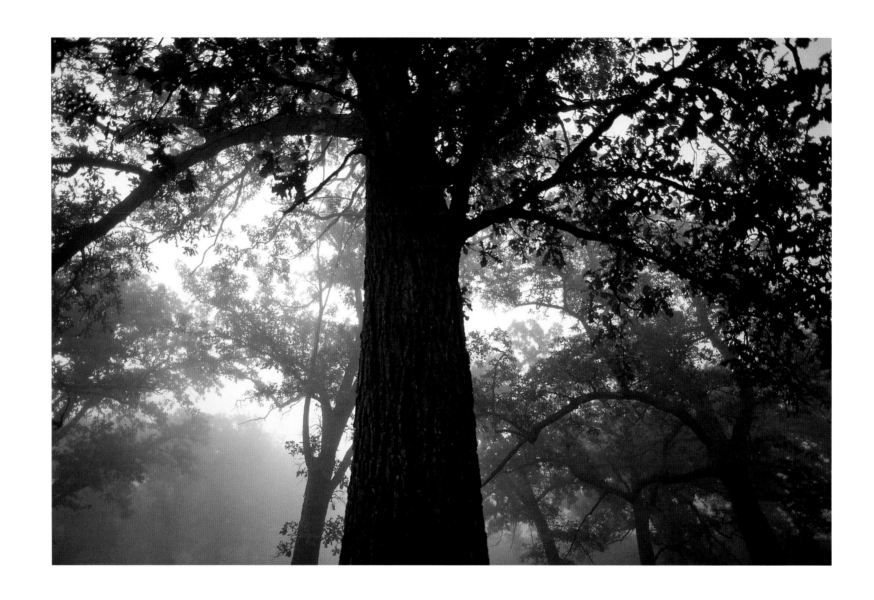

PLATE 56 *Oaks in Mist, Funks Grove, Illinois*

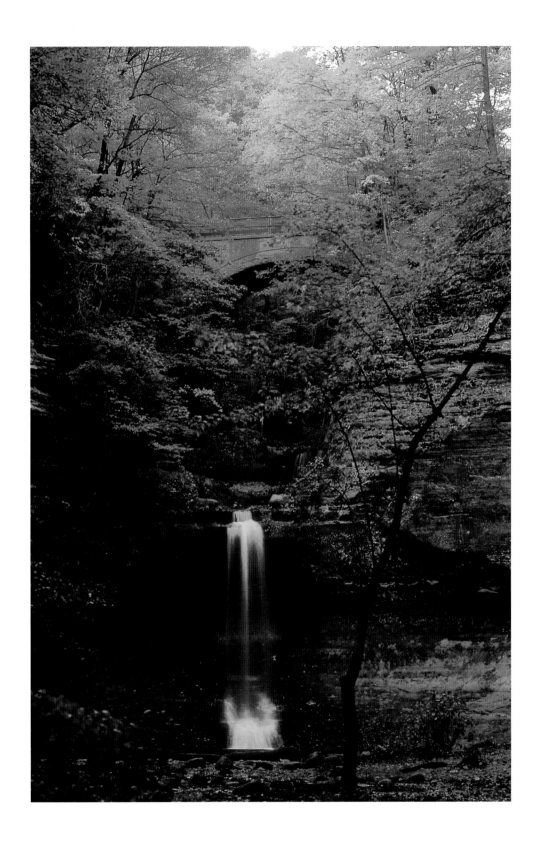

PLATE 57 *Waterfall, Matthiessen State Park, Illinois*

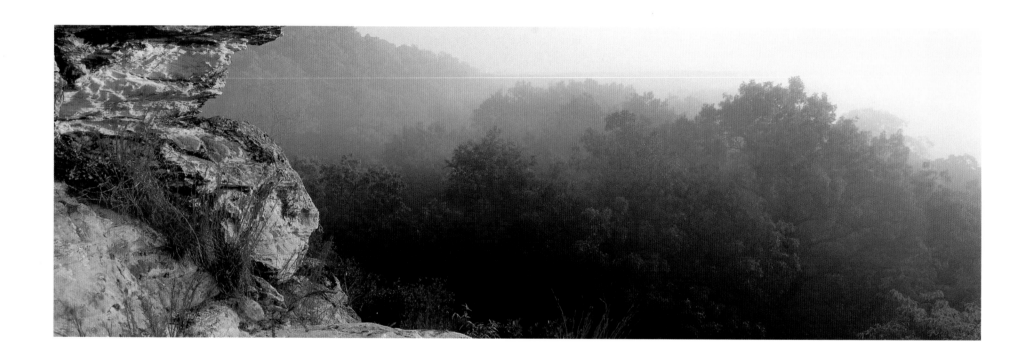

PLATE 58 *Early Morning Fog, Castle Rock, Rock River, Illinois*

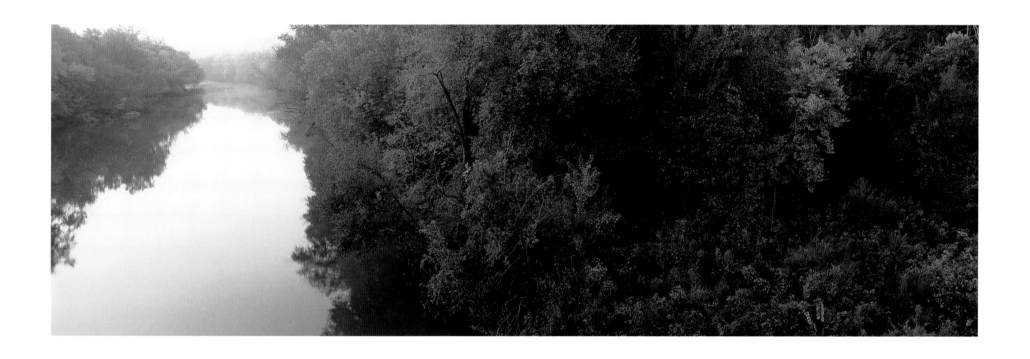

PLATE 59 *Early Autumn, Vermilion River, Illinois*

PLATE 60 *Tamarack Forest, Volo Bog Natural Area, Illinois*

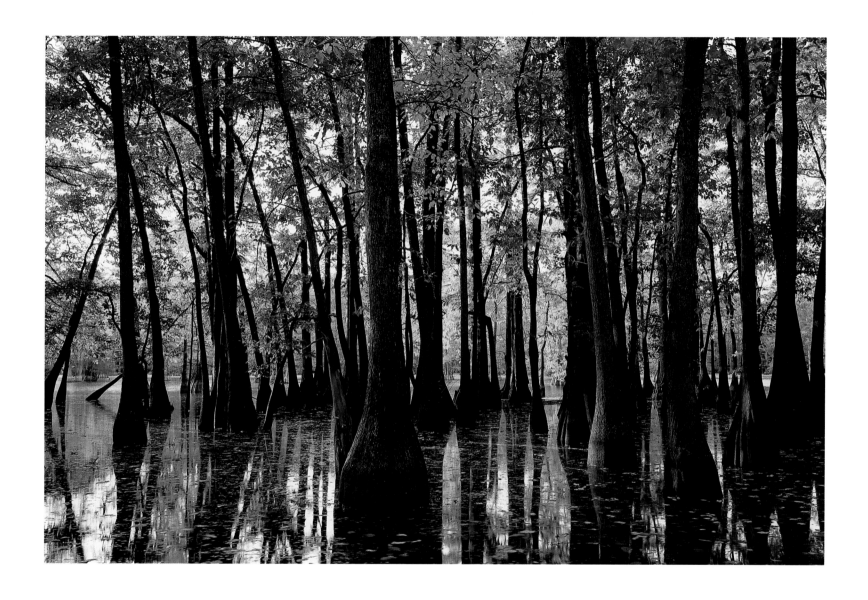

PLATE 61 *Cypress and Tupelo Swamp, Horseshoe Lake, Illinois*

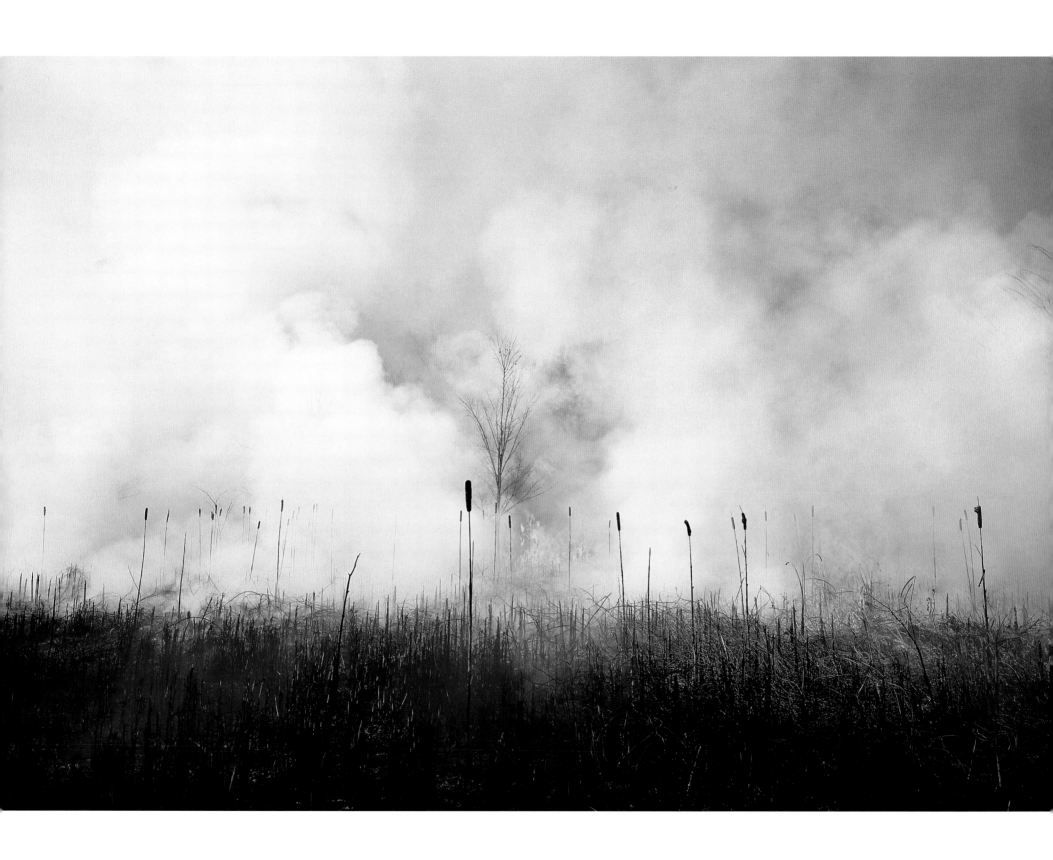

PLATE 62 *Marsh Fire, Du Page County Forest Preserve, Illinois*

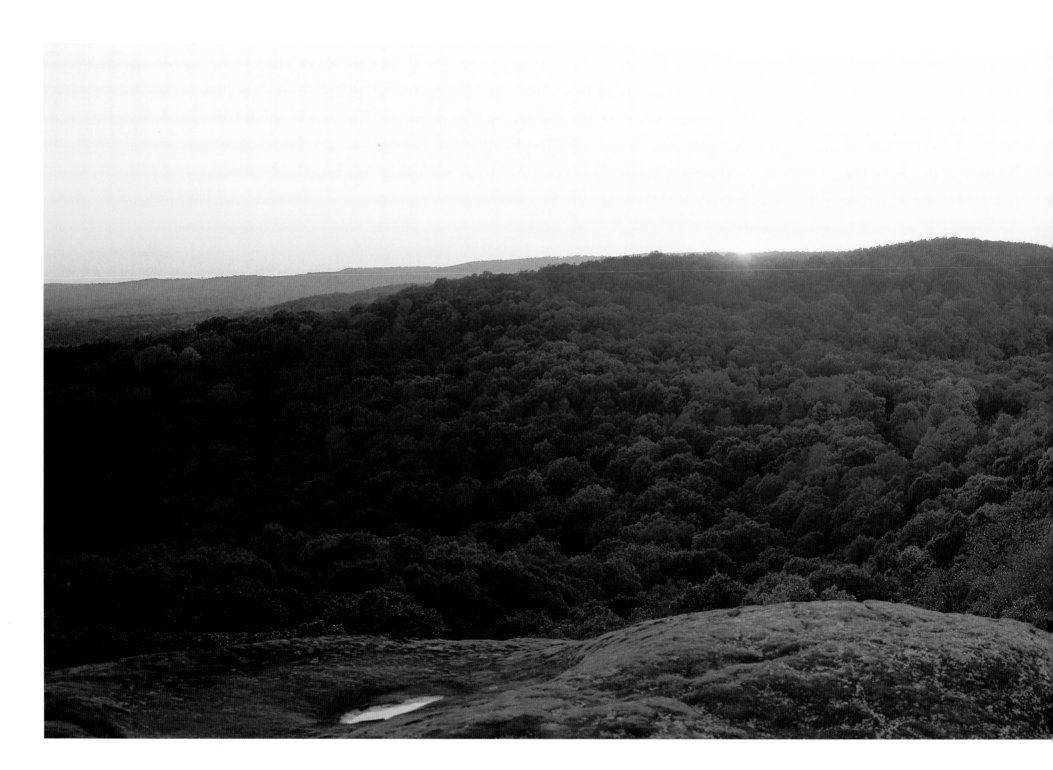

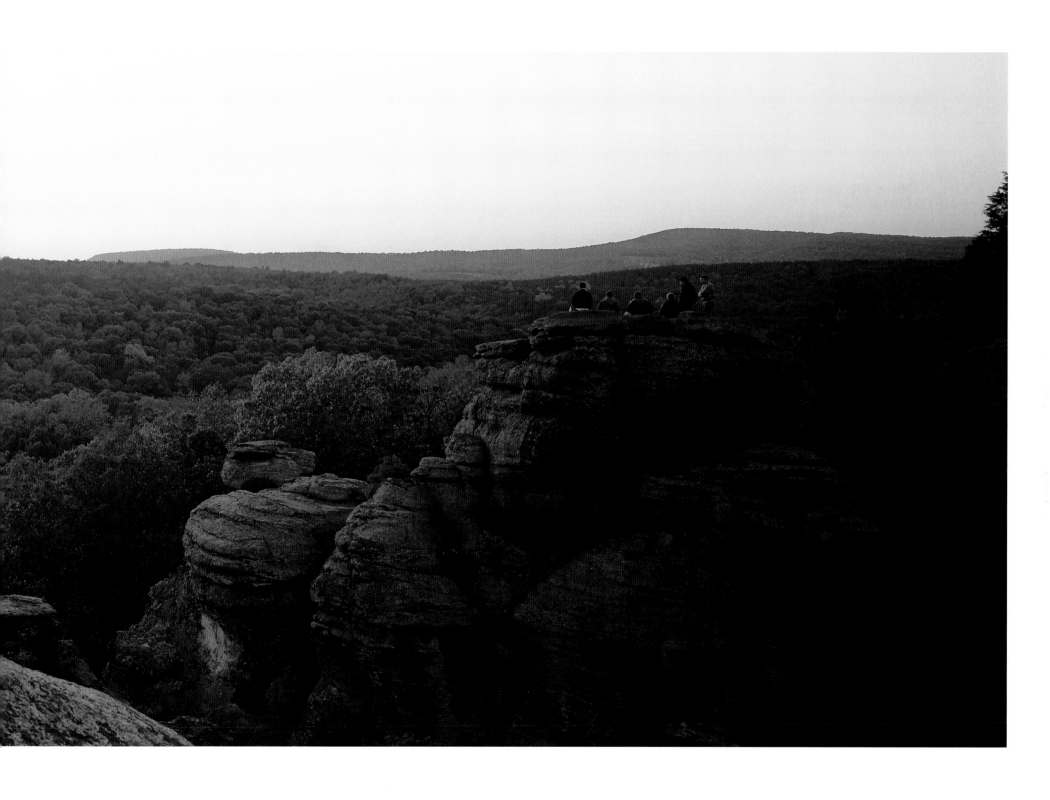

PLATE 63 *Sunset, Garden of the Gods State Park, Illinois*

PLATE 64 *Evening in Late Autumn, Mark Twain National Forest, Missouri*

PLATE 65 *Rock, St. François Mountains, Missouri*

PLATE 66 *Late Afternoon in Early Spring, St. François Mountains, Missouri*

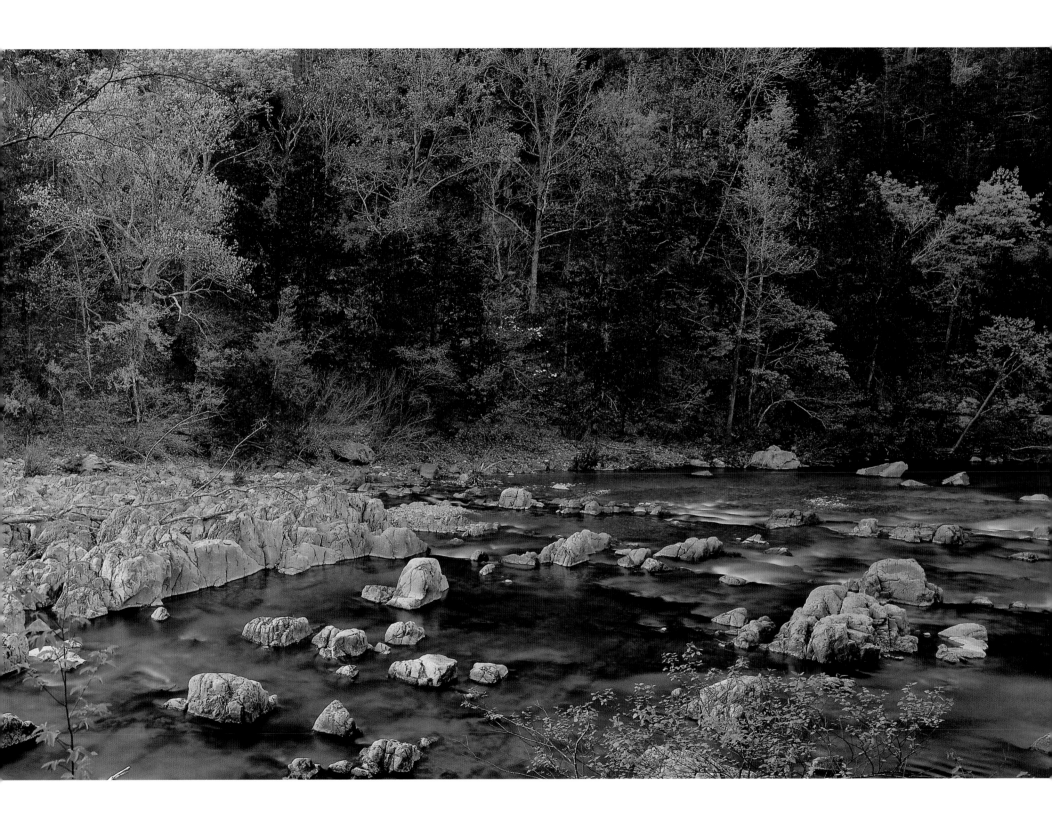

PLATE 67 *Spring along the Black River, St. François Mountains, Missouri*

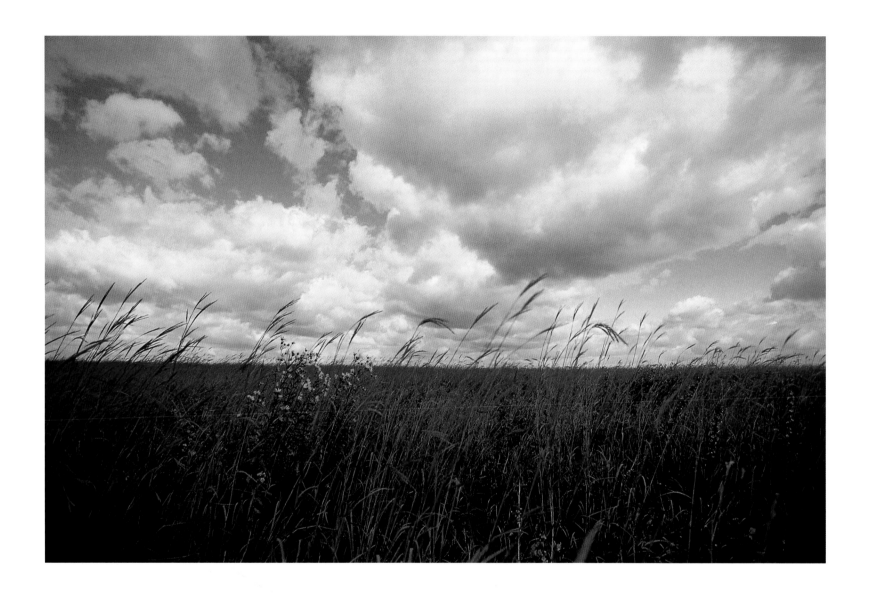

PLATE 68 *Earth and Sky, Hayden Prairie, Iowa*

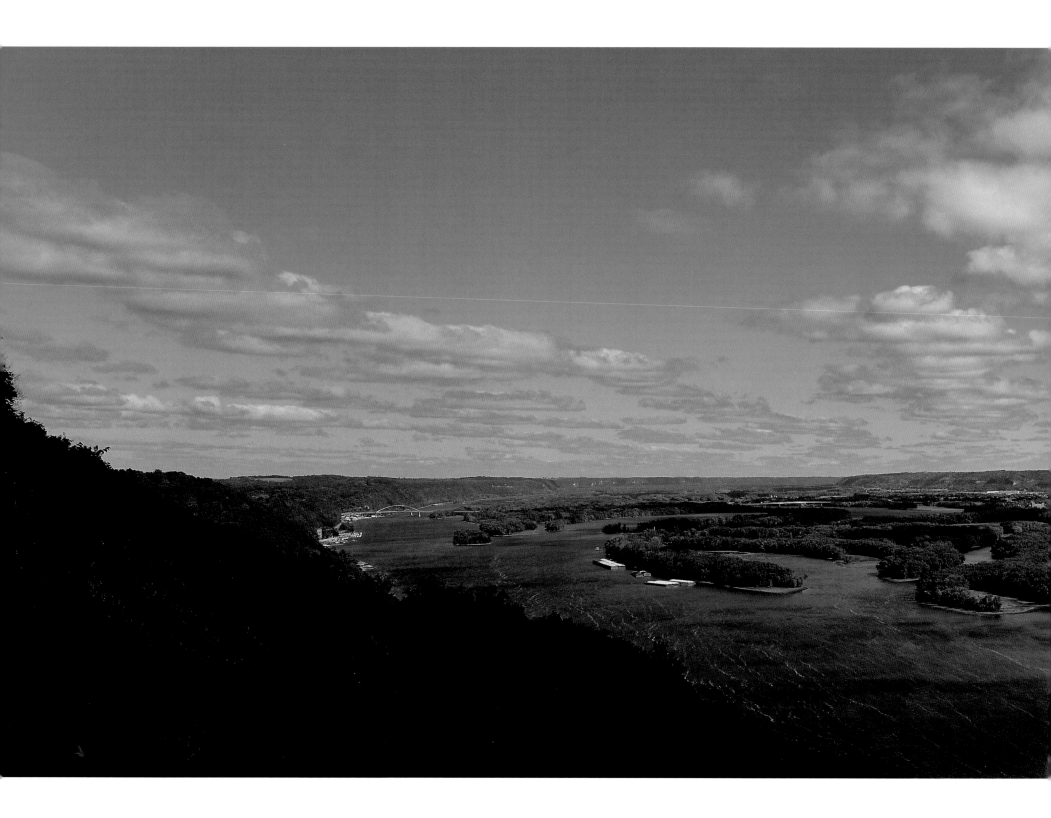

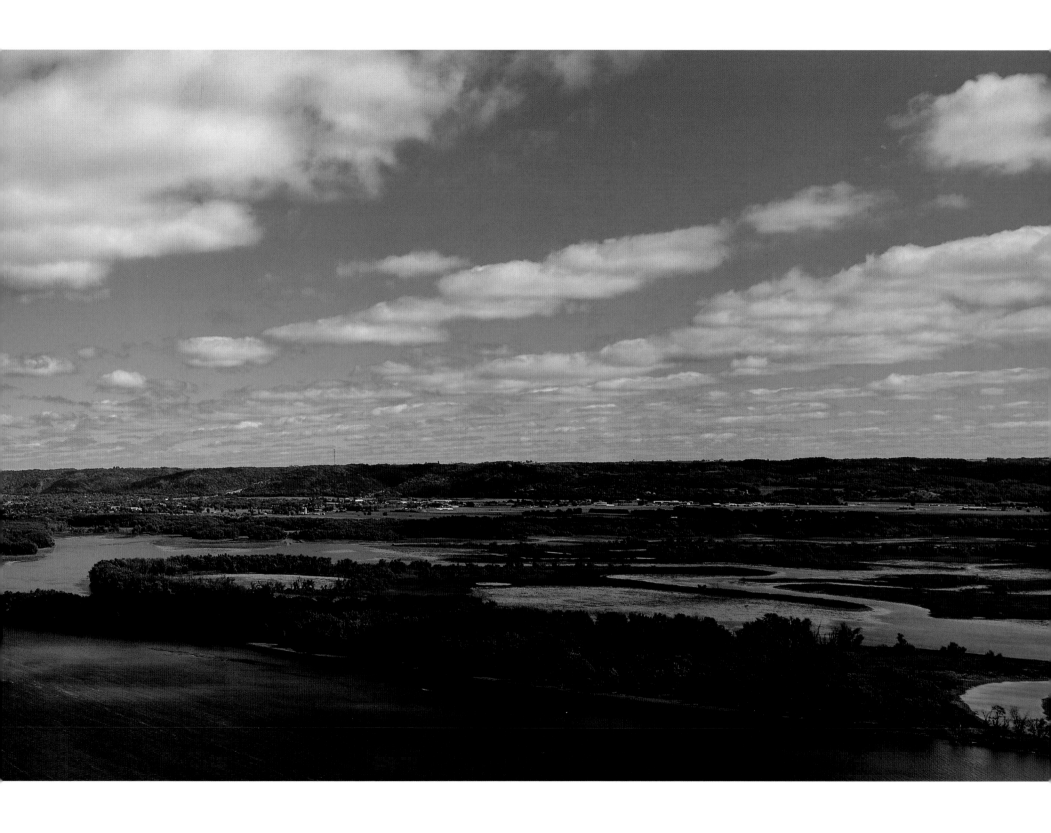

PLATE 69 *Mississippi River, Effigy Mounds National Monument, Iowa*

PLATE 70 *Oak Tree in Wind, near West Branch, Iowa*

PLATE 71 *Late Summer, Loess Hills, Iowa*

PLATE 72 *Hill Prairie Grasses, Loess Hills, Iowa*

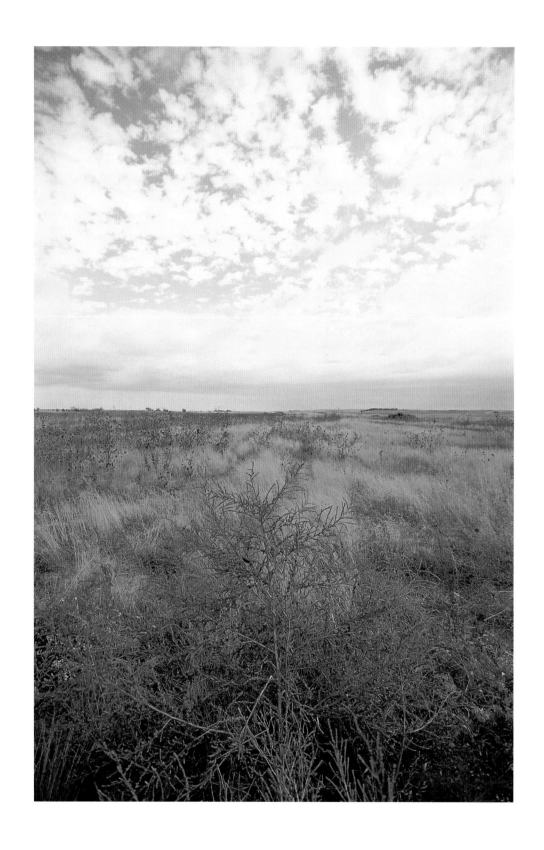

PLATE 73 *Open Field along U.S. 20, Nebraska*

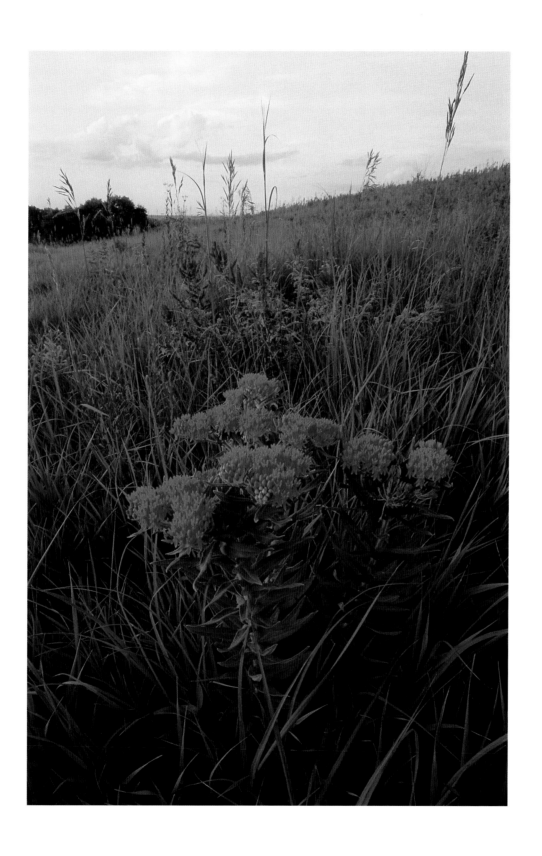

PLATE 74 *Butterflyweed, Cummings Cemetery Prairie, Nebraska*

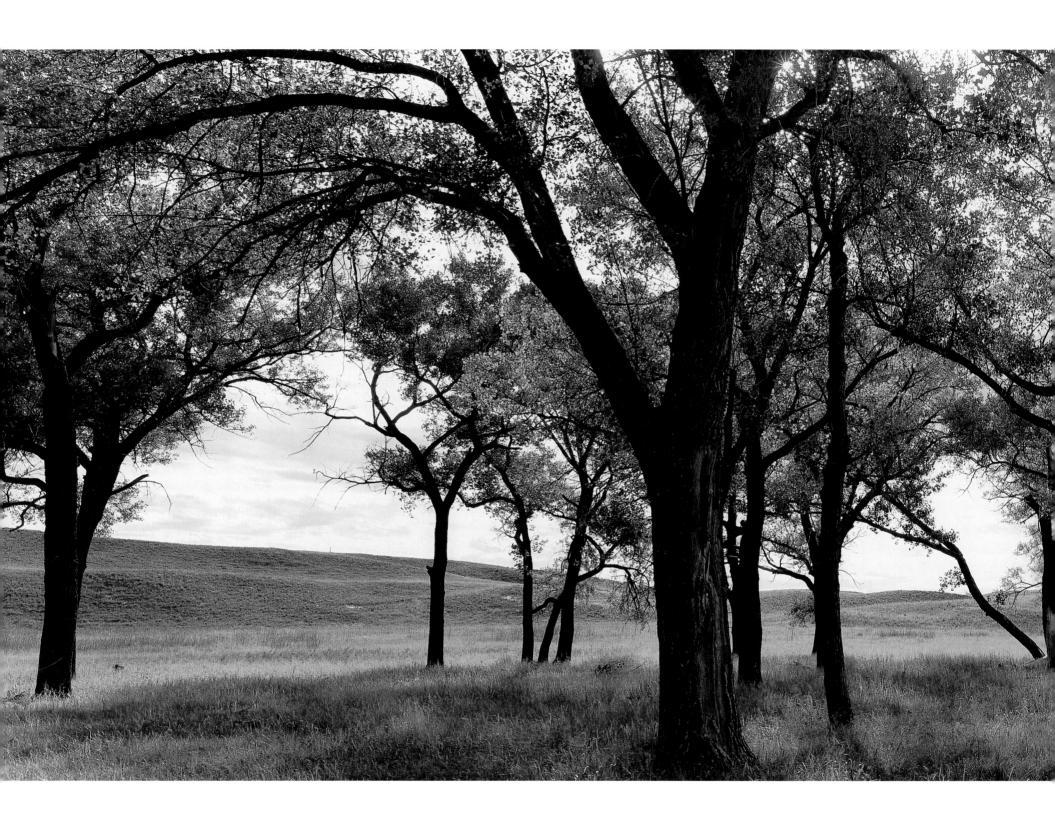

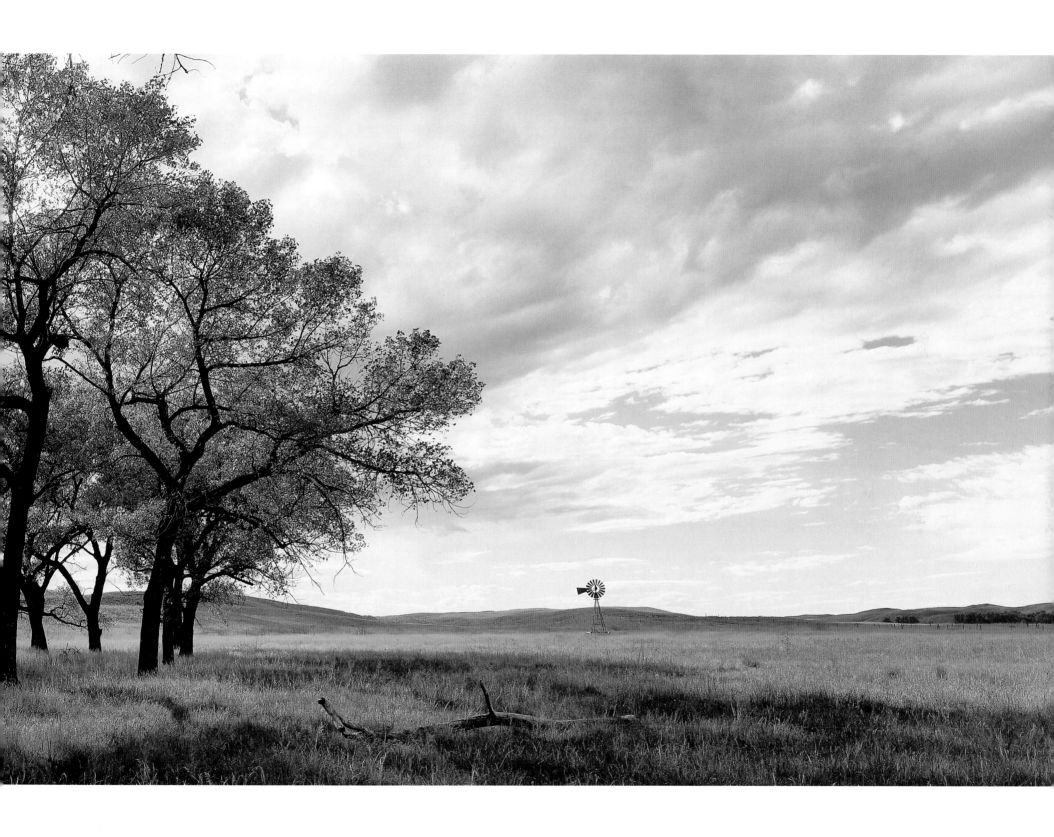

PLATE 75 *Cottonwoods, Sand Hills, Nebraska*

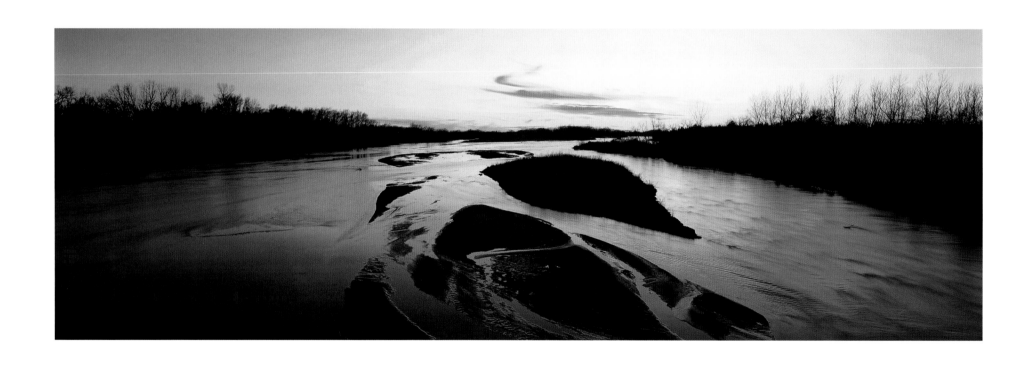

PLATE 76 *Sunset, Platte River, Nebraska*

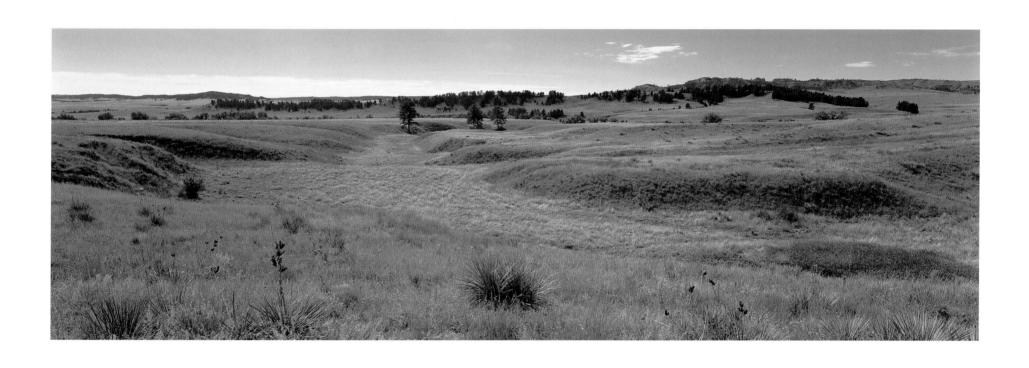

PLATE 77 *Meadow, Soldier Creek Wilderness, Nebraska*

PLATE 78 *Earth and Sky, Western Panhandle, Nebraska*

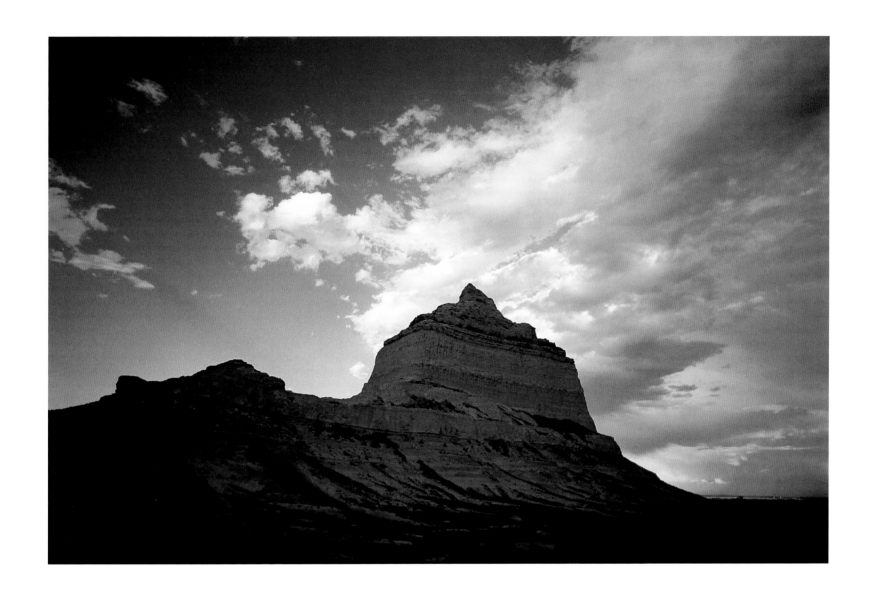

PLATE 79 *Courthouse Rock, Scotts Bluff National Monument, Nebraska*

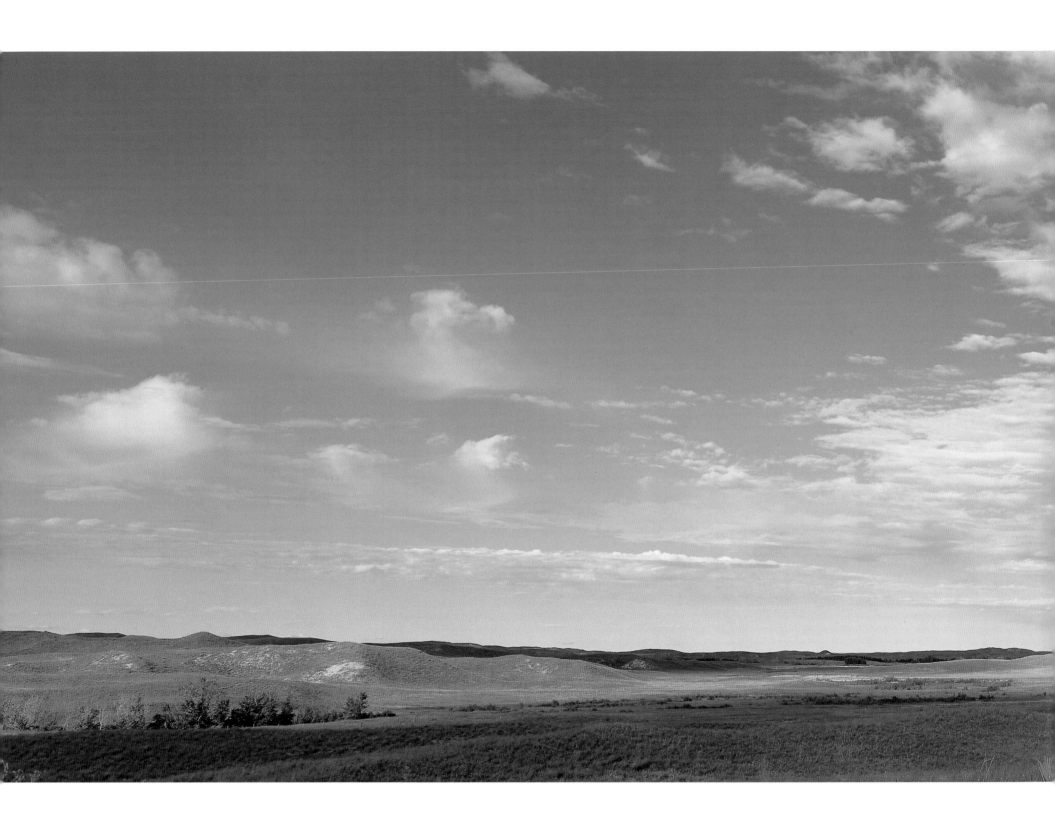

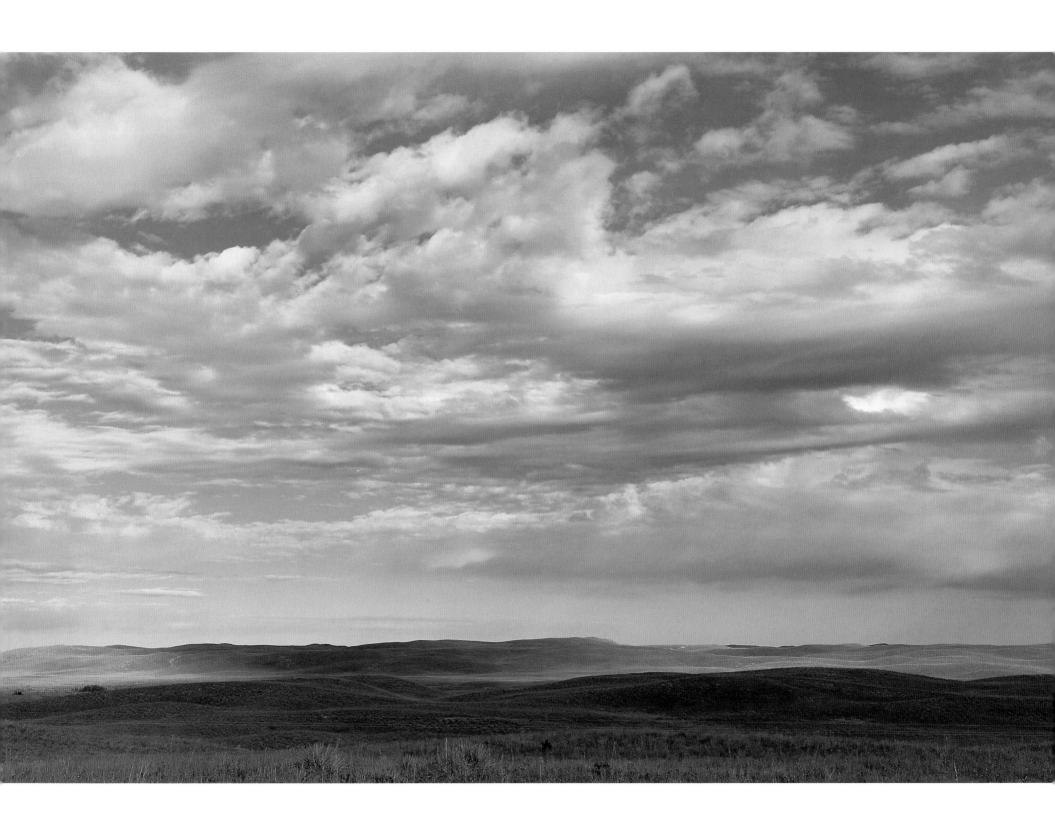

PLATE 80 *Summer Sky, Sand Hills, Nebraska*

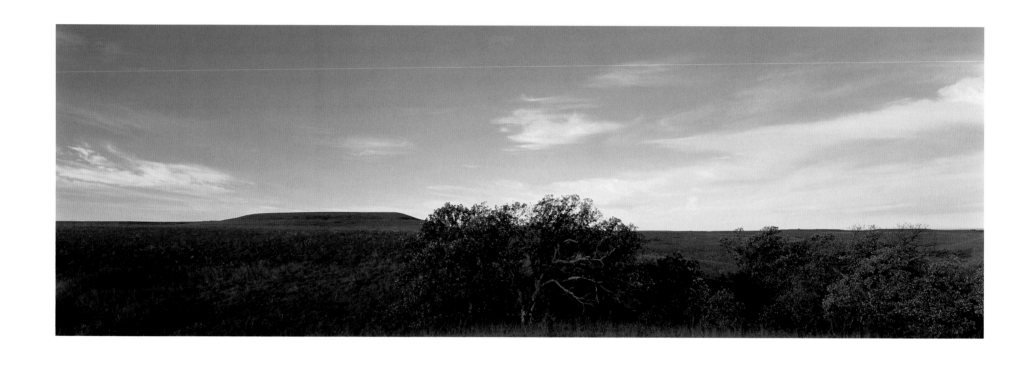

PLATE 81 *Konza Prairie, Flint Hills, Kansas*

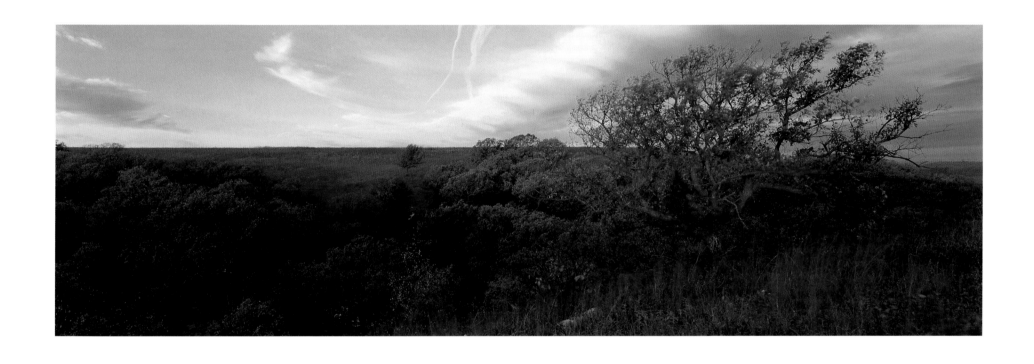

PLATE 82 *Konza Prairie, Flint Hills, Kansas*

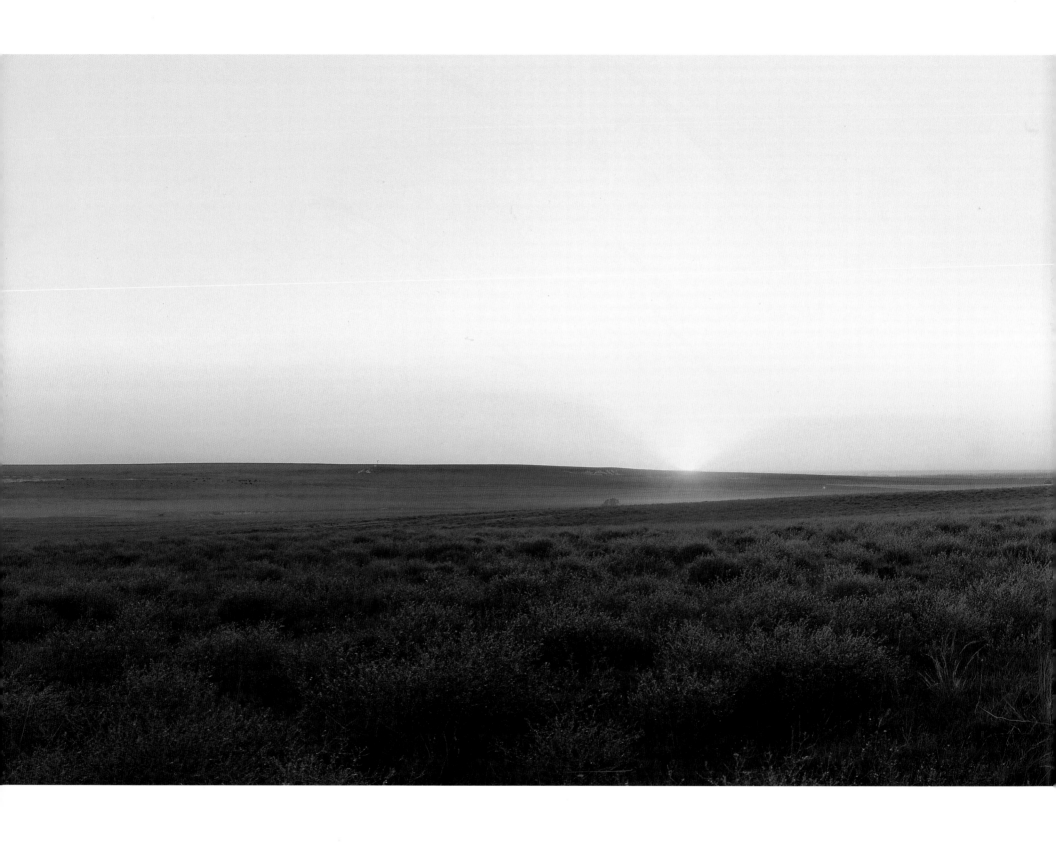

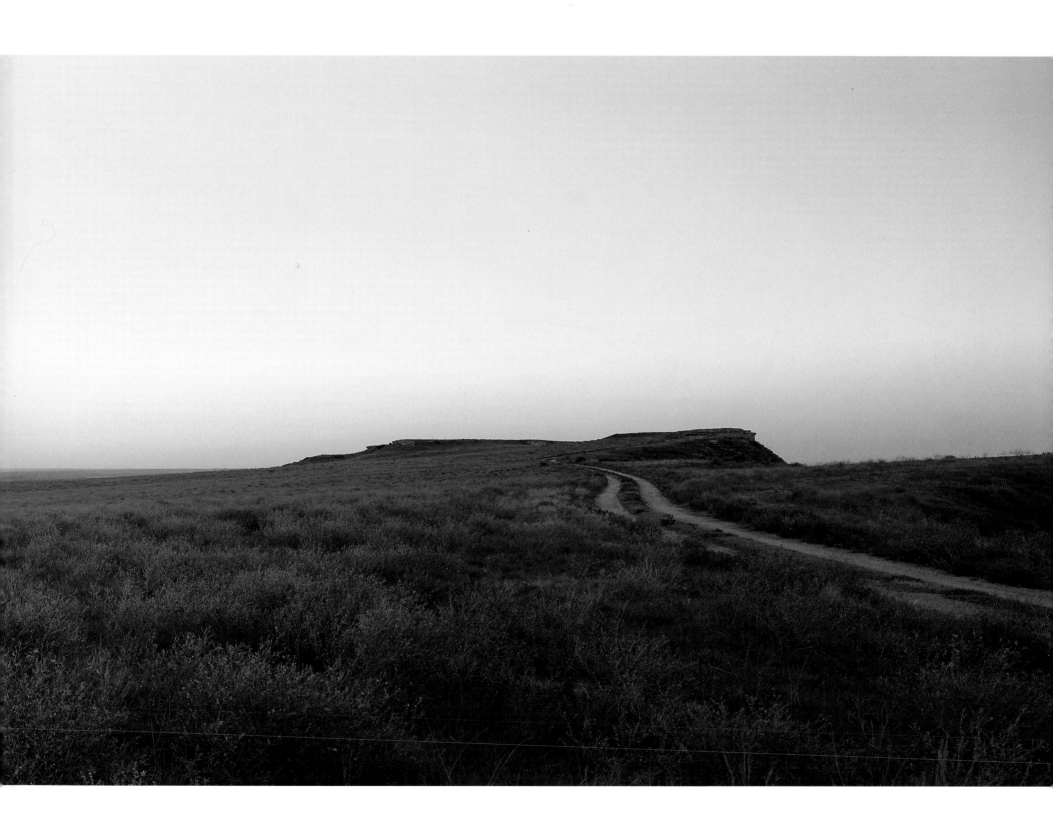

PLATE 83 *Dusk, Smoky Hills, Kansas*

ACKNOWLEDGMENTS

I would like to extend my deep and sincere gratitude to my family and friends, who provide a warm welcome when I return from my solitary travels. I dedicate the photographs in this book to the memory of Lenora Irving, a daughter of the prairie.

GARY IRVING

My thanks go to Richard Wentworth, director of the University of Illinois Press, for concurring that the natural wealth of the Midwest is a worthy subject. I also thank my editor, Carol Bolton Betts, and the anonymous readers who reviewed the text.

I am indebted to the naturalists, ecologists, interpreters, and rangers who took the time to walk with me and explain the elegant complexities of the Midwest's interlocking natural parts.

MICHAL STRUTIN

GARY IRVING is an award-winning landscape photographer whose works have appeared in exhibitions nationwide and in numerous magazines. His books include *Beneath an Open Sky; Illinois;* and *Smithsonian Guides to Natural America: Great Lakes.*

MICHAL STRUTIN is the author of *Chaco: A Cultural Legacy,* which won an award from the National Parks Cooperating Association. Her other books include *Smithsonian Guides to Natural America: Great Lakes; Smithsonian Guides to Natural America: Southeast;* and *Guide to Northern Plains Indians.* She was awarded the Bradford Williams Medal for best feature article in *Landscape Architecture* magazine.

Technical Note

The photographs in this volume were produced using the Linhof 617s Technorama and the Fuji G617 Panoramic cameras as well as the Nikon FM2 35 mm SLRs with Nikkor Ai lenses. Slight warming filters were used as needed and a linear polarizer was occasionally used. Fuji RVP was the film of choice, with supplementary use of 35 mm Kodachrome.

This book is set in Adobe Garamond with Trajan display
Designed by Copenhaver Cumpston
Typeset by Jim Proefrock at the University of Illinois Press
Printed on Potlatch McCoy, velvet, 100# text
Manufactured by Friesens Corporation